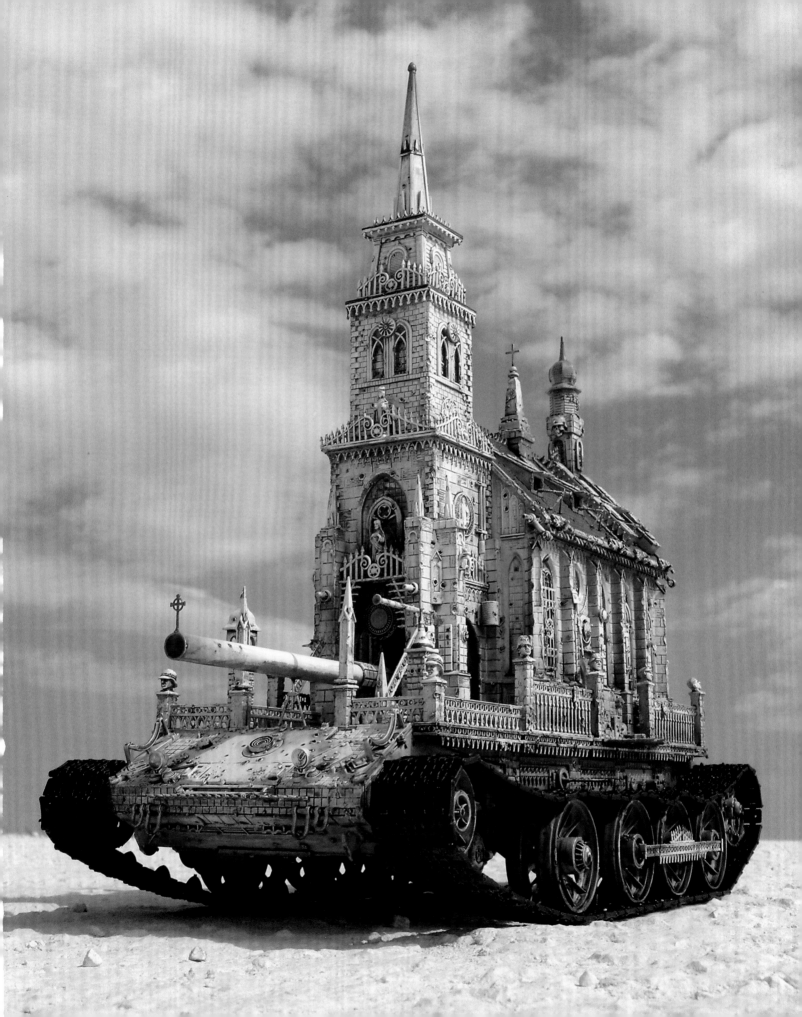

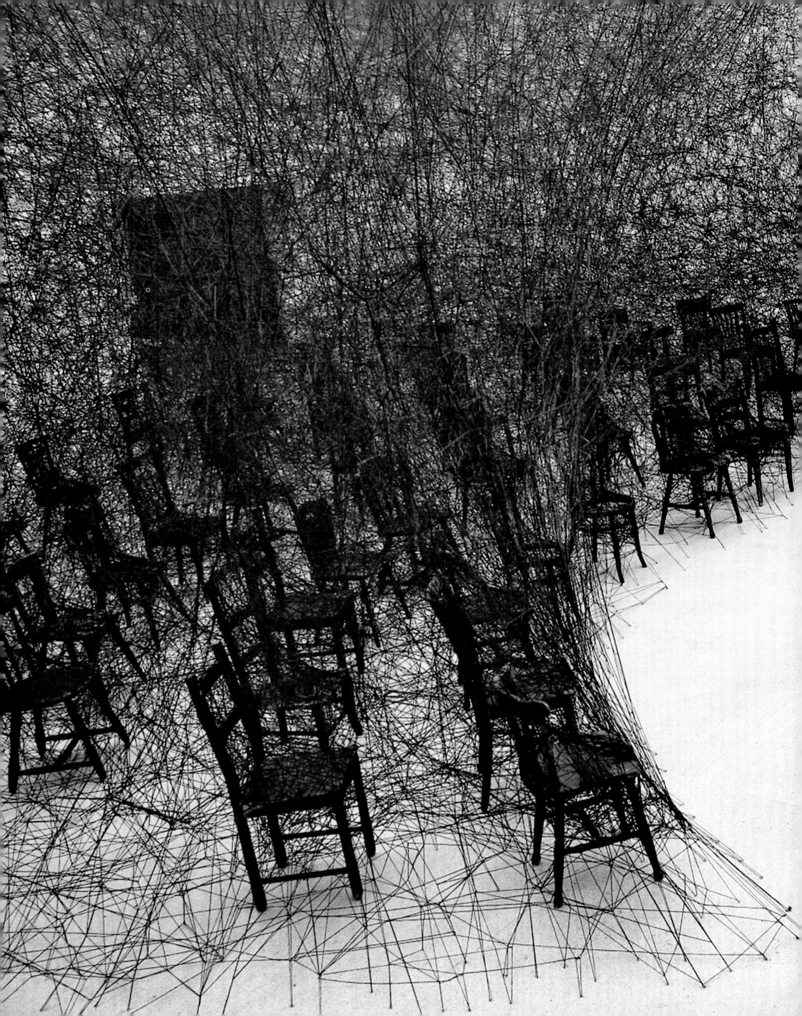

Aaron Rosen

ART+RELIGION
IN THE 21ST CENTURY

Thames & Hudson

Dr Aaron Rosen lectures in Sacred Traditions and the Arts at King's College London. He previously taught at Yale, Oxford, and Columbia Universities, after receiving his PhD from the University of Cambridge. He has written widely for scholarly and popular publications, and has provided commentary for the *New York Times*, *Los Angeles Times*, *Times Higher Education*, BBC Radio 4, and other outlets. He is the author of *Imagining Jewish Art* (Legenda, 2009) and the editor of *Religion and Art in the Heart of Modern Manhattan* (Ashgate, 2015), as well as a guest curator at the Jewish Museum London.

Art & Religion in the 21st Century © 2015 Thames & Hudson Ltd, London

Text © 2015 Aaron Rosen

First published in 2015 in hardcover in the United States of America by Thames & Hudson Inc., 500 Fifth Avenue, New York, New York 10110

thamesandhudsonusa.com

Library of Congress Catalog Card Number 2015932463

ISBN 978-0-500-23931-5

Printed and bound in China by C & C Offset Printing Co. Ltd

Front cover:
RON MUECK AUSTRALIA
Youth, 2009 (see p. 212)
Courtesy the artist, Anthony d'Offay, London and Hauser & Wirth. Photo Alex Delfanne, © Ron Mueck

Back cover and opposite:
AWST & WALTHER
WALES AND GERMANY
Temptation, 2008 (see p. 149)
© Awst & Walther

Half-title page:
KRIS KUKSI USA
Churchtank Type 7C, 2009
Mixed-media assemblage,
48.3 x 19.1 x 40.6 cm (19 x 7½ 16 x in.)

Title page:
CHIHARU SHIOTA JAPAN
In Silence, 2008 (see p. 91)

contents

INTRODUCTION 6

PART I) ◇ people of the image? 24
1 ◆ IN THE BEGINNING 26
2 ◆ SWEET JESUS! 46

PART II) ◇ wonder 68
3 ◆ THE SUBLIME 70
4 ◆ HEAVEN AND EARTHWORKS 92

PART III) ◇ cultural identities 112
5 ◆ CREATIVE DIFFERENCES 114
6 ◆ CONFLICTING IMAGES 136

PART IV) ◇ ritual 158
7 ◆ PERFORMANCE RITES 160
8 ◆ STRUCTURE AND LOSS 182

PART V) ◇ indwelling 204
9 ◆ EMBODIMENT 206
10 ◆ GALLERIES AND SANCTUARIES 228

BIBLIOGRAPHY 248

ACKNOWLEDGMENTS 253

ILLUSTRATION CREDITS 254

INDEX 255

INTRODUCTION

▽ **LEONARDO DA VINCI** ITALY

The Last Supper, c. 1495–8

Tempera and oil on plaster, 460 x 880 cm (181⅛ x 346½ in.)

Leonardo depicts the moment when Jesus signals his betrayal: '"Very truly, I tell you, one of you will betray me." The disciples looked at one another, uncertain of whom he was speaking. One of his disciples – the one whom Jesus loved – was reclining next to him' (John 13.21-23). The identity of the 'one whom Jesus loved' has been the subject of great speculation.

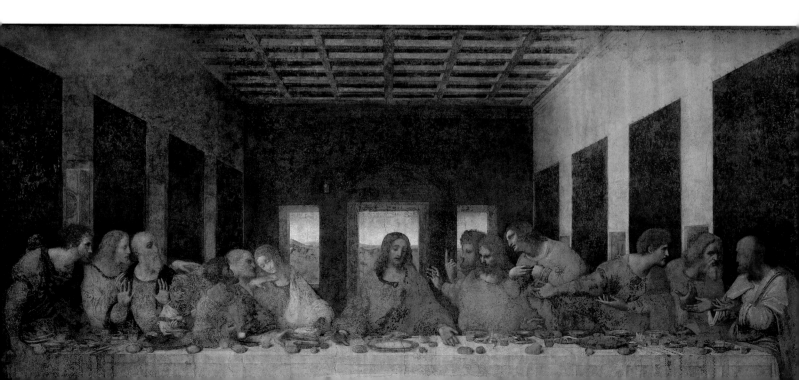

When you enter the world of art, you are, like it or not, entering the realm of religion. Consider some of the world's most famous works of art – the Parthenon Marbles, the Buddhas of Bamiyan, *The Last Supper*, the Blue Mosque – and it becomes clear just how deeply the history of art has been coloured by the history of religion. But these are all examples from earlier epochs. What about more recent times?

▽ Sultan Ahmed I Mosque, 1609–17
Istanbul, Turkey

The Sultan Ahmed Mosque – sporting a then staggering six minarets – was part of a comprehensive effort by Ottoman monarchs to transform the once Christian city of Constantinople (now Istanbul) into a self-evidently Islamic metropolis. It received its moniker, the 'Blue Mosque', from the 21,000 hand-painted floral tiles lining the interior. The delicate calligraphic decorations are by Seyyid Kasim Gubari.

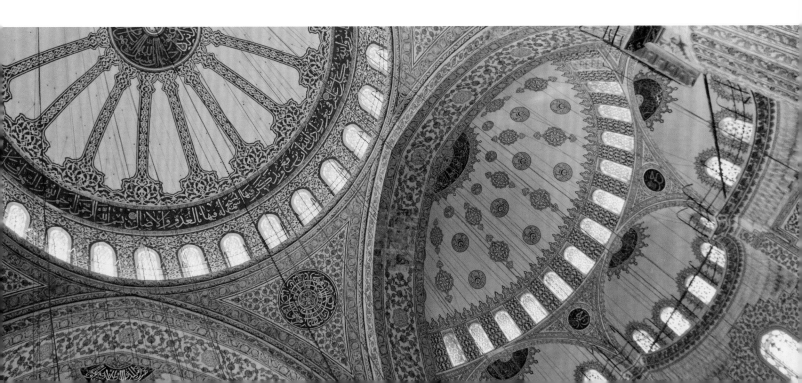

Carved into cliffs in the Hindu Kush, these monuments once formed the world's largest standing sculptures of the Buddha, with the tallest reaching 50 metres (165 feet). Located along a branch of the ancient Silk Road, for centuries Bamiyan was a flourishing site of Buddhist culture, with monasteries and sanctuaries clustered along the cliffs. Claiming them to be false idols, the Taliban demolished them in 2001, unintentionally revealing what was behind them: the world's oldest oil paintings.

No longer beholden to religious institutions for commissions, and free to explore subjects drawn from various faiths or none at all, it is certainly true that modern art has not been the same faithful handmaiden of religion as it often was in the past. And yet, since its birth in the nineteenth century, modern art has continued to draw extensively upon religious themes and images. Paul Gauguin frequently painted biblical subjects, imagining himself as everything from a suffering Christ to a devious Satan or a new Adam. Despite being an avowed atheist, Pablo Picasso subtly incorporated religious iconography in masterpieces such as *Les Demoiselles d'Avignon* (The Young Ladies of Avignon; 1907) and *Guernica* (1937). Mark Rothko, who came from a Jewish background, considered his abstract chapel paintings his crowning achievement. Meanwhile, Andy Warhol was a regular churchgoer who created a powerful series of 'Last Supper' paintings in his final years.

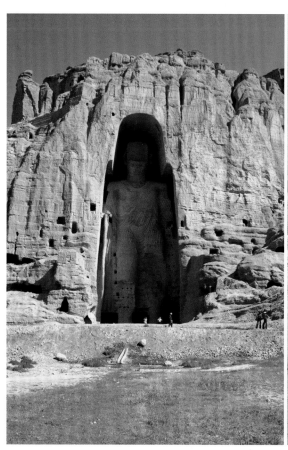
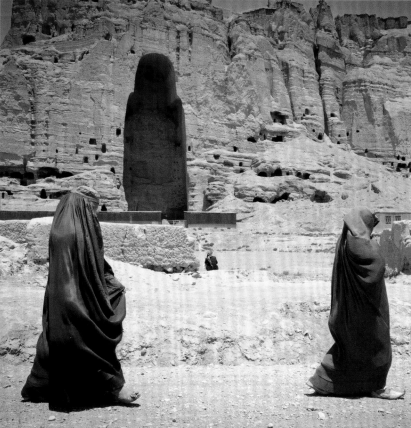

Despite this rich history of mutual engagement, however, religion and modern art continue to be typecast as mortal enemies. Misperceptions are particularly rampant when it comes to contemporary art. To judge simply by the headlines, it would seem that art and religion are headed for an apocalyptic showdown. In the winter of 2000 to 2001 a modern art museum in Warsaw exhibited Maurizio Cattelan's sculpture of Pope John Paul II felled by a meteorite. Two outraged members of the Polish Parliament marched into the gallery, rolled away the boulder, and left a letter defaming the 'Jewish origin' of the director, who was forced to resign. In 2006 British MP Ann Widdecombe launched a jeremiad against Gilbert & George for their exhibition *Sonofagod Pictures: Was Jesus Heterosexual?* at White Cube in London, calling it 'blasphemous in the extreme, as [they] will find out when finally they stand before the Son of God'.

▽ Three goddesses from the Parthenon, The Acropolis, Athens, Greece, 438–32 BCE Marble, length 233 cm (91 in.)

These figures from the Parthenon's east pediment are most likely the goddesses Hestia, Dione, and Aphrodite. Originally, they flanked a central sculpture of Athena emerging from the cranium of her father, Zeus. The temple was dedicated to the worship of Athena Parthenos, the Virgin. Around 500 CE it was converted into a church dedicated to the Virgin Mary, before later becoming a mosque. Today, ownership of the Parthenon (Elgin) Marbles, is hotly contested between Greece and Great Britain as they are now housed in the British Museum, London.

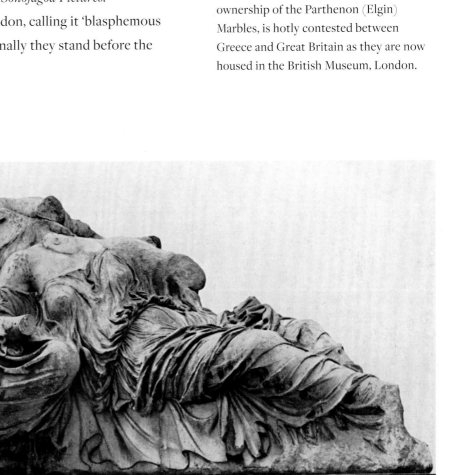

In 2008, Pope Benedict XVI called for the removal of Martin Kippenberger's *Zuerst die Füsse* (Feet First; 1990), a sculpture of a crucified frog, from a gallery in northern Italy, while an elected official held a hunger strike in protest. And under Vladimir Putin an increasing number of Russian artists have been charged with inciting religious hatred, including Avdey Ter-Oganyan and Oleg Mavromatti, who fled the country to escape prison.

The notion of contemporary artists as godless marauders on a quest to offend is compelling stuff. Scintillating as it may be, however, it tells only a small part of the story. Contemporary art is far more than just a cluster of conflagrations, and even these are not always what they first appear. Before we can progress any further in our exploration of religion and contemporary art, we need to take a moment to unpack the stereotype of the iconoclastic artist, and just whom it benefits. The stakes of various parties are perhaps clearest in the case of two works that have ignited widespread controversy in America over the past two dozen years: Andres Serrano's *Piss Christ* (1987) and Chris Ofili's dung-bedecked *The Holy Virgin Mary* (1996).

▽ **PAUL GAUGUIN** FRANCE
Where Do We Come From? Where Are We Going?, 1897–8
Oil on canvas, 139.1 x 374.6 cm
(54¾ x 147½ in.)

Painted in Tahiti as a sort of last testament before a failed suicide attempt, Gauguin considered this work his masterpiece; in his words, 'a philosophical work...comparable to the Gospels'. Comparing it to a fresco, he explained that it was a story of spiritual and chronological progression, from the infant on the far right to the elderly woman on the left. In a fusion of mythologies, a blue idol mirrors the central figure, seemingly reaching for a forbidden fruit.

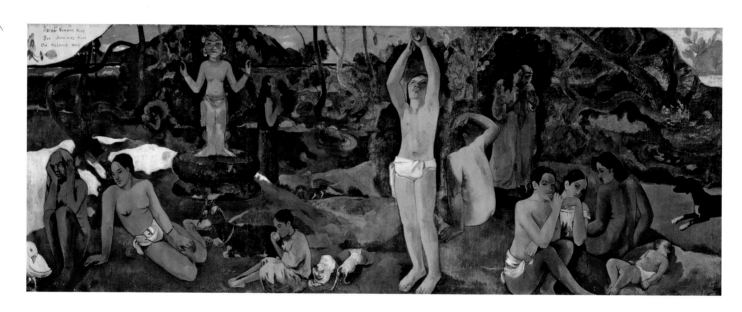

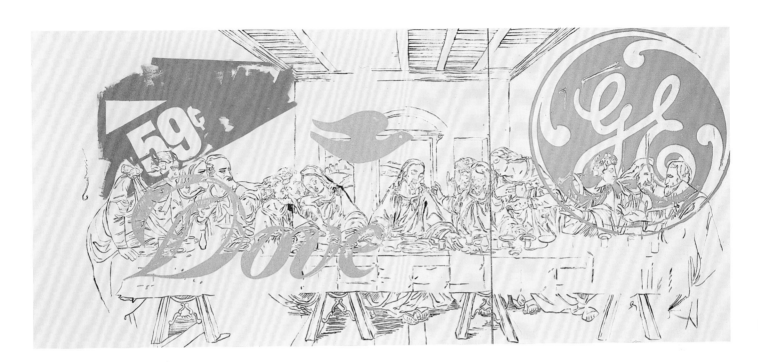

△ **ANDY WARHOL** USA

The Last Supper, 1986
Synthetic polymer paint on canvas, 302.3 x 668 cm (119 x 263 in.)

Warhol first showed his 'Last Supper' suite in a gallery opposite
Milan's Santa Maria delle Grazie, which holds Leonardo's original.
The seemingly cheeky superimposition of advertisements is in fact
theologically astute. Dove soap provides an image of the Holy Spirit,
while its price tag prompts us to consider the cost of grace, perhaps
suggesting it comes too cheaply today. Meanwhile, General Electric's
company logo summons its appropriate motto, 'We bring good things
to light.'

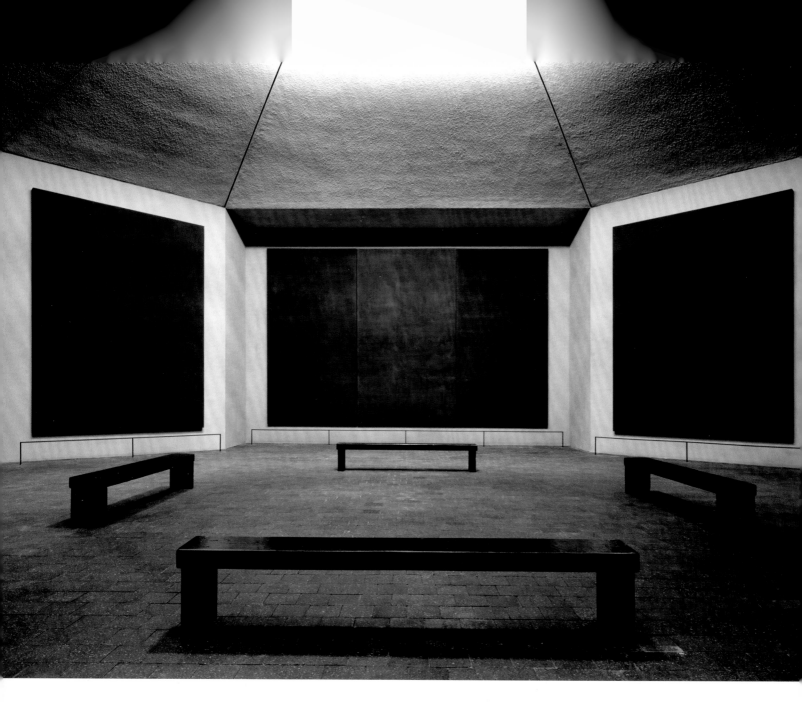

△ **MARK ROTHKO** USA

Untitled, 1964–7

Dry pigments, polymer, rabbit-skin glue, and egg/oil emulsion on canvas,
triptych, each panel: 457 x 754 cm (180 x 297 in.)

North apse, Rothko Chapel, Houston, Texas

While it was posthumously dedicated as a nondenominational space,
the chapel was originally intended to be Catholic, a fact the artist
willingly accepted. By grouping his works in triptychs, Mark Rothko
encouraged viewers to approach them as they would a traditional
altarpiece. This was not, however, a repudiation of Judaism. Instead,
working with the norms and expectations of a Christian space allowed
Rothko the freedom to investigate religious dimensions he felt
uncomfortable addressing directly in a Jewish idiom.

Unsurprisingly, the first people to benefit from denouncing Serrano's Jesus and Ofili's Mary were politicians. In the late eighties and early nineties, US Senator Jesse Helms used a 1989 exhibition of *Piss Christ* in his home state of North Carolina as a pretext to call for severe funding cuts to the National Endowment for the Arts – part of a larger assault on what the senator considered the propagation of anti-Christian values. New York Mayor Rudolph Giuliani spotted a similar opportunity after reading a tabloid report inaccurately describing Ofili's dung-'splattered' Virgin, part of the 1999–2000 *Sensation* exhibition at the Brooklyn Museum of Art. Recognizing a chance to shore up support among the religious right in his senate campaign against Hillary Clinton, Giuliani launched an unsuccessful crusade to cut off public funding for the museum in retaliation for the 'aggressively anti-religious' exhibition.

▽ **MAURIZIO CATTELAN** ITALY
La Nona Ora (The Ninth Hour), 1999
Sculpture, polyester resin, painted wax, human hair, fabric, clothing, accessories, stone, and carpet, dimensions variable

Anda Rottenberg, the curator forced to resign over displaying this work in Warsaw's Zachęta National Gallery, said of the work: 'People didn't know what to feel when they saw it. It is super-realistic and human-size, and the pope is lying on the floor very much alone and abandoned. He is a human being; it is an egalitarian monument.' In the Gospels, Jesus calls out at the ninth hour, 'My God, my God, why have you forsaken me?' (Mark 15.34).

13

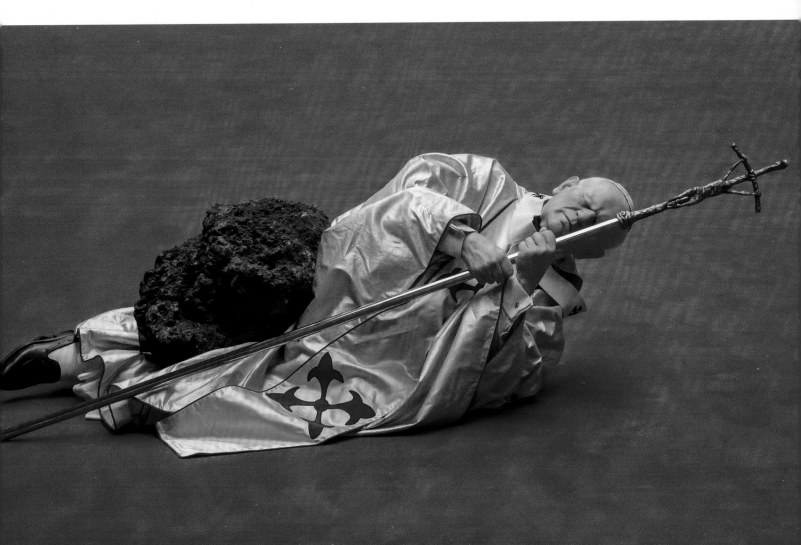

In both cases, the culture battles over these works proved an immensely profitable business. Jesse Helms's denunciation of *Piss Christ* did more for Serrano's career than any endorsement from an art critic ever could. Not only did it dramatically increase the financial value of *Piss Christ*, it instantly enshrined it as a symbol of artistic freedom, a status burnished recently when Republican lawmakers and Fox News pundits demanded that President Barack Obama denounce the work upon its return to New York City for a 2012 exhibition. Likewise, while Ofili's work was somewhat overshadowed by that of Marcus Harvey, Damien Hirst, and the Chapman brothers when *Sensation* opened at London's Royal Academy in 1997, in New York it took centre stage thanks to castigations from Giuliani, Cardinal John O'Connor, and William Donohue of the Catholic League. Despite being placed behind a Plexiglas shield, an elderly man managed to reach behind and smear it with white paint, hoping – in his words – to make the besmirched Virgin 'pure and clean'. Recognizing the marketing coup they had on their hands with Ofili and other artists, the museum displayed a 'Health Warning' for visitors, doubling down on the *succès de scandale*. Predictably tantalized, New Yorkers flocked to the exhibition, lining the coffers not only of the museum but of Charles Saatchi, who owned many of the works and had partly bankrolled the exhibition, causing a controversy in its own right.

With politicians, media, museums, and artists all benefiting to a greater or lesser extent, it is no surprise that the stereotype of the blaspheming modern artist has had such staying power. Ironically, the only real losers in this equation may be the principal parties themselves: art and religion. While controversy attracts attention and inflates prices, it seldom helps us understand works of art any better. Individual pieces quickly get lost in the combative rhetoric that swirls around them, becoming signposts for warring ideologies rather than retaining the indeterminacy that is the *sine qua non* of good art. Take *Piss Christ*, for instance. It may indeed have an element of iconoclasm. And yet it can be read, just as easily, as a devotional image by an artist born and bred in a Brooklyn neighbourhood steeped in Catholicism. What better way to meditate on the torments and degradation of Christ – both in his time and ours – than to see his form

◀ **ANDRES SERRANO** USA
Piss Christ, 1987
Cibachrome print, 152.4 x 101.6 cm
(60 x 40 in.)

Serrano photographed replicas of other sculptures submerged in urine, including a Madonna and Child, Michelangelo's *Moses*, *Discobolus*, and the *Winged Nike of Samothrace*. *Piss Christ*, however, has been the overwhelming focus of verbal and physical attacks, suffering vandalism in 1997 in Australia and in 2011 in France. 'The thing that offends me is that they characterize me as being an anti-Christian bigot,' says Serrano, 'They are barking up the wrong tree when they are saying I am not a Christian.'

15

submerged in urine? At the same time, the resplendence of the image, suffused in hazy, golden light like an icon, seems to signal Christ's capacity to triumph over ignominy.

Ofili's *Holy Virgin Mary* likewise bears salvific as well as sceptical messages. The artist has stated that he uses elephant dung – inspired by his studies in Zimbabwe – as a positive marker of his African heritage, citing sacred properties attributed to it. But even as simple excrement, the dung may symbolize the Virgin's power to rise above the earthly and the mundane, to retain and radiate her immaculacy in a world filled with, well, shit. More controversial, although often unnoticed by detractors, are the pornographic magazine clippings of buttocks and genitalia which flutter around her. Would Mary, whose son kept company with prostitutes, be shocked by such images, or would she see in them exploited bodies capable of redemption? However ignoble their origins, they circle the Virgin like faithful cherubim, albeit with chubby cheeks of another sort. For all Ofili's embellishments, this depiction of a majestic Madonna, robed in ultramarine, suspended against a stippled gold sky, may not be far removed from as reverent an image as Raphael's *Sistine Madonna* (*c.* 1512–14).

▷ **CHRIS OFILI** UK

The Holy Virgin Mary, 1996
Acrylic, oil, polyester resin, paper collage,
glitter, map pins, and elephant dung on linen,
243.8 x 182.8 cm (96 x 72 in.)

After painting *The Holy Virgin Mary* (1996), Ofili returned to the image of the Madonna in *No Woman, No Cry* (1998). Channelling the iconography of the Pietà, in which Mary grieves for her deceased son, Ofili evoked the tragic murder of the black teenager Stephen Lawrence at a London bus stop in 1993, and his mother Doreen's campaign for justice. We look at more of Ofili's work in Chapter 10.

Not only, then, are such works more complicated than they first appear, they have the potential to summon powerful religious meanings, responses, and questions. What is the difference, they ask, between the sacred and the profane? Is it possible to believe in the symbols of the past in the same ways? And perhaps most of all, what is the difference between challenging tradition and rejecting it? These are crucial questions, especially today. And good art can often do a better job of asking them than any other medium. Unfortunately, the tendency to denounce provocative art in an effort to defend religion often ends up depriving religion of a precious resource. While there do exist artists who simply aim to shock and offend religious sensibilities, they are surprisingly rare. Contemporary artists who engage seriously with religious traditions, themes, and institutions are much more prevalent, and, I would argue, much more interesting. As a new millennium begins to find its legs, it is time we set aside old assumptions about the antagonism between art and religion and look at the topic with fresh eyes. When we do so, we discover a tremendous potential for reciprocity.

In recent years there have been some positive signals, which hopefully signify wider trends. Take the following examples regarding Catholicism and Islam, both of which are frequently caricatured as bitter opponents of modern art. On Easter Sunday, 1999, Pope John Paul II issued a letter to artists affirming their special spiritual vocation and inviting them into a 'renewed dialogue' with the Catholic Church. Heeding this call, in 2013 the Vatican contributed its first ever pavilion to the Venice Biennale, assembling an international group of artists to produce works on the theme of Genesis.

Meanwhile, the contemporary art market in the Middle East – headlined by the United Arab Emirate's Sharjah Biennial, started in 1993, and the Art Dubai fair, founded in 2007 – has grown exponentially, revealing an immense appetite for contemporary art in the Islamic world. And recent exhibitions such as the British Museum's *Word into Art: Artists of the Modern Middle East* (2006), the Saatchi Gallery's *Unveiled: New Art from the Middle East* (2009), and the Victoria and Albert Museum's *Jameel Prize* (launched in 2009) – to name a handful of examples just in London – have showcased a wide range of artists exploring Islamic themes and traditions.

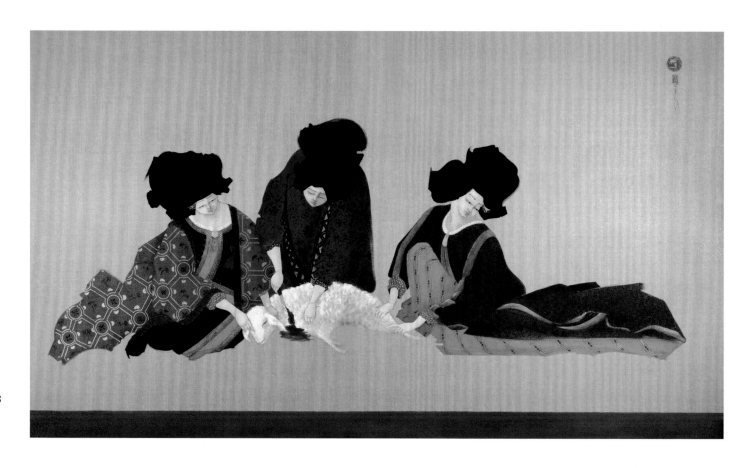

△ **HAYV KAHRAMAN** IRAQ/USA
Collective Cut, 2008
Oil on linen, 106.5 x 173 cm (41⅞ x 68⅛ in.)

Kahraman was born in Baghdad in 1981, fleeing with her family to Sweden as an adolescent, before eventually moving to the States. Her work appeared in *Unveiled* (2009) in London, and has been shown at numerous venues, including Art Dubai in 2014. *Collective Cut* belongs to a body of work meditating on sacrifices by and of women, in this case calling to mind the Muslim feast of Eid al-Adha, when an animal is slaughtered in memory of Ibrahim's near sacrifice of his son, Isma'il.

Not only does the dialogue between art and religion appear to be deepening, the studies of both art and religion have undergone sizeable shifts in recent years, enabling us to approach the association differently from in the past. For much of the twentieth century, the prevalence of the secularization thesis, the notion that society was progressively turning away from religion, made a meaningful intersection between art and religion seem unlikely or insignificant. While many mainstream denominations in the West have seen a drop in attendance and observance since the mid-twentieth century, charismatic groups have witnessed the opposite trend. As the 1990s and 2000s have palpably demonstrated – from the culture wars simmering between American liberals and conservatives to the extremist attacks perpetrated in New York, Madrid, London, Mumbai, Paris, and elsewhere – religion is hardly disappearing any time soon. If anything, some scholars have suggested, we may be entering a period of 'desecularization', much to the chagrin

of such dogged critics of belief as Richard Dawkins and Christopher Hitchens. Given the prominent role that religion has already played in the social, cultural, and political landscape of this young century, it should come as no surprise that so many artists have registered its impact.

But while we might agree that religion wields significant power in the contemporary world, it remains difficult to agree on a definition of religion. For much of the twentieth century, scholars of religion understandably spent a great deal of energy attempting to do just this. Over the past couple of decades, however, emphasis has shifted away from taxonomy, seeking to establish what makes religion distinct from other phenomena, to thinking about it as a lived experience, inextricable – and sometimes indistinguishable – from other cultural practices. What this emphasis on cultural studies loses in specificity, it makes up for in breadth, allowing us to encompass areas such as visual culture, which in the past often got defined as unrelated or orthogonal to religious studies. While some topics we cover in this book fit comfortably within traditional concepts of religion – such as depictions of religious figures, myths, and rituals – we also examine many that fall outside a narrow definition of religion, including issues of cultural identity, civic memory, and embodied practice. Instead of proceeding from or towards a single definition of religion, we will look instead for key areas in which contemporary art poses questions for and about religion, including the very question: 'What is religion?'

The questions I am interested in asking are shaped not only by recent debates within religious studies but also by significant changes within art history. Well into the 1970s, the predominance of formalism discouraged art historians and critics from asking questions about religious and cultural identity, especially when looking at the purportedly pure domain of modern art. Over the past several decades, art-writing has increasingly swung in the other direction, with a powerful interest in identity issues, albeit political and economic more often than religious. Since the nineties, we have seen a dramatic surge in approaches drawn from postcolonial theory, seeking to redress the implicitly white, Christian, male, heterosexual gaze that has defined so much art history, and indeed

religious studies. Any attempt to chart the confluence of religion and art today must simultaneously reckon with race, class, gender, and sexuality, and the way they inevitably inflect the production and reception of the works in question. I have attempted to do justice to this diversity and complexity in both the themes I have identified and the works of art I have selected. Although readers with a passionate scholarly or personal interest in certain issues will no doubt see room for expansion, I hope I have at least avoided celebrating the same small cadre of art stars who appear in most publications.

There are, of course, key junctures at which I have had to draw a line in the sand, often reluctantly, in order to maintain focus. One of these is my decision to focus on visual art, rather than attempting an even wider survey of religion in visual and material culture. That said, I have chosen to conceive of visual art in a broad sense, featuring familiar media such as painting and sculpture alongside newer media including performance, installation, video, street art, and comics. A surprisingly difficult decision, made at a relatively late stage in the preparation of this book, was to disinvite from the party works of bad art, or kitsch. Thomas Kinkade's candyfloss Calvary sunrise, *The Cross* (2010), for instance, or Jon McNaughton's *One Nation under God* (2009), in which Jesus proudly clasps the US Constitution, surrounded by the founding fathers, are both wildly popular in America, and their reception can indeed tell us a great deal about how people choose to articulate their religious identities. Yet with limited space, I made the unabashedly personal choice to favour works that I believe are more aesthetically and intellectually challenging. My goal is to give, as far as possible, an indication of the most interesting and relevant things that twenty-first-century art has to say about religion.

Some of the artists featured in this book might be surprised to find their work included under the heading of religion, and some might even object. But while I often quote directly from artists, when possible from personal interviews, I do not constrain my readings by how artists themselves define their religiosity or that of their work. First, many artists are reluctant to disclose too much about their religious backgrounds or commitments, often concerned – with good reason in today's art world –

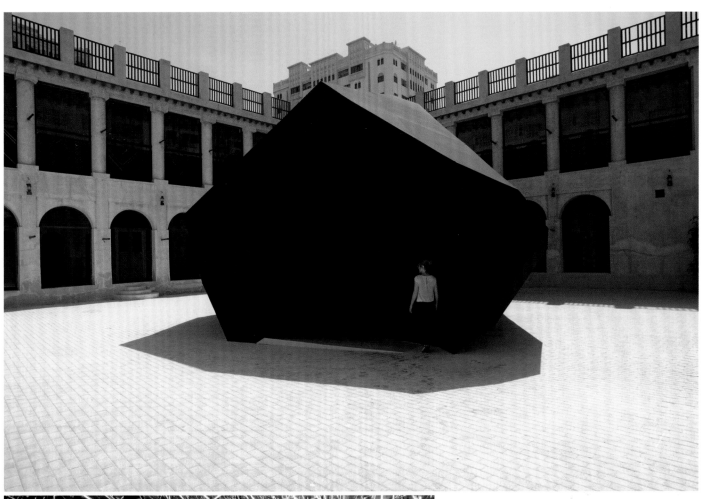

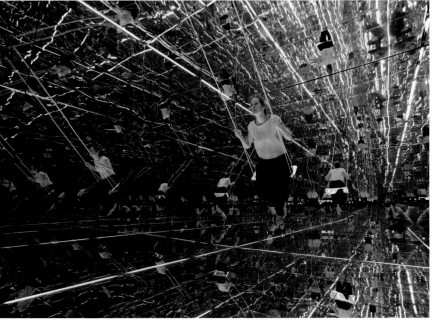

THILO FRANK GERMANY
Infinite Rock, 2013
Steel, aluminium, fabric, mirrors, wood, and rope,
660 x 450 x 1350 cm (260 x 177 x 531½ in.)
Intallation view, Sharjah Biennial II

Frank's mysterious black fortress may evoke
the Ka'aba in Mecca and the Black Stone
embedded in its wall. Despite its solemn
exterior, when viewers stepped inside Frank's
rock they discovered a shimmering chamber
of mirrors, with a child's rope swing hanging
from the ceiling. As they swung, their image
was infinitely reflected in every direction,
enveloping them in a state of ecstatic –
perhaps even frightening – abandon.

that being labelled a 'Muslim artist' or 'Jewish artist', as the case may be, will 'ghettoize' them, as one Jewish artist confided to me. Rather than risk restricting their potential audience or interpretations of their work, many artists – if they speak on the topic of religion at all – tend to fall back on predictable shibboleths: for example, 'I am an artist who *happens* to be Christian', or 'I am spiritual but not religious'. These statements may be true, but they rarely tell the full story. I am particularly reluctant to take spirituality as a self-evident category. Disguised within this apparently neutral term is usually a conflicted assertion about the ways in which someone *does* and *does not* see themselves as religious. And these tensions, and the ways they surface in works of art, are much more interesting.

It is important not only to discover the ways in which works of art might speak profoundly – sometimes unexpectedly – to religious themes and concerns, but to allow these works to speak to one another. Although the study of religion and art has grown steadily in recent years, it still tends to be divided into discrete sub-fields with little cross-pollination. Christian, Jewish, and Islamic art are seldom studied in conjunction, for instance, and even less in the company of non-Abrahamic traditions such as Hindu or Sikh art. Such monolithic categories themselves raise a variety of problems, and too often scholars focus on demarcating the boundaries of certain categories of religious art – whether by artist, subject, style, period, or region – at the expense of investigating actual works and the issues they raise. By taking a thematic approach in this book, I hope to sidestep convoluted discussions about what counts as Christian or Hindu art, for example, while simultaneously creating fresh conversations across multiple traditions. Beyond demonstrating the capacity of art to illuminate religious issues, this book provides new topics and resources for interfaith dialogue in its widest sense, whether between practitioners of different faiths or none at all.

On a practical level, this book is divided into five major sections, with two chapters apiece. Each section tackles different themes and utilizes different approaches, allowing readers to experience not only a wide range of art but also a variety of methodologies. In Section One, we adopt a theological approach, considering works that represent two key

subjects in the history of art: Creation and the figure of Jesus. Section Two takes a more philosophical turn as we examine how we experience wonder through art, whether in elaborate man-made constructions or within the natural world. In Section Three, we take our cues from cultural studies, looking at how artists negotiate experiences such as migration and conflict, which impinge on religious identity. Section Four takes us into the domain of sociology and anthropology as we deal with how art depicts and enacts rituals. Finally, Section Five engages with more phenomenological questions as we analyse ideas of indwelling, from how we inhabit our own bodies to how we occupy sacred spaces. All of these sections, and indeed the chapters themselves, can be read independently, in any order, although they do refer to other parts of the book when making interconnections is particularly helpful. Together, the topics and approaches covered in this book are meant to be suggestive, not definitive. What I hope they indicate, above all, is the sheer multiplicity of ways in which artists today are engaging with religion, and will continue to do so in the foreseeable future.

▽ **SLAVS AND TATARS**
Long Live Long Live!, Death to Death to!, 2011
Installation view, exterior of Heritage House,
Sharjah Biennial 10

The artistic collective Slavs and Tatars often seeks to create unexpected geographical, cultural, and religious juxtapositions. *Friendship of Nations: Polish Shi'ite Showbiz*, installed at the tenth Sharjah Biennial (2011), combined references to Iran's Islamic Revolution and the Polish Solidarity Movement. According to the artists, this banner on the exterior of Heritage House 'affirms the celebratory gesture and condemns the revenge and rhetorical justice which often undermine true popular revolutions'. In 2014, the artists curated a section of Art Dubai devoted to Central Asia and the Caucasus.

23

PART I) people of the image?

I ◆ IN THE BEGINNING

2 ◆ SWEET JESUS!

I ◆ IN THE BEGINNING

+ We often hear that Jews, Christians and Muslims share a common identity as people of the book. Similarly, the texts of non-Western religions such as Hinduism and Buddhism are frequently treated as the most authentic, purest expression of these religions. And yet, each of these religions possesses a rich visual culture, which has been, and continues to be, a central aspect in their beliefs and practices. Nowhere is this more evident than in the way artists have shaped our imagination of creation. God's outstretched finger on the ceiling of the Sistine Chapel, or the bronze sculptures of Shiva as Nataraja, the Lord of the Dance, have become indispensable to the way millions of people conceive of the origins of the world. For their part, contemporary artists have continued to reinterpret creation myths in ways that simultaneously challenge and perpetuate religious tradition.

For many indigenous communities, whose oral traditions are in danger of dying out with the passing of elders, visual art has proved a particularly powerful tool to record and teach ancient stories, chief among them creation myths. In Australia, since the 1970s aboriginal artists have increasingly committed sacred images of Dreamtime – once reserved for sand, rock, and body paint – to permanent materials. Over the same period, the Canadian artist Bill Reid spearheaded a revival of the traditional woodcarving practised by the Haida people of the Pacific Northwest, frequently turning to creation stories. In *We Were Always Here* (2012), installed on the National Mall in Washington, DC, Rick Bartow – a member of the Wiyot tribe of northern California – combines figures from multiple creation myths to stake a claim of belonging on behalf of America's indigenous peoples, the continent's first inhabitants.

Creation stories not only provide the opportunity to reflect on national and religious origins, they can serve as profound metaphors

◀ **DOUG ARGUE** USA
Detail of *Genesis (Scale)*, 2009

▷ **MAKOTO FUJIMURA** |APAN/USA

John – In the Beginning, 2010
Mineral pigments, gold on Belgian linen,
152.4 x 121.9 cm (60 x 48 in.)

Fujimura was born in Boston to Japanese parents and later studied the ancient tradition of Nihonga painting in Japan. *John – In the Beginning* is part of a series commissioned by Crossway Publishing for an edition of the Gospels commemorating the 400th anniversary of the publication of the King James Bible. A committed Christian, Fujimura has written extensively on religion and aesthetics. He writes that the Gospel of John records 'the physical invasion into the cosmos by the Creator'.

for artistic practice. In the opening chapter of Genesis, God sees his creations and pronounces them 'very good' (Genesis 1.31), like an artist standing back to admire his handiwork. Several chapters later, when God decides to 'blot out' life on earth with a massive flood (Genesis 6.7), the Lord again appears like an artist, this time confronting a composition gone horribly awry. In his illustrated Genesis, the comics master R. Crumb deftly draws out this analogy, depicting God as an aging graphic artist. In Crumb's opening panel, a leathery, hoary-bearded God shapes a spiralling void, seemingly part supernova, part ink blot – a symbol of both cosmic and comic origins. A similar skein of self-reflexivity runs through *Creation (Megaplex)* (2012), by the video artist Marco Brambilla, who imagines a universe comprised of film clips, the by-products of our collective imagination.

To depict creation is, to some extent, to re-enact it. The choices artists make – what they plan and what they leave to chance – echo some of the most fundamental questions of theology. Why is there something instead of nothing? Is there order behind existence, or merely chaos? Above all, is there a Creator behind creation? Contemporary artists have approached these questions with attitudes ranging from disbelief to faith, and sometimes both at once. Even in the apparent maelstrom of Jason Rhoades's *Creation Myth* (1998), where two toy trains run towards each other amid scattered debris, there is order and intention, as demonstrated in 2013 when curators relied on his meticulous notes to recreate the installation at the Institute of Contemporary Art in Philadelphia. In his 'Milkyway Galaxy' series, Sandile Zulu harnesses the unpredictable power of fire to burn patterns into the canvas, suggesting a universe in which purpose conquers chaos. Similarly, in Govinda Sah's paintings the cosmos explodes and unfurls dramatically, yet with axial symmetry.

If there is indeed a divine power guiding creation, how does it work? The Bible suggests that language not only describes the universe, it forms it. Thus, 'God said, "Let there be light"; and there was light' (Genesis 1.3). While this seems a far cry from the revelations of modern astrophysics, Doug Argue descries an unexpected harmony between science and scripture. In *Genesis* (2007–9), he paints the letters of the biblical text

For this series, Bialobrzeski travelled to the so-called Cradle of Humankind, a UNESCO World Heritage Site northwest of Johannesburg, South Africa, which has yielded some of the oldest hominid fossils ever found, including the roughly two-million-year-old 'Mrs Ples' (short for Pleistocene). This attempt to revisit humanity's origins finds its bookend in Bialobrzeski's 'Paradise Now' series, which depicts the eerie glow of artificial light that heavily developed areas of Asian cities cast over surrounding natural landscapes.

twisting and colliding in space like sub-atomic particles, which in turn 'spell out' an image of the Big Bang. Makoto Fujimura, meanwhile, chooses not to depict the individual words of scripture, but rather the creative energy of the Word itself. He takes as his inspiration the famous prologue of the Fourth Gospel: 'In the beginning was the Word, and the Word was with God, and the Word was God' (John 1.1).

How we narrate our beginnings reveals a great deal about our present. Nowhere is this clearer than in the way artists have imagined the Garden of Eden. While many nineteenth-century landscape painters, especially in America, depicted an unsullied Eden within our grasp, contemporary artists have been inclined to agree with writers, such as Jorge Luis Borges and Erich Fromm: there are no paradises, only lost ones. In the impenetrable thickets of Peter Bialobrzeski's 'Eden', nature itself – perhaps in an act of self-protection – seems to bar our way back to paradise. Even Raqib Shaw's dazzling *Garden of Earthly Delights III* (2003), like the dreamscapes of Hieronymus Bosch, turns out to be dangerous and demented (beware the sodomizing shrimp!). The pristine garden of Marc Quinn, stocked with a menagerie of orchids, is no more habitable. Every last blossom is frozen dead in sub-zero silicone, kept from decay only by a hermetically sealed tank, chilled to a constant -25° C. Perhaps the best we can hope for is to recreate Eden in virtual reality – a possibility explored by Michael Takeo Magruder and Studio Azzurro.

If we can no longer find our way back to Eden, the Bible informs us that we have only humanity to blame, for it was Adam and Eve's decision to eat from the Tree of Knowledge that led to their expulsion from Paradise. Yet for many interpreters, including artists, this story raises more questions than it resolves. What kind of God, knowing human nature, would set humanity up to fail so spectacularly from the start? Are we not, as Huang Yong Ping's sculpture suggests, simply puppets in the hands of a capricious Creator? Or, to use Maurizio Cattelan's metaphor, maybe we are merely pawns in a farcical game of *Good versus Evil* (2003). As Elaine Reichek intimates, the moral simplifications of Genesis, and their theological legacy, are particularly dangerous for women, who have been vilified through Western history in the name of Eve.

For his part, Grayson Perry weaves a withering picture of Eden as a middle-class English cul-de-sac, complete with white picket fence and a shiny new Range Rover. A decorative vase full of greenery and a plate of luscious cupcakes stands in for the Tree of Knowledge of Good and Evil and its infamous fruit. And where a cherub wields a sword in Masaccio's Renaissance masterpiece, in Perry's tapestry a middle-aged father brandishes a golf club to chase Adam and Eve away from 'Number 8 Eden Close'. Paradise turns out to be a bourgeois fabrication. Perhaps, Perry intimates, the sin we must repent of does not lie in some primal past but in the false Edens we construct in the present, in our everyday lives. Perry and the other artists in this chapter do more than just illustrate creation stories, they encourage us to reinvent and revitalize them. The truth is: we don't need Eden to give us life. It needs us.

▷ **RICK BARTOW** USA

We Were Always Here, 2012
Carved cedar wood poles, height 609 cm (240 in.)
Installation view, National Museum of the American
Indian, Smithsonian, Washington, DC

'The Welcoming Bear and Raven, Healer and
Rascal sit atop the sculpture poles,' explains
Bartow, 'one, slow and methodical, fiercely
protective of her children, the other a playful,
foible-filled teacher of great power. . . .On
each pole are repeated lower horizontal
patterns that symbolize successive waves,
generations following generations, an
accumulation of wisdom and knowledge. The
tree used for the sculptures is approximately
500 years old. . .[embodying] our sacred and
precious natural resources.'

◁ **ROBERT CRUMB** USA

Chapter 1, page 1, *The Book of Genesis*,
illustrated by Robert Crumb, 2009
Pen and ink on paper, 37.4 x 29.2 cm (14¾ x 11½ in.)

Given his history of subversive, often sexually
explicit comics, many people expected Crumb
to produce a more scandalous work. 'I did try
to be respectful,' he commented, 'I decided not
to make fun of the text, not to put any kind of
jokey stuff in there. I was tempted a few times.
But I whited it out later because it distracts
from the text. The text itself is so compelling
that merely illustrating it is enough.'

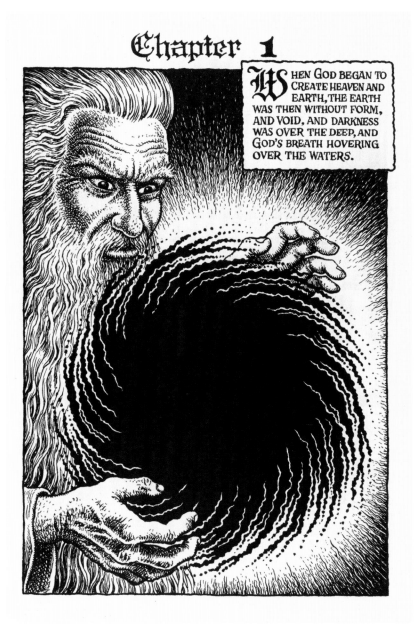

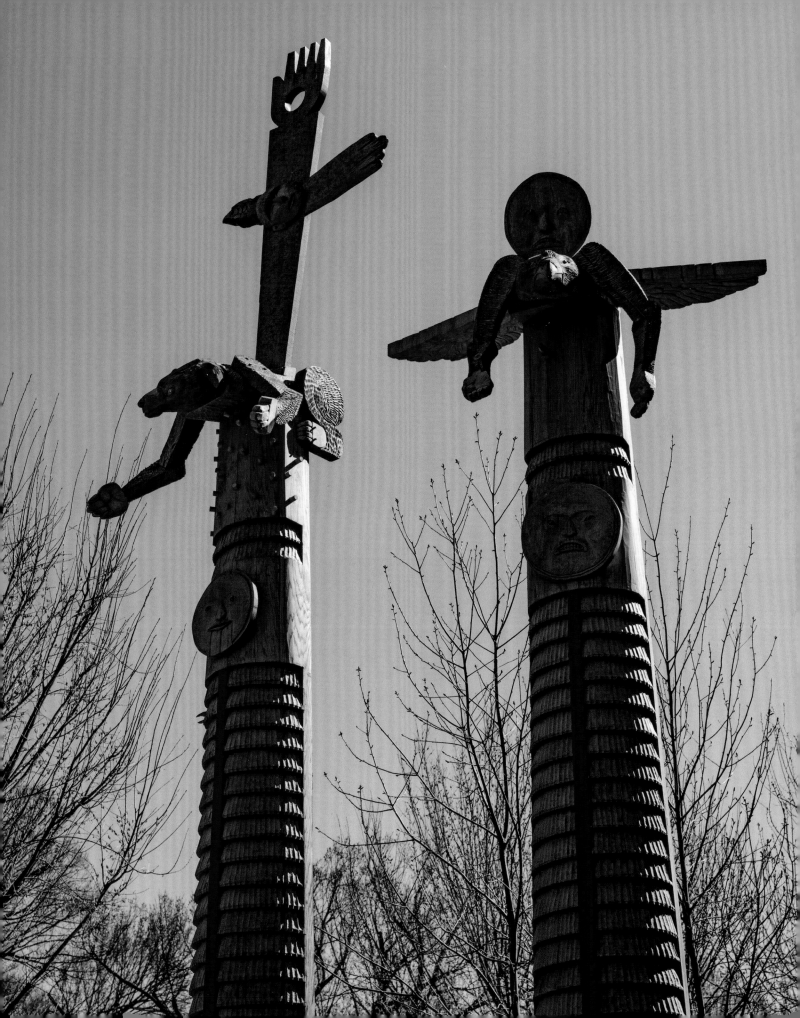

▽ **SANDILE ZULU** SOUTH AFRICA

Galaxy 2, 2005

Fire, water, earth, and air on canvas, 160 x 300 cm (63 x 118 in.)

The artist entitled his first solo exhibition *Fire!*, announcing both the medium and subject of many of his works. For all of his canvases, including the 'Milkyway Galaxy' series, Zulu symbolically lists his materials as 'fire, water, air and earth', emphasizing the ritual and elemental nature of his work.

▷ **MARCO BRAMBILLA** ITALY/USA

Creation (Megaplex), 2012

3D high-definition video, colour, and sound, duration: 4 min., loop, dimensions variable

Vignettes culled from hundreds of films, ranging from the *Sound of Music* to *Star Wars*, swirl together in *Creation* like a spiral galaxy or a double helix of DNA. In 2013, the video was shown in St Patrick's Old Cathedral in Manhattan – one of the oldest Roman Catholic churches in New York – accompanied by a live choir. Attendees watched from pews while wearing 3D glasses, evoking questions about what kinds of visionary experiences people expect to have in church today.

▽ **DOUG ARGUE** USA
Genesis, 2007–9
Oil on linen, 406.4 x 584.2 cm (160 x 230 in.)

Following his signature process, Argue began by breaking the English text of Genesis into a jumble of letters, then distorting each one on a computer. Next, he turned the contorted letters into stencils and transferred them to canvas. He comments, 'What's important to me is the flux of language. . .and letters as metaphors for molecules, atoms, and chromosomes – providing a system of combining and recombining with almost infinite variation, while providing continuity in the evolution of the universe, life, and language.'

▷ **GOVINDA SAH 'AZAD'** NEPAL
Between Earth and Heaven, 2013
Acrylic on canvas, 50 x 50 cm (19⅝ x 19⅝ in.)

In Sah's recent paintings, one can still feel the guiding structure of mandalas – the cosmic maps common in Sah's native Nepal – that are explicit in the forms and titles of many of his early works. His abiding interest in cosmogony can be seen in numerous works, including *Life/Light* (2013), *Empyreal* (2012), *Emanate* (2011), and *Begin* (2010). Sah's works fit equally well alongside those examined in our chapter on the sublime (Chapter 3), a key concept for the artist.

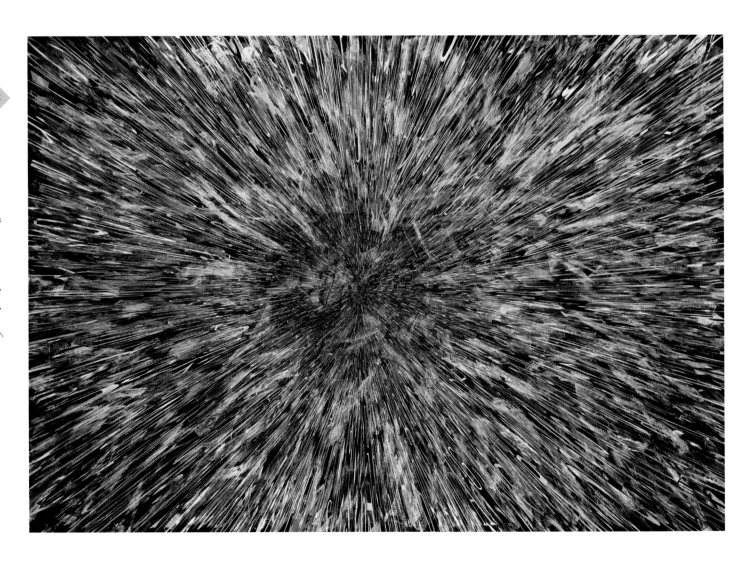

▽ **STUDIO AZZURRO** ITALY

In Principio (e poi), 2013
Video installation, the Pavilion of the Holy See (Vatican), Venice Biennale

The curators of the Vatican Pavilion at the fifty-fifth Venice Biennale
assigned Studio Azzurro the theme of Creation (followed by Un-
Creation and Re-Creation by other artists). To embody creation,
the group manufactured interactive video walls that displayed the
gestures of deaf-mute people, while also recording the impressions
of viewers' hands. The piece hints at a kind of intimate, immediate,
and intuitive communication we have all but lost – a sort of original
language prior to the confusion of tongues.

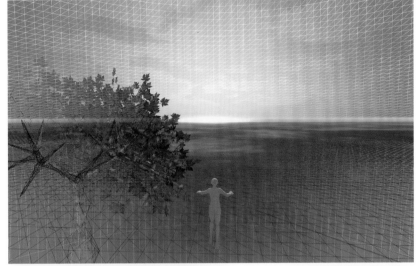

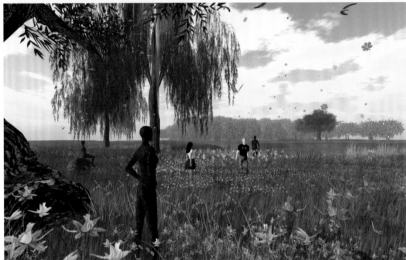

▷ **MICHAEL TAKEO MAGRUDER** USA/UK

Visions of Our Communal Dreams v2.0, 2012
Mixed-reality installation, OpenSimulator, gallery,
internet

In Magruder's work, users in the real world of
the gallery help shape a shared, virtual Eden.
'I sought to adopt God's position as creator
and instigator by constructing a beautiful
realm of open possibilities that others could
inhabit as they desired,' says Magruder. He
imagines 'the world's first rays of virtual
sunlight illuminat[ing] a newly rendered
synthetic landscape made from data and code
– the fundamental building blocks of creation
in the Information Age'.

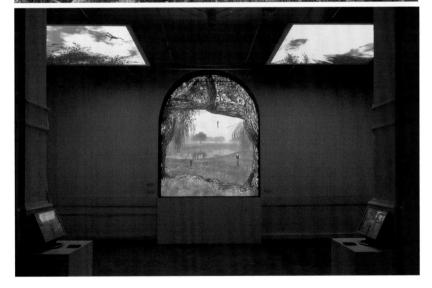

△ **MARC QUINN** UK

Italian Landscape (5), 2000
Permanent pigment on canvas, 109.9 x 166.4 x 4.2 cm
(43¼ x 65½ x 1⅝ in.)

Quinn calls this work 'a garden completely modulated by desire',
adding, 'It's also about how the flowers have given up their physical
mortality to stay immortal in this image: they died young to stay
beautiful.' The artist continued his exploration of the subject of
the Garden of Eden with *DNA Garden* (2001), in which he created
a triptych with panels holding DNA from two people, surrounded by
DNA culled from various plants, evoking the lushness of Paradise.

Garden of Earthly Delights III, 2003

Acrylic, glitter, enamel, and rhinestones on board,
triptych, each panel: 304.8 x 152.4 cm (120 x 60 in.)

Shaw was born in Calcutta to a wealthy family
of carpet merchants. He was raised in the
northern Indian region of Kashmir, renowned
for its traditional decorative arts, especially
pashminas and other cashmere (Kashmir)
products. His finely detailed works draw on
imagery and styles from his native country
as well as Persian miniature painting and
other sources.

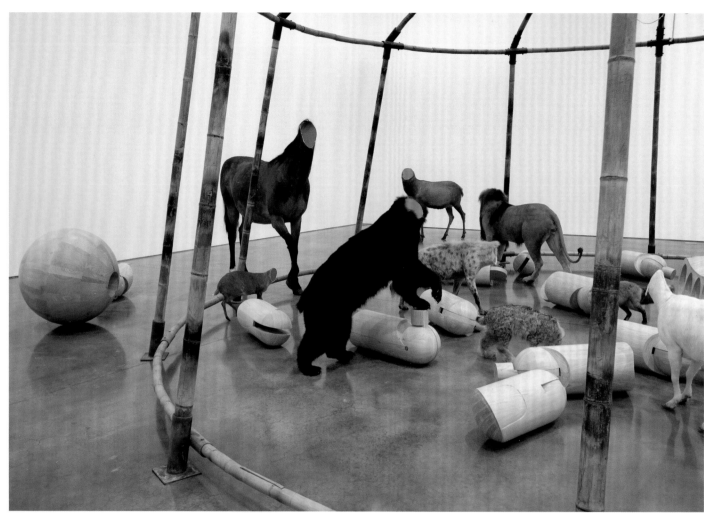

◁ **HUANG YONG PING** CHINA/FRANCE

Circus, 2012

Wood, bamboo, taxidermy animals, resin, steel, cord, and cloth, 841.1 x 1000.1 x 1000.1 cm (331⅛ x 393⅜ x 393⅜ in.)

Ping blends the biblical creation story with the Chinese legend of Sun Wukong, the hubristic Monkey King, who was captured in the Buddha's palm. A superhuman hand pulls the strings of a skeletal monkey, who in turn plays puppeteer to the remains of a smaller simian. The larger monkey stares at us through cavernous eye-sockets, as if confirming our kinship. Like him, we only think we are in control, as we wobble at the whim of a greater power.

▽ **MAURIZIO CATTELAN** ITALY

Good Versus Evil, 2003

32 hand-painted porcelain figures, wood, chessboard, and travel case, case: 67 x 67 cm (26⅜ x 26⅜ in.)

Cattelan's mock chess set satirizes our tendency to see things in black and white. The pieces on the 'good' side include: Superman, the Dalai Lama, Gandhi, Che Guevara, Joan of Arc, Martin Luther King, Jr, and – in a nod to the heroes of the attacks of 11 September 2001 – a New York City fireman. Representing evil are: the treacherous serpent of Genesis, Rasputin, Hitler, Cruella de Vil, Dracula, Stalin, and the figure of Death from Ingmar Bergman's *The Seventh Seal*.

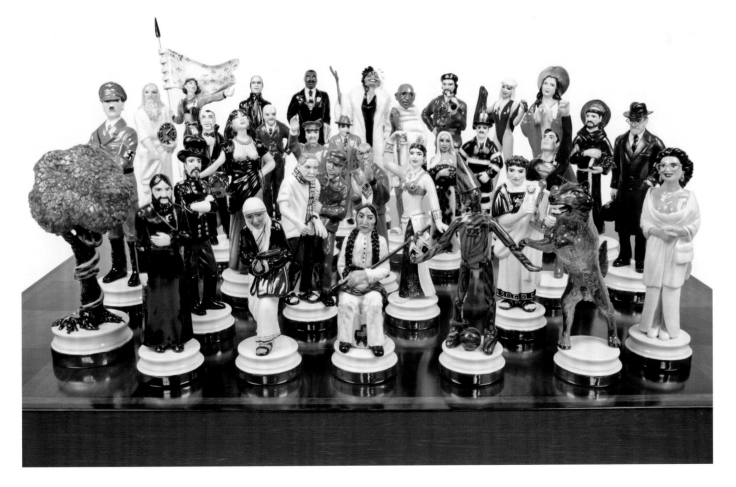

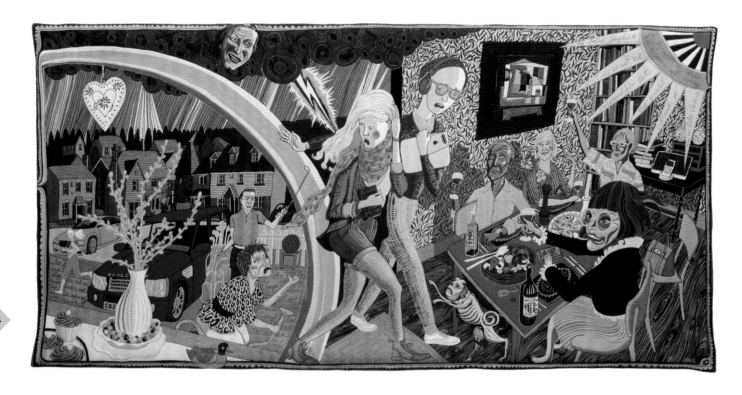

△ **GRAYSON PERRY** UK

Expulsion from Number 8 Eden Close, 2012
Wool, cotton, acrylic, polyester, and silk tapestry,
200 x 400 cm (78¾ x 157½ in.)

This is one of six tapestries included in Perry's exhibition *The Vanity of Small Differences* (2012). According to Perry, 'The tapestries tell the story of class mobility, for I think nothing has as strong an influence on our aesthetic taste as the social class in which we grow up. . .I focus on the emotional investment we make in the things we choose to live with, wear, eat, read or drive. Class and taste run deep in our character – we care.'

▷ **ELAINE REICHEK** USA

Sampler (Adam & Eve), 2002
Hand embroidery on linen,
82 x 72.4 cm (32¼ x 28½ in.)

Reichek routinely combines references to 'high art', from old to modern masters, with the 'folk art' of women's embroidery. This sampler depicts the supposed inception of Original Sin, when Eve heeded the serpent and shared the forbidden fruit with Adam. By rendering the story in needlework, a pastime traditionally practised by women, Reichek asks what it means for women to grow up repeating a story that portrays them as sinful, and how we might alter this harmful pattern.

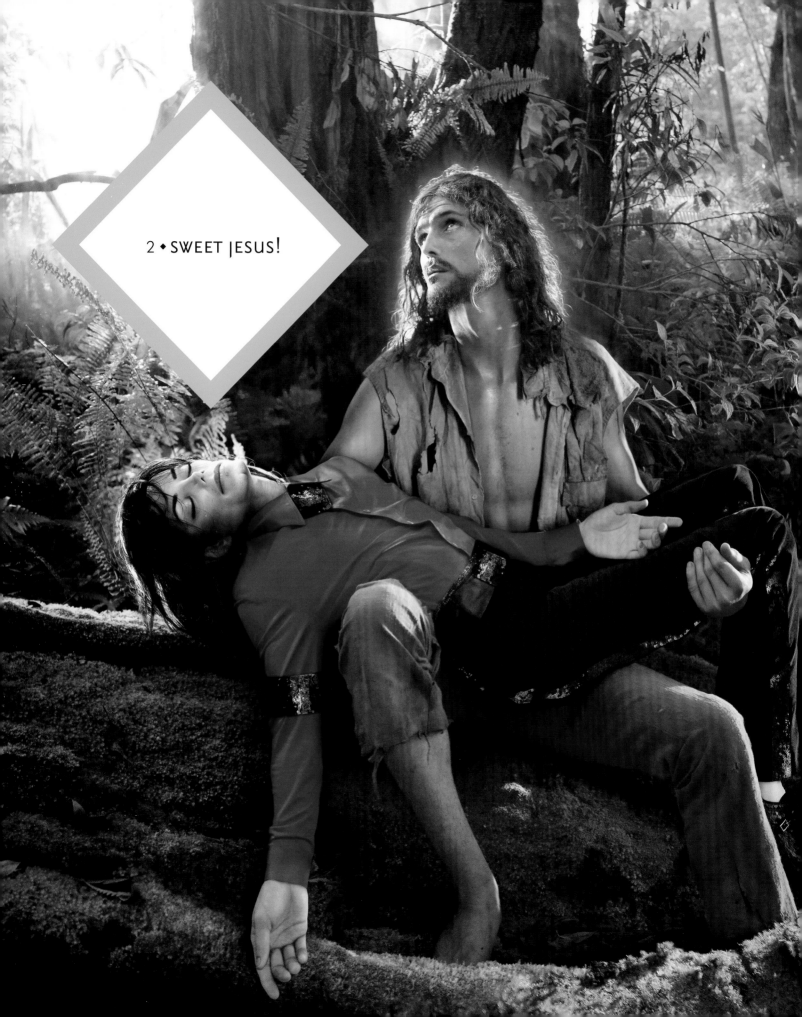

2 • SWEET JESUS!

+ For millennia, Christians have argued passionately – sometimes violently – over what constitutes an appropriate depiction of Jesus. During the Byzantine Iconoclasm of the eighth and ninth centuries, and the Reformation of the sixteenth and seventeenth centuries, fierce conflicts erupted over whether it was permissible to depict Jesus at all. Even in periods and places where images of Christ were permitted, it was still a matter of intense debate how to balance his humanity and divinity. Matthias Grünewald brought Jesus uncomfortably close to contemporary reality, covering him in boils and oozing sores that mirrored the symptoms of the afflicted peasants who prayed before the *Isenheim Altarpiece* (c. 1515). Caravaggio rankled ecclesiastical authorities with another brand of realism, taking the models for his New Testament scenes straight from the seedy streets – and brothels – of Rome. While contemporary artists are often branded heretics or blasphemers for their representations of Jesus, even the most controversial artists follow a long and venerable tradition of creating challenging images of Jesus.

Following in Caravaggio's footsteps, many contemporary artists have set biblical scenes in the midst of modern, everyday life. Sometimes, the message is affirmational, reminding us that miracles can occur in the midst of the mundane, as in Roger Wagner's *Walking on Water III* (2005), in which Jesus glides over the muddy surface of the River Thames. At other times, choosing a contemporary setting has enabled artists to voice their dissent from dominant religious and artistic traditions. For a number of artists, re-envisioning Leonardo da Vinci's *Last Supper* has offered a symbolic opportunity to turn the tables on the historically white, male, Christian gaze of Western art. Renee Cox and Greg Semu staged photographs of the Last Supper with themselves

◄ **DAVID LACHAPELLE** USA
Detail of *American Jesus: Hold Me, Carry Me Boldly*, 2009

▽ **ROGER WAGNER** UK
Walking on Water III, 2005
Oil on board, 76.2 x 101.5 cm (30 x 40 in.)

While the Gospel story takes place
on the Sea of Galilee, 'battered by the
waves' (Matthew 14.24), Wagner sets it in
Battersea. More than just a clever pun, the
defunct Battersea Power Station reminds
us to place our faith not in man-made
creations, but in divine power. This is
precisely where Peter falters. When the
wind picks up he becomes frightened and
starts to sink. Jesus catches him, chiding,
'You of little faith, why did you doubt?'
(Matthew 14.31).

at the centre, calling attention to the exclusion of minorities from
prominent positions in Western culture. Other artists have used
the iconography of the Last Supper to take aim at a host of ideologies,
from capitalist greed (Yinka Shonibare and Zeng Fanzhi) to military
sacrifice (Adi Nes). In an era of globalization and endless digital
reproduction, Leonardo's iconic image is no longer the cultural
property of any one region or religion; a fact fittingly embodied in
Zhang Huan's *Ash Jesus* (2011), composed of ashes collected from
Buddhist temples.

In addition to the Last Supper, contemporary artists have also
frequently depicted the Stations of the Cross, following modern
masters including Henri Matisse and Barnett Newman. A sequence
of fourteen events believed to have occurred in Jesus' final hours, from

his condemnation to entombment, the Stations have traditionally served a liturgical function for many Christians, who contemplate them in succession during the days leading up to Easter Sunday. It is this interactive dimension that has fired the imagination of many artists, regardless of their religious commitments. In *Ecce Homo* (1999), Mark Wallinger placed a diminutive Jesus atop a massive plinth in London's Trafalgar Square, in effect incorporating passersby into a sacred drama, asking them to imagine whether they would condemn or defend Jesus if he stood before them today. In *Via Dolorosa* (2002), Wallinger also asks viewers to take an imaginative leap. By superimposing a black rectangle over all but the margins of Franco Zeffirelli's film *Jesus of Nazareth* (1977), Wallinger forces us to recreate the Passion for ourselves, relying on only the faintest of cues.

As we have seen, when it comes to depicting the life of Jesus, contemporary artists have had a penchant for traditional motifs and iconography, repeatedly recreating some of Christianity's most celebrated images. What has consistently proven controversial, however – no matter how conventional the subject – is the choice of an unorthodox medium, perhaps best demonstrated by Andres Serrano's *Piss Christ* (1987). For their part, Wim Delvoye and Damien Hirst have drawn opprobrium for using animals to represent Christ. In doing so, however, one could argue that they actually underscore Jesus' humanity, emphasizing the raw, bestial nature of his torments. Indeed, Hirst's crucified sheep carcass simply provides an unusually visceral embodiment of Christ's identity as the Lamb of God. Annette Messager's crucified *stuffed* animal may actually be more unsettling, turning the Passion into a sort of sinister fairytale. Cosimo Cavallaro uses another seemingly innocuous material – milk chocolate – to render the Crucifixion, thus recasting Easter confectionary into a reminder of the grisly sacrifice at the heart of the holiday. Ironically, what many religious viewers find upsetting in these works – their insistent, palpable corporeality – lies at the very heart of Christian theology: the Incarnation of God in human flesh.

In addition to raising theological questions, artists have also used the Crucifixion to hammer home political points, harking back to modern precursors including Francisco de Goya, George Grosz, and Marc Chagall.

50

▷ WIM DELVOYE BELGIUM
'Viae Crucis', 2006
Cibachrome on dibond, 14 panels,
each: 80 x 100 cm (31½ x 39½ in.)

'[M]y language is global, universal,'
comments Delvoye. 'Yet 70 percent
of my work could not be done in the
United States. The country is far too
puritanical. . .I'm the one who, like Jesus,
kisses Judas. I embrace the negative.'
He has created numerous works with
religious themes, including stained-
glass windows with images derived from
X-rays of the digestive tract – another
common refrain in his work – and bronze
sculptures of distorted crucifixes.

In their 'Sonofagod' series (2005), Gilbert & George lash out at what they perceive as Christianity's harmful teachings on sex, particularly the condemnation of homosexuality, declaring in one work, 'Jesus Says Forgive Yourself: God Loves Fucking! Enjoy'. A 2012 photograph by Erik Ravelo goes so far as to simulate a crucifixion with an adolescent slung against the back of a Catholic priest, symbolizing the Church's abandonment of children to predatory clergy. Vanessa Beecroft, meanwhile, photographed a Sudanese child as the crucified Christ in a series intended to criticize Western responses to humanitarian crises. Perhaps most shockingly, in 2000 Oleg Mavromatti crucified himself in a work that has since become a symbol of artistic repression in Russia under Vladimir Putin.

Where the Crucifixion is the consummate symbol of public trauma, the Pietà – the moment when Mary cradles the body of her dead son – is a classic embodiment of private anguish. Much like Leonardo's *Last Supper*, Michelangelo's massive marble *Pietà* (1498–9) in St Peter's Basilica has cast a long shadow over subsequent depictions of the theme. Sam Jinks, for instance, inverts the positions of parent and child, depicting the sorrow of an adult son as he holds the frail, naked body of his father. Sam Taylor-Johnson, on the other hand, captures the commiseration of friends, supporting the actor Robert Downey, Jr – who had recently emerged from rehab – as he begins to stir to life. In another permutation, David LaChapelle portrays Courtney Love clasping the body of an actor playing her deceased husband, Kurt Cobain, with stigmata visible alongside the track marks of heroin addiction, which contributed to Cobain's suicide. Despite the formal difference between Taylor-Johnson's austere video and LaChapelle's elaborate tableau, both use religious iconography to endow their subjects – and their pain – with a dignity often lost in the worship of celebrity icons.

After examining a variety of works that depict the life and death of Jesus, it seems appropriate to end with a piece that looks ahead to his prophesied return. While there is no shortage of works that treat the Second Coming – often drawing upon the apocalyptic imagery of the Book of Revelation – one of the most profound is David Shrigley's

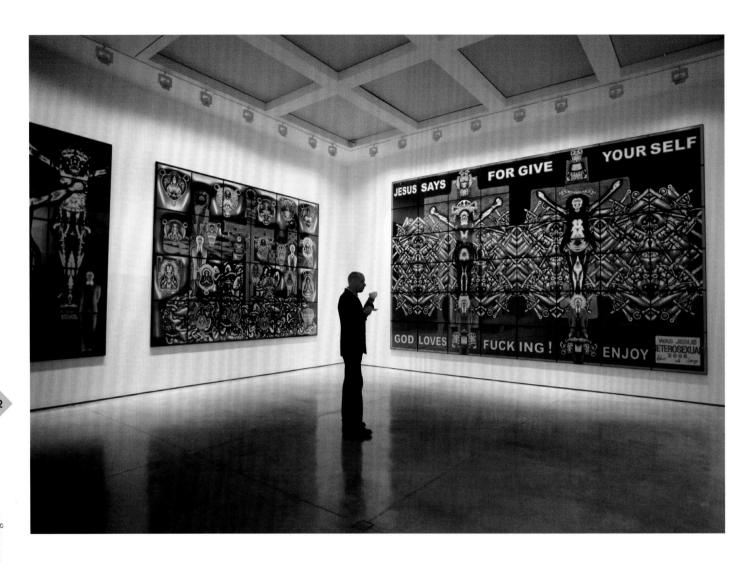

△ **GILBERT & GEORGE** ITALY/UK

Was Jesus Heterosexual?, 2005
Mixed media, 381 x 604 cm (150 x 237¾ in.)
Installation view, White Cube, London, 2006

Gilbert & George sometimes feature their own naked bodies as
well as enlarged images of excreta. By placing bodily fluids under
a microscope they 'discovered various religious and other symbols'.
'Out of these drops of blood come stained-glass windows from
fourteenth-century cathedrals, or Islamic writing. . . .In piss you find
pistols, flowers, crucifixes. Spunk amazes us. . .it really does look like
a crown of thorns.' They see themselves as demystifying religion,
claiming 'Religion is superstition, that's it.'

beguilingly simple sculpture, *The Bell* (2007). Alongside an old-fashioned bell – like that rung by a town crier – Shrigley places a simple, hand-written reminder: 'Not to be rung again until Jesus returns.' On the one hand, this sculpture could be read as simple sarcasm, its juvenile script mirroring a childish hope. On the other hand, it seems to exude a pure, unwavering faith. It assumes the devout patience of everyone who passes by before the end of time, and a future viewer who will heed its instructions and loudly proclaim the good news of Christ's return. It is just this sort of ambivalence – the uncertain boundary between mockery and piety – that has proved so infuriating to reactionary critics when confronting contemporary art, especially about Jesus. Rather than looking for an affirmation of humanity in a female Christ, a moral critique of ecclesial failure in a crucified child, a celebration of the Eucharist in a chocolate Redeemer, or a prophetic message in a silent bell, critics have often preferred to take interpretive shortcuts and skip straight to condemnation. What is required is a little more faith – in art.

▷ **DAVID SHRIGLEY** UK
The Bell, 2007
Brass bell and aluminium sign, overall with vitrine: 155.5 x 50 x 50 cm (61 x 19¾ x 19¾ in.)

'[M]y art is very fatalistic,' says Shrigley. 'But hopefully the humour redeems it slightly from being just depressing. And when it comes to death – well, I prefer to see the humorous side of it. . . .I think if you try to make some sort of fine gesture about the portrayal of God or the state of the world, you will inevitably fail. The only profundity you should ever achieve is in the particular, in very specific and personal things.'

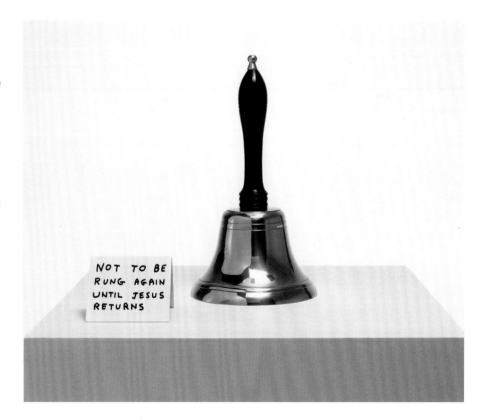

▽ **YINKA SHONIBARE MBE** UK/NIGERIA

Last Supper (after Leonardo), 2012
13 life-size mannequins, wax printed cotton, wood table and chairs, silver cutlery and vases, antique and reproduction glassware and tableware, and fibreglass and resin food, 158 x 742 x 260 cm (62¼ x 292⅛ x 102⅜ in.)

At the centre of Shonibare's *Last Supper* sits a cloven-hoofed Pan, who leads a bankers' bacchanal, before 'their crucifixion in recession', as Shonibare puts it. There is no Jesus, only Judases, all ready to betray the public trust for thirty pieces of silver (or a golden parachute, as the case may be). The figures' vibrant, eighteenth-century outfits, emblazoned with € and £ signs, implicate these avaricious disciples in a legacy of colonial greed stretching back centuries.

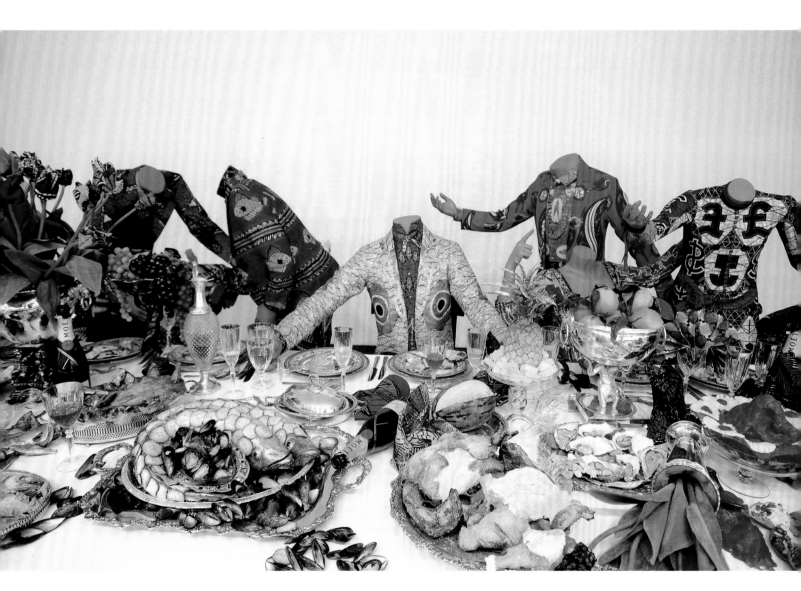

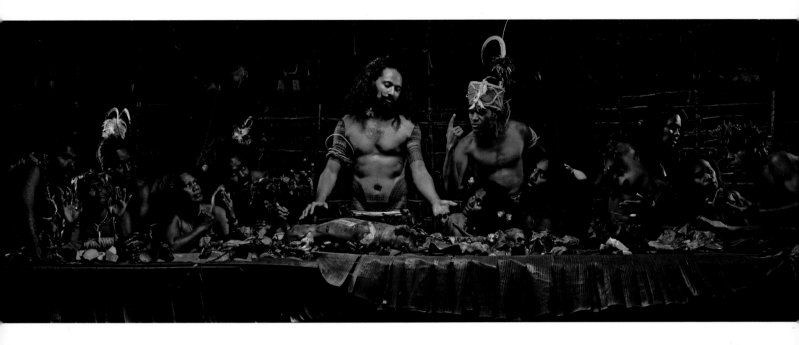

△ **GREG SEMU** NEW ZEALAND/AUSTRALIA

Auto Portrait with 12 Disciples, 2010
Digital C-print, 100 x 286 cm (39⅜ x 112⅝ in.)

In this photograph, from his series 'The Last Cannibul Supper. . .cause tomorrow we become Christians', Semu, an artist of Samoan heritage, depicts himself surrounded by Kanak tribesmen from New Caledonia. His tableau satirizes stereotypes of indigenous Pacific Islanders, while ironically tossing the charge of cannibalism back at Christians, for whom bread and wine are the body and blood of Christ. 'The theme that runs strongly through my work,' writes Semu, 'is cultural displacement, colonial impact on indigenous cultures, particularly [in the] Pacific Islands.' Christianity, he says, has both 'saved and paralysed' Pacific island culture.

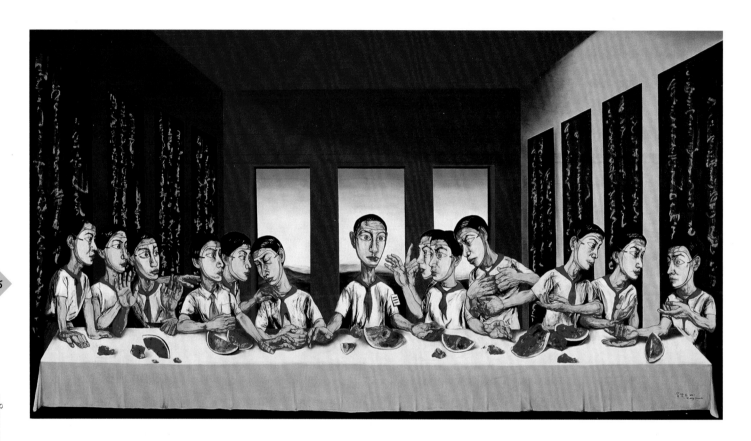

△ **ZENG FANZHI** CHINA

The Last Supper, 2001

Oil on canvas, 220 x 400 cm (86⅝ x 157½ in.)

All but one of the adolescents in Fanzhi's canvas wear the red scarf of the Young Pioneers, China's Communist youth group. The exception – a sort of Judas, Jr – has swapped his party uniform for the yellow necktie and collared shirt of a Western businessman, trading national solidarity for individual prosperity. The red watermelon juice, which stains the children's hands and faces, seems to presage an impending clash between these conflicting ideologies.

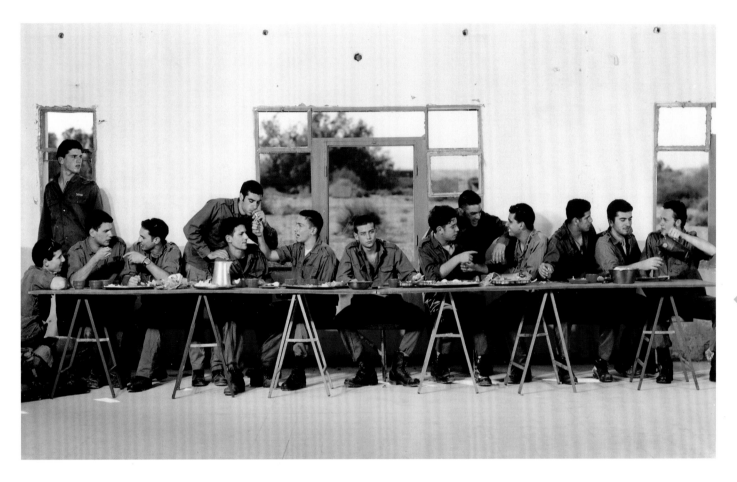

△ **ADI NES** ISRAEL

Untitled, 1999

Colour photographic print, 89.7 x 149 cm (35⅜ x 58⅝ in.)

By staging the Last Supper with young Israeli soldiers in a military
mess hall, Nes calls attention to the institutionalization of sacrifice
in Israeli society. Any soldier in this scene might be called to play the
part of Jesus, laying down his life for the sake of his comrades. How
many more last suppers, Nes seems to ask, will be enacted by Israeli
youth going off to war? And what ideologies, religious as well as
secular, motivate these sacrifices?

▽ **ZHANG HUAN** CHINA

Ash Jesus, 2011
Sculpture, ash, steel, and wood, 260 x 320 x 320 cm (102⅜ x 126 x 126 in.)

Zhang first began using ash after relocating from New York to his native China in 2005 and becoming a Buddhist. While literally fashioned out of Buddhist prayers – the ash comes from incense burned before statues of the Buddha – Zhang's Jesus also recalls the Christian commemoration of Ash Wednesday, when believers are anointed with ashes. The traditional blessing on that day, 'Remember that you are dust, and to dust you shall return,' fittingly resonates across both religions.

▷ **MARK WALLINGER** UK

Via Dolorosa, 2002
Projected video installation (DVD transfer), duration: 18 mins 8 secs

Via Dolorosa was installed in 2005 in the crypt of the Duomo in Milan. Alongside *Ecce Homo*, it is part of Wallinger's longstanding investigation of religious themes. In an earlier video work, *Angel* (1997), Wallinger filmed himself in the guise of his sightless alter ego, Blind Faith, reciting the opening lines of the Gospel of John on the moving escalator of London's Angel tube station.

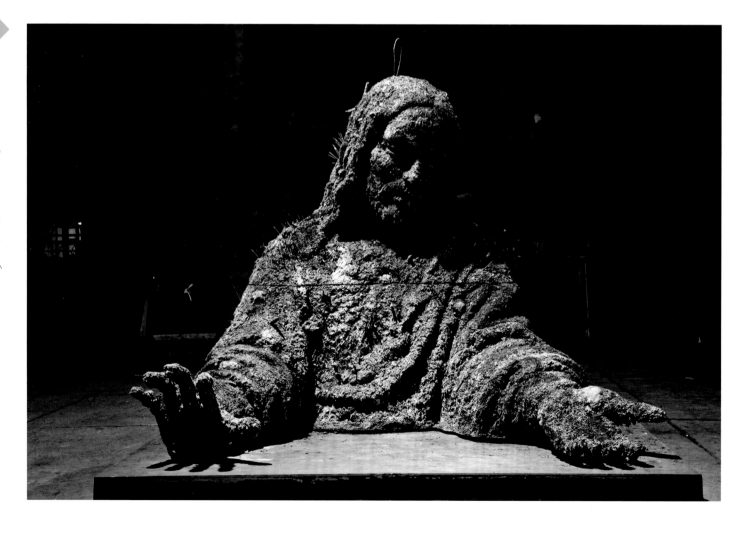

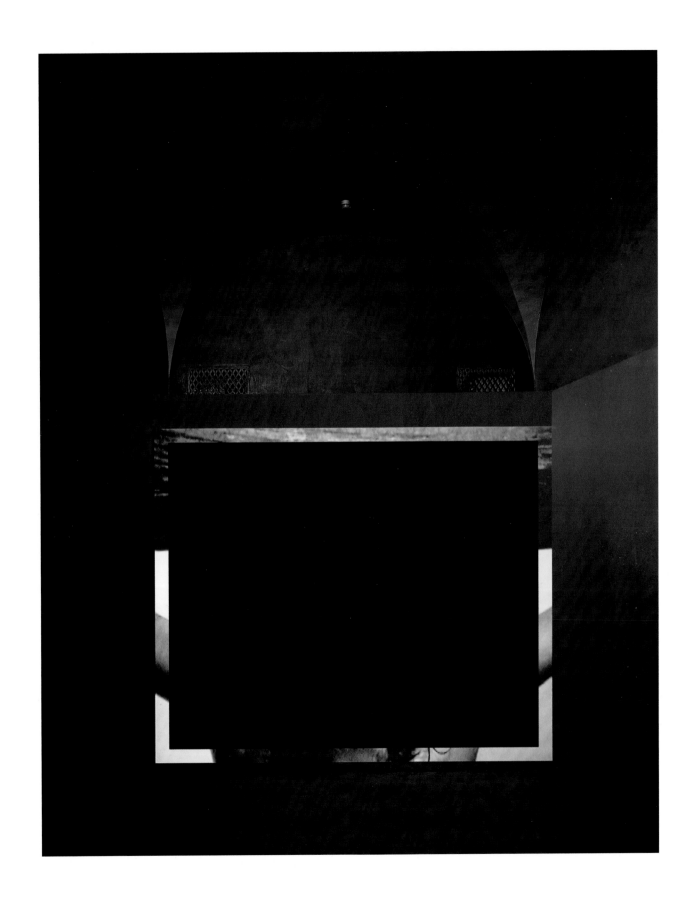

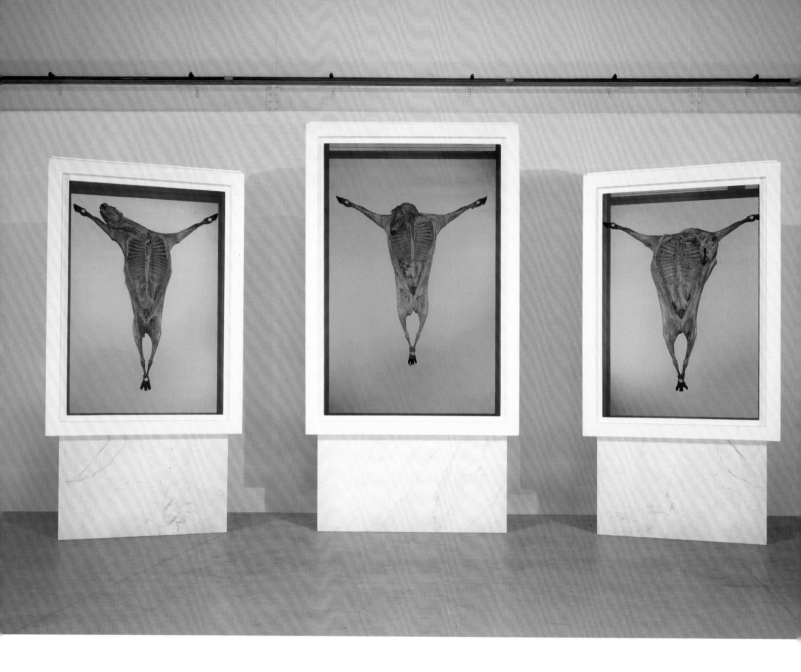

△ **DAMIEN HIRST** UK

God Alone Knows, 2007
Glass, painted stainless steel, silicone, mirror, stainless steel, plastic cable ties,
sheep and formaldehyde solution with steel and Carrara marble plinths,
triptych without plinths: (left and right) 324.6 x 170.9 x 61 cm
(127⅞ x 67⅜ x 24 in.), (centre) 380.5 x 201.4 x 61 cm (149⅞ x 79⅜ x 24 in.)

'I was brought up Catholic 'til I was twelve,' says Hirst, 'so I've got
a lot of that imagery locked inside my head, and I know it's bollocks,
but I like to use the images. I think I'll never get rid of all that shit
even though I don't believe in the big fella. Indoctrinating children
is bad shit man, but fuck me if it don't work like a dream.'

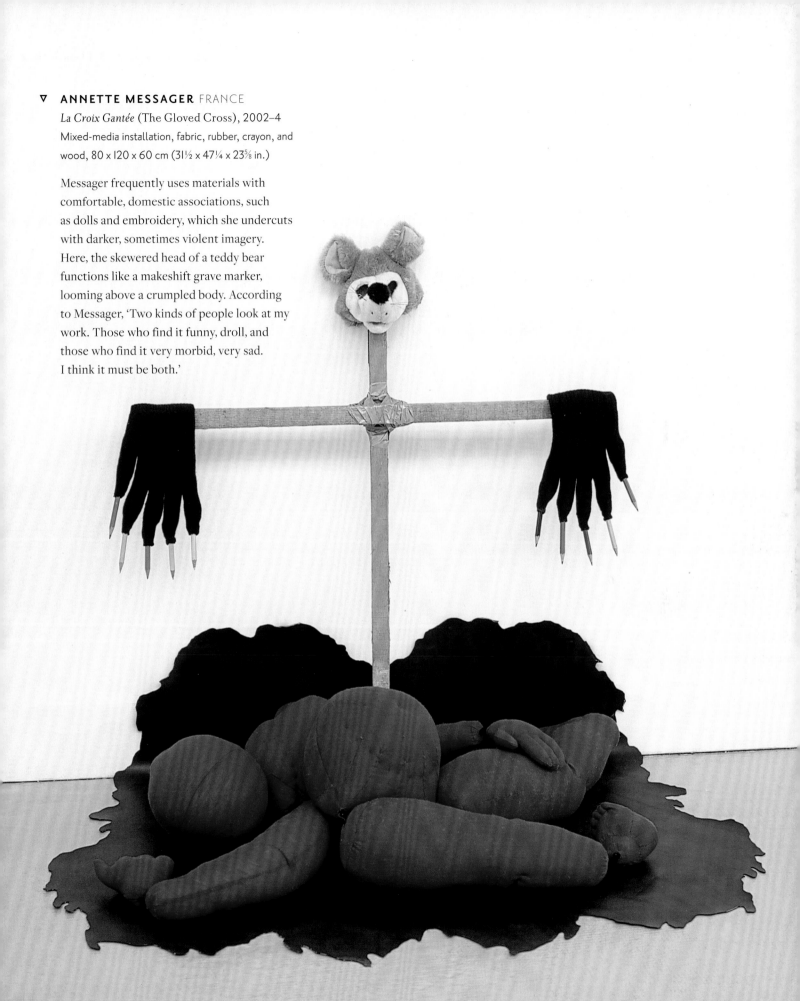

▽ **ANNETTE MESSAGER** FRANCE

La Croix Gantée (The Gloved Cross), 2002–4
Mixed-media installation, fabric, rubber, crayon, and
wood, 80 x 120 x 60 cm (31½ x 47¼ x 23⅝ in.)

Messager frequently uses materials with
comfortable, domestic associations, such
as dolls and embroidery, which she undercuts
with darker, sometimes violent imagery.
Here, the skewered head of a teddy bear
functions like a makeshift grave marker,
looming above a crumpled body. According
to Messager, 'Two kinds of people look at my
work. Those who find it funny, droll, and
those who find it very morbid, very sad.
I think it must be both.'

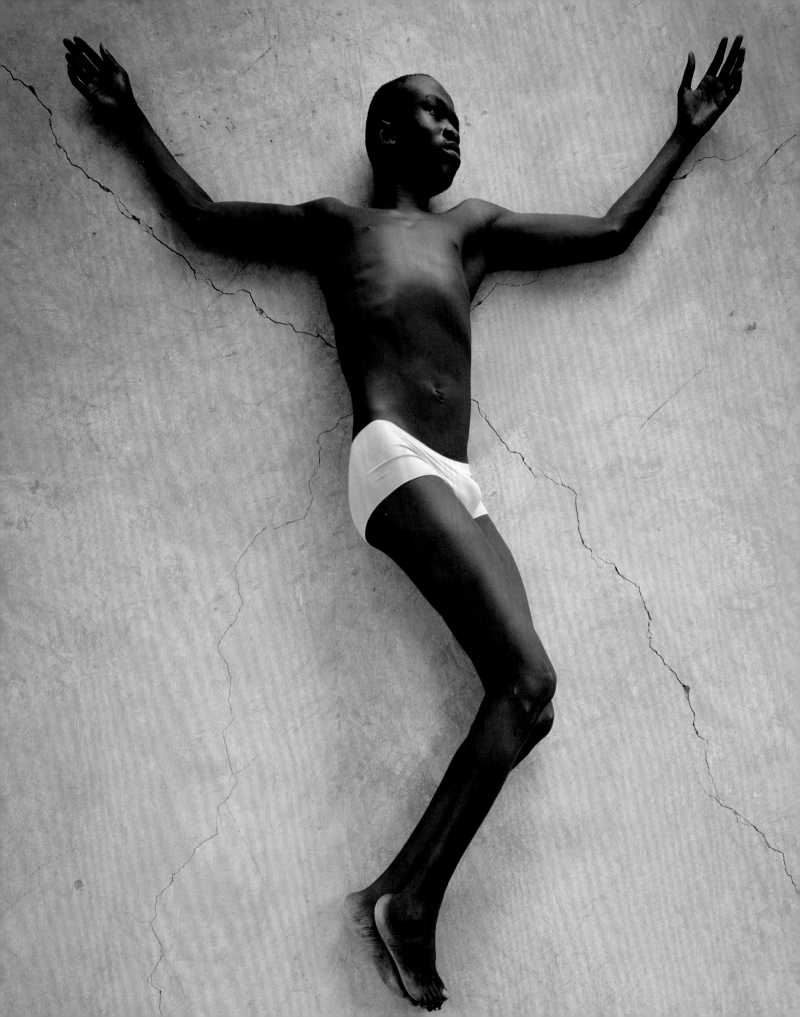

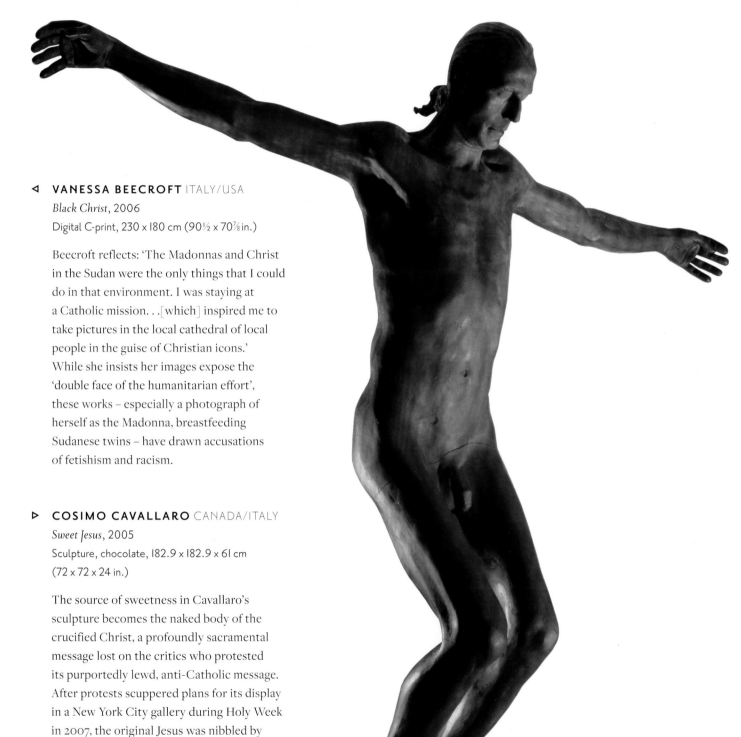

◁ **VANESSA BEECROFT** ITALY/USA

Black Christ, 2006

Digital C-print, 230 x 180 cm (90½ x 70⅞ in.)

Beecroft reflects: 'The Madonnas and Christ in the Sudan were the only things that I could do in that environment. I was staying at a Catholic mission. . .[which] inspired me to take pictures in the local cathedral of local people in the guise of Christian icons.' While she insists her images expose the 'double face of the humanitarian effort', these works – especially a photograph of herself as the Madonna, breastfeeding Sudanese twins – have drawn accusations of fetishism and racism.

▷ **COSIMO CAVALLARO** CANADA/ITALY

Sweet Jesus, 2005

Sculpture, chocolate, 182.9 x 182.9 x 61 cm (72 x 72 x 24 in.)

The source of sweetness in Cavallaro's sculpture becomes the naked body of the crucified Christ, a profoundly sacramental message lost on the critics who protested its purportedly lewd, anti-Catholic message. After protests scuppered plans for its display in a New York City gallery during Holy Week in 2007, the original Jesus was nibbled by rodents in storage, forcing Cavallaro to recast him for an exhibition in the city six months later.

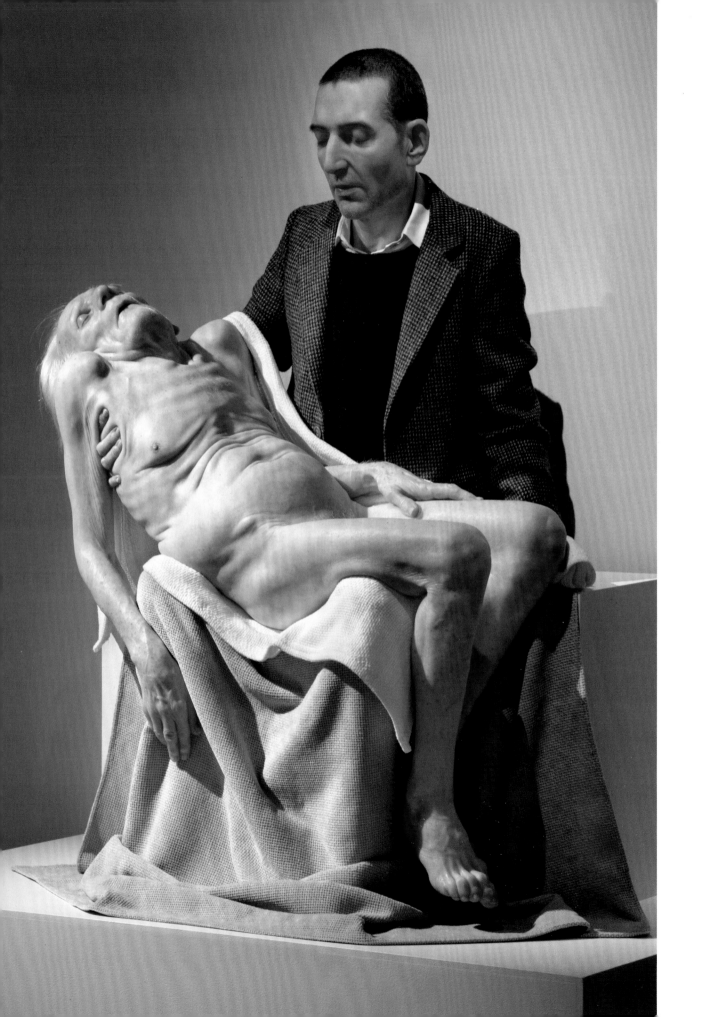

◁ **SAM JINKS** AUSTRALIA
Still Life (Pietà), 2007
Sculpture, silicone, paint, and human hair, 160 x 123 cm
(63 x 48⅜ in.)

The artist originally honed the skills needed to
make such highly realistic sculptures by working
on special effects in film and television. 'I like
the idea that you can make something precious
and powerful,' he says about his process. In
addition to *Still Life*, he also takes inspiration
from Christian iconography in *The Hanging Man*
(2007), which resembles a Crucifixion.

▽ **SAM TAYLOR-JOHNSON** UK
Pietà, 2001
Film still from 35 mm film/DVD projection, duration: 1 min. 57 secs

In the same year that Sam Taylor-Johnson filmed this work, she
directed Robert Downey, Jr in a video for Elton John's 'I want Love',
in which she films the actor walking through an empty mansion.
The lyrics to the song reinforce the pathos of *Pietà*, 'I want love,
but it's impossible / A man like me, so irresponsible / A man like me
is dead in places / Other men feel liberated.'

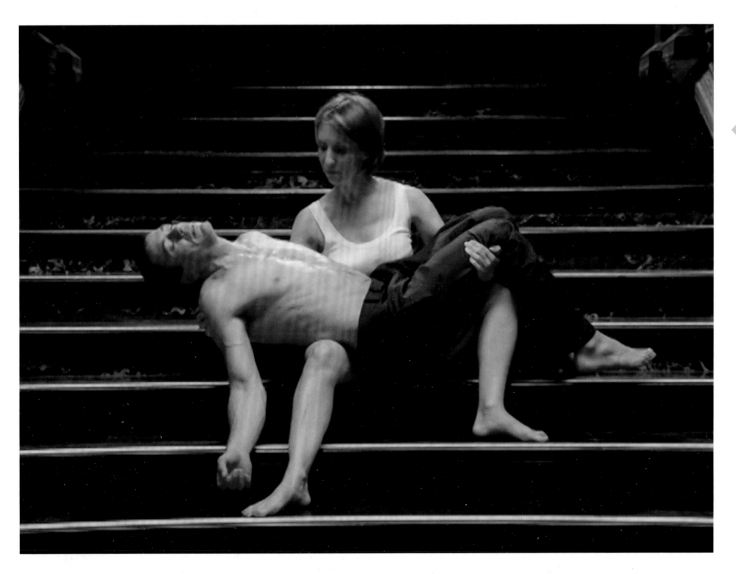

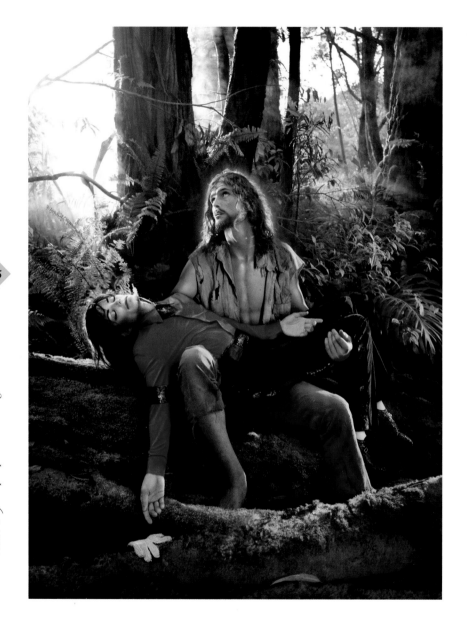

PART I 〉 people of the image?

◁ **DAVID LACHAPELLE** USA
American Jesus: Hold Me, Carry Me Boldly, 2009
C-print, 137.2 × 61 cm (54 × 24 in.)

LaChapelle created a posthumous Pietà of Michael Jackson cradled by Jesus, part of his 'American Jesus' series (2009). LaChapelle was raised Catholic, and often draws on Christian symbolism, although he no longer defines himself by one religion. He received his first break working for Andy Warhol, and shot the final portrait of his mentor. 'I put two bibles beside his head and framed it,' LaChapelle recalls, '[Warhol] went to church every Sunday when he was in New York.'

▷ **MARK WALLINGER** UK
Ecce Homo, 1999
Sculpture, white marbelized resin and gold plated, barbed wire, life size

The Latin title, 'Behold The Man', refers to Pontius Pilate's words when presenting Jesus to the hostile crowd. Wallinger comments: 'I was interested in how much of our thinking and morality in a secular society is a residue of Christianity, even among avowed atheists. As a spiritual focus it was intended as an antidote to the empty celebration of the millennium that the Dome represented in Greenwich. It also came not long after the Bosnian war, in which your religion was a matter of life and death. Democracy is about the rights of the minorities to have free expression, not the majority to browbeat, marginalise, make a subject of pillory.'

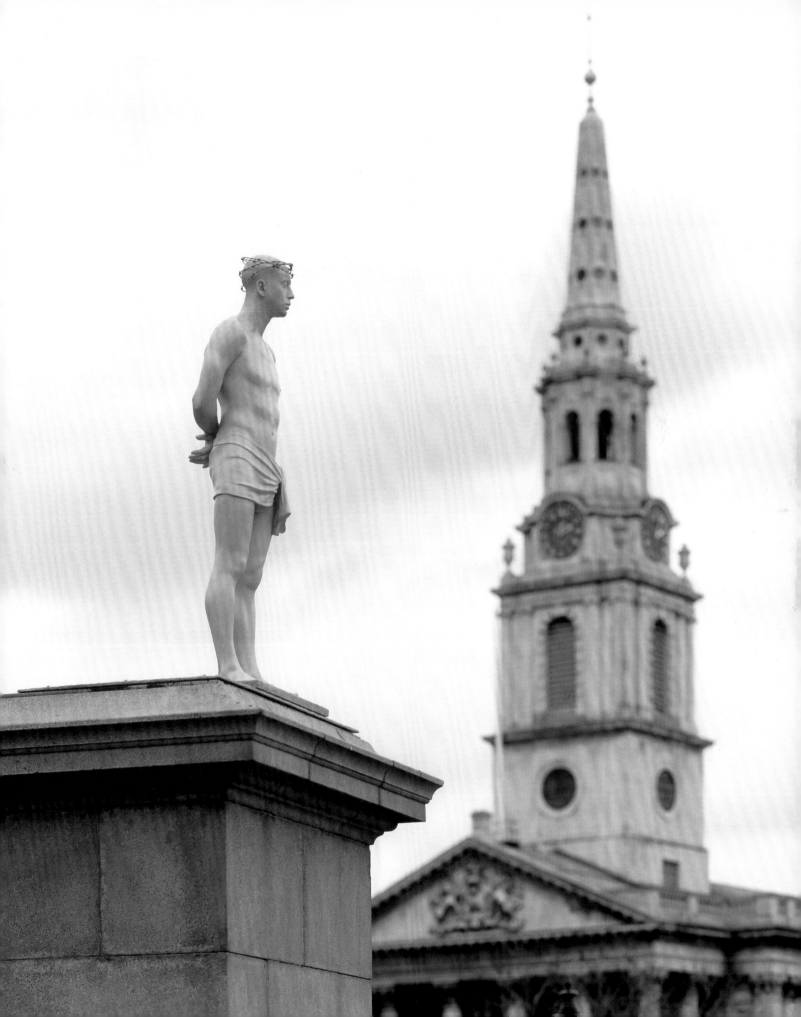

PART II) wonder

3 ♦ THE SUBLIME

4 ♦ HEAVEN AND EARTHWORKS

3 ◆ THE SUBLIME

+ In the previous two chapters we examined religious subjects and iconography. But works of art can generate religious experiences without depicting anything explicitly religious. Indeed, when it comes to representing concepts like eternity or infinity, or conjuring states of terror or ecstasy, sometimes works of art with no apparent religious symbolism can be the most effective. How we express such ideas and feelings that stretch our cognitive capacities has of course been a topic of rich speculation since antiquity. However, in the eighteenth and nineteenth centuries the question of how to describe and evaluate such 'limit experiences' became a central focus in the emerging field of aesthetics. While philosophers differed about how to define such experiences, they began to refer to this sensation of ineffability as the sublime, usually in contradistinction to its tamer sibling, the beautiful. As philosophical discourse about the sublime continued to evolve, artists began to join the discussion. By the mid-nineteenth century, the Romantics routinely invoked the sublime, while a century later Barnett Newman summed up the aspirations of his fellow Abstract Expressionists by declaring, 'The Sublime is Now'. For their part, twenty-first-century artists have staked their own claim to the sublime, raising questions that resonate across the history of philosophy, from the Englightenment to postmodernism.

Although the origins of the word sublime can be traced to Longinus in the classical period, its most forceful evocation came in 1757 with Edmund Burke's publication of *A Philosophical Enquiry into the Origin of Our Ideas of the Sublime and Beautiful*. Burke asserts in this treatise – a far more lively and accessible piece than its title might suggest – that 'terror [is] the common stock of every thing that is sublime'. He goes on to enumerate various characteristics that can produce terror – and hence the sublime – including power, emptiness, vastness, magnitude, and darkness. He notices adroitly, however, that the same sensations that

◁ **YAYOI KUSAMA** |APAN
Detail of *Infinity Mirror Room – The Souls of Millions of Light Years Away*, 2013

71

72

▷ **RICHARD SERRA** USA
The Matter of Time, 1994–2005
8 sculptures, weathering steel,
dimensions variable

For all their ominous weight, Serra's
constructions also constitute massive
fields of colour and texture, leading
Robert Hughes to call him 'the last
Abstract Expressionist'. Winding around
and through these expanses is an
intensely physical experience, leading
to a heightened sense of time and place.
'It brings you back to yourself and the
place where you are,' says Serra. 'You have
to deal with your internal relationships,
both physical and psychological and you
either deal with it or you don't.'

spur terror can also provide us with pleasure. '[T]hey are delightful,'
he suggests, 'when we have an idea of pain and danger, without being
actually in such circumstances.' The sublime awakens in us the pleasure
of self-preservation, the titillation that comes from playing at peril with
the promise of safety just around the corner.

In the nineteenth century, Romantic artists made a science out of
eliciting these sensations, from J. M. W. Turner's tumultuous seascapes
and jagged mountaintops to the volcanic infernos painted by his more
populist contemporary John Martin. Following in their footsteps,
contemporary painters such as James Lavadour and Julian Bell leave us
teetering before their own ominous landscapes. Other contemporary
artists have found ways to push themselves and their viewers even
closer to the precipice. Hiroshi Sugimoto created his *Lightning Fields* by
personally directing a blast of electricity from a 400,000-volt Van de
Graaff generator across a swathe of photo-sensitive paper. Meanwhile,
Richard Serra's torqued sheets of rusted steel feel liable to crush visitors
as they wind their way through his installation at Guggenheim Bilbao.
While Burke was confident that only words could summon supreme
sublimity, artists today have harnessed the terrible in ways that would
surely have made the philosopher tremble.

In 1790, in this third *Critique*, Immanuel Kant offered a more complex
treatment of the sublime, which he divided into the 'mathematical' –
which bears some analogy to the beautiful – and the 'dynamical'. It is
the latter that is most relevant to us here. Kant cites a host of natural
examples that stimulate the dynamical sublime, such as stormy seas, cliffs,
mountains, and lightning, in addition to man-made marvels such as the
Egyptian pyramids and St Peter's Basilica. Thus far, there are parallels
with Burke. Still, there are crucial differences. When we recoil from the
magnitude of the sublime, it is not our physical survival that provides
the antidote, according to Kant, but rather our cognitive faculties. As
Ben Quash explains, 'when we have what are (at the sensible level)
overwhelming experiences, [according to Kant] we retain the capacity
to think about ourselves *having* these experiences'. It is precisely this
triumph of reason that Angus Massey seems to celebrate in *Contemplating*

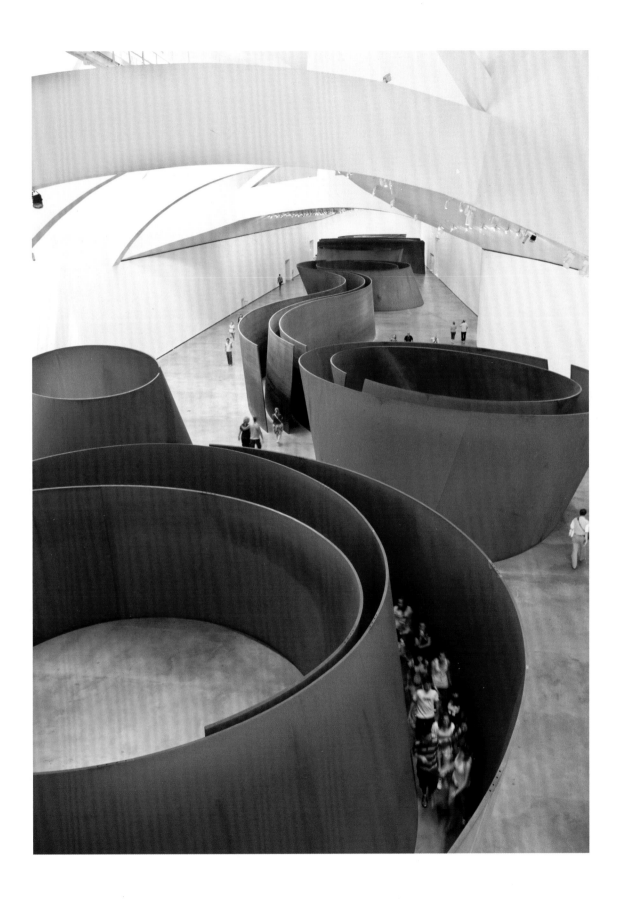

Contemplating the Sublime, 2011
Sculpture, bronze, steel, height 232 cm (91⅜ in.)

'The figures I create are bisected along their
central axis and placed against a mirrored
surface,' writes Massey. 'The dividing line
between three-dimensional reality – the actual
physical sculpture [–] and two dimensional
reality – its reflection on the steel surface
[–] is crossed by creating an entity that
exists between dimensions, suggesting the
unified nature of reality.' While Massey finds
connections with the Advaita Vedanta School
of Hinduism, we might also read his sculptures
through the lens of Western philosophy,
especially Idealism.

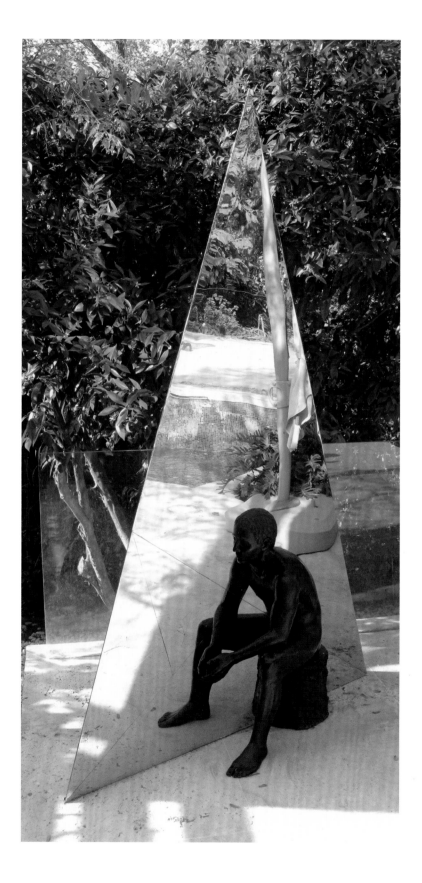

the Sublime (2011). Yet there are also hints of the Kantian sublime in Olafur Eliasson and Leandro Erlich's mirrored creations. For all their immersive power, both the *Weather Project* (2003–4) and *Dalston House* (2013) invite us to peer behind the curtain, as it were. Our pleasure comes not just from *experiencing* their sensory mysteries, but from *thinking* about them.

In the nineteenth century, John Ruskin added a further wrinkle to our notion of the sublime. Ruskin dismisses the idea that the sublime must always be terrifying. It can also be genuinely pleasing, he asserts, and not just as an after-effect of self-preservation or self-reflection. Ruskin's insight allows us to identify the sublime in the overwhelming scale yet shimmering beauty of Anish Kapoor's *Cloud Gate* (2004–6), the dazzling infinitude of Yayoi Kusama's mirrored rooms, or the pleasurable throbbing of our pupils as we pass through Carlos Cruz-Diez's *Chromosaturation* (1965–2013). Perhaps Ruskin would have even found walking into the *Rain Room* (2012–13), the ethereal box of *BLIND LIGHT* (2007), or the crepuscular haze of *You and I, Horizontal* (2005), akin to stepping inside one of the canvases of his beloved Turner.

Ruskin also recognized that although the sublime might be easiest to recognize in the mighty and overwhelming, it could also speak to us in another register, perhaps all the more effective for being subtle.

> [I]t is not in the broad and fierce manifestations of the elemental energies, not in the clash of the hail, nor the drift of the whirlwind, that the highest characters of the sublime are developed. God is not in the earthquake, nor in the fire, but in the still small voice. They are but the blunt and the low faculties of our nature, which can only be addressed through lampblack and lightning. It is in quiet and subdued passages of unobtrusive majesty, the deep, and the calm, and the perpetual. . . that the lesson of devotion is chiefly taught, and the blessing of beauty given. These are what the artist of highest aim must study.

We find just such 'unobtrusive majesty' in Jaume Plensa's gently glowing 'souls', as he calls them, perched like beacons above a city square. The contemplative sublime also pervades Xu Bing's *The Living Word* (2001–11), in which the Chinese characters for bird metamorphose and take flight, evoking for the artist the Zen imperative to 'look for harmony in the living

▷ **ANDREAS GURSKY** GERMANY
Chicago Board of Trade III, 1999–2009
C-print, 223 x 307 x 6.2 cm (87⅞ x 120⅞ x 2⅜ in.)

This work belongs to Gursky's series of photographs of stock exchanges taken around the world, including Hong Kong, Tokyo, and Kuwait. Like most of Gursky's oeuvre, it is shot from a God's-eye perspective, in which swarms of people scuttle across the trading floor like so many insects. The unblinking dispassion of Gursky's gaze – at once scientific and theological – is echoed in his assertion that he is 'never interested in the individual but in the human species and its environment.'

word. . .[not] lifeless sentences'. Similarly, in the pure, radiating circles of Oliver Marsden's 'OM' paintings, we might hear – if not a still, small voice – the gentle hum of Hinduism's sacred syllable.

Yet quiet can also be unnerving, as we can feel so palpably in the photographs of G. Roland Biermann and Gregory Crewdson, or the webbed rooms of Chiharu Shiota. According to Sigmund Freud, the direct shock of the sublime is no match for the creeping dread of the uncanny, the *Unheimlich*. The uncanny, writes Freud, 'is that species of the frightening that goes back to what was once well known and had long been familiar': an urge or memory so disturbing that we have buried it deep in the recesses of our unconscious. Where Kant theorized that the terror of the sublime flings us back into ourselves, into the refuge of reason, for Freud the far greater terror lies within us. It would come as no surprise to Freud that if we follow the dark skeins of Shiota's imagination it leads back to a traumatic childhood memory: a charred piano sitting in the smoldering wreckage of her neighbour's home, destroyed by fire.

In the late twentieth and early twenty-first centuries, several theorists have suggested that it is not just the inner workings of our minds, but the logic of modern life itself that might be uncanny or terrifying. Some writers pinpoint the ubiquity and incomprehensibility of technology as the source of a new sublime. Fredric Jameson offers a related, but more nuanced diagnosis:

> The technology of contemporary society is. . .mesmerizing and fascinating not so much in its own right but because it seems to offer some privileged representational shorthand for grasping a network of power and control even more difficult for our minds and imaginations to grasp: the whole new decentred global network of the third stage of capital itself.

There is no better representation of this 'postmodern sublime', as Jameson terms it, than Andreas Gursky's *Chicago Board of Trade III* (1999–2009). More frightening than Bell's hellmouth, Gursky's photograph reveals a network of forces so pervasive and incalculable that merely to regard them makes us quiver with vertigo. On the one hand,

this postmodern sublime seems to leave no room for any other, least of all the religious sublime. Yet on the other hand, maybe it is not so different from the yawning vista of Caspar David Friedrich's *Monk by the Sea* (1809), or the flat expanse of Barnett Newman's *Vir Heroicus Sublimis* (1950–51). Perhaps staring into the abyss of late capitalism merely provides us with an updated metaphor for the greater mystery of the Divine. Or maybe staring into the mirror of our own monstrous creations we cannot help but recoil towards the redemptive promises of theology. The twentieth-century French philosopher Jean-François Lyotard was right in more ways than one: 'The spirit of the times is surely not that of the merely pleasant: its mission remains that of the immanent sublime, that of alluding to the nondemonstrable.'

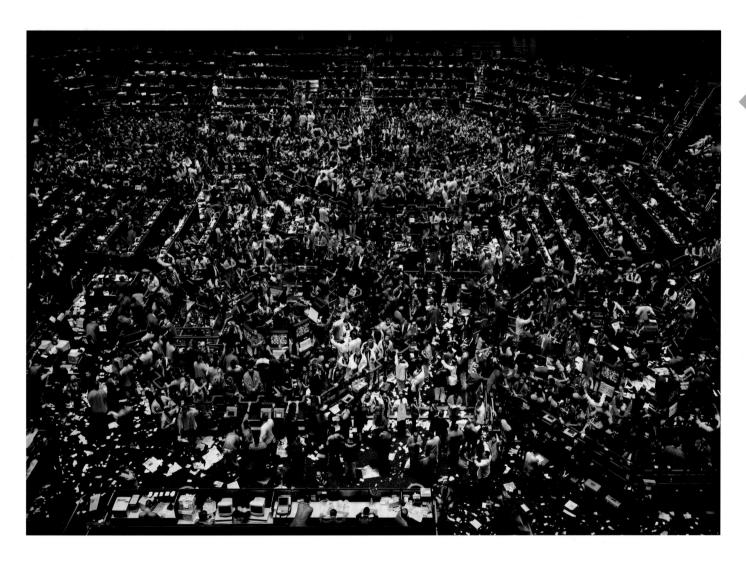

Tremor 3, 2012

Oil on panel, 61 x 76.2 cm (24 x 30 in.)

Growing up in Oregon's Umatilla reservation, Lavadour was self-trained. 'I began to look at paint as an organic event,' he says, 'an event of nature itself. So I began to see parallels of what was happening in the paint and what was happening in the mountains, with light, with water, with hydrology, with erosion; all those things were happening on the canvas. . . .I'm causing these little organic circumstances to happen in paint. . .it's really not a picture of something, it *is* something.'

△ **JULIAN BELL** UK

Darvaza, 2012

Oil on canvas, 1397 x 2438 cm (550 x 959⅞ in.)

This image is inspired by the artist's visit to a fiery pit in
Turkmenistan's Karakum Desert, ignited by a failed Soviet gas
probe in 1971. Bell began the work by pouring paint onto the canvas.
'[By] inviting a relatively random process into the making of the
image. . .I was reaching out to touch something other in my studio
– something not entirely self-willed and human – even as I had
confronted something powerfully other, standing a previous
evening by that flame-lit cliff edge.'

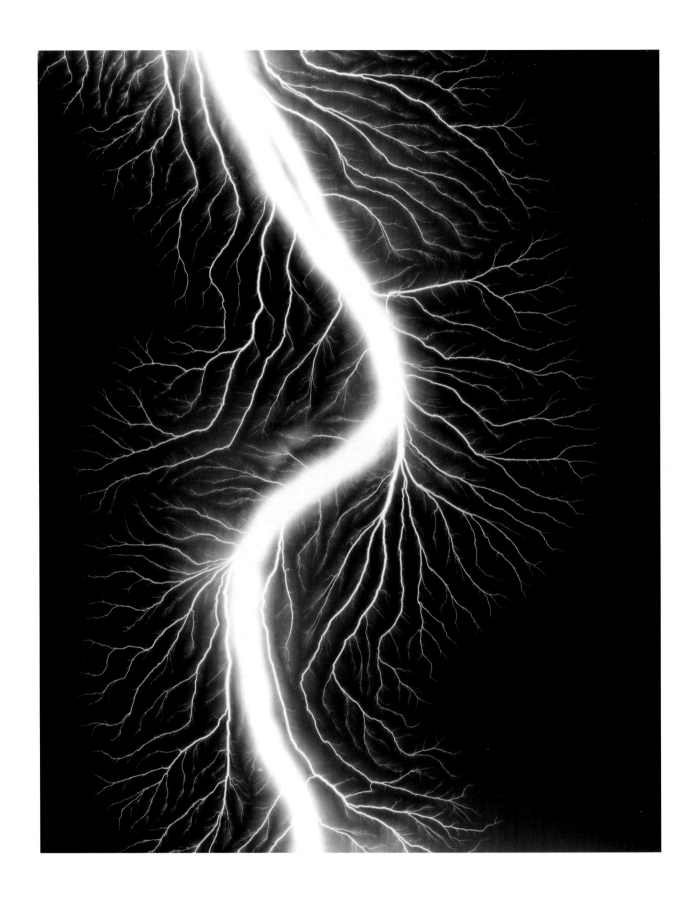

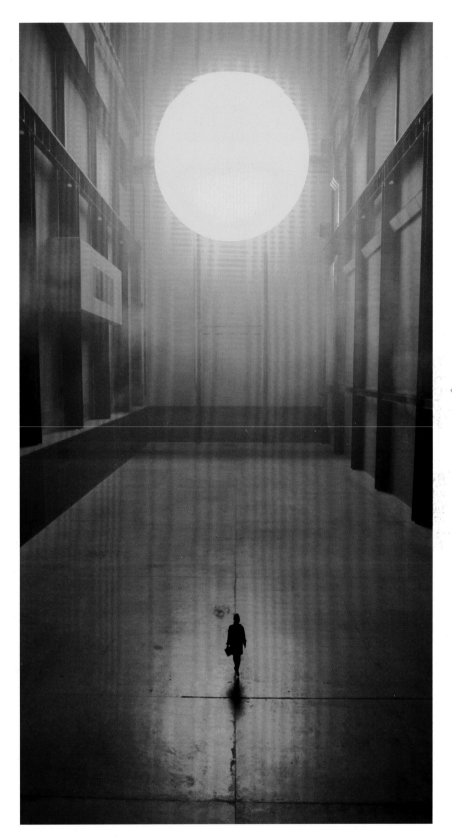

HIROSHI SUGIMOTO |APAN/US

Lightning Fields 225, 2009
Gelatin silver print, 149.2 x 119.4 cm (58¾ x 47 in.)

'[T]o be a good photographer you have to be a scientist as well,' says Sugimoto, who likens his *Lightning Fields* to early photographic experiments, as well as cosmic events, such as 'the first meteorite hitting the Earth'. Yet science does not occlude religion. 'People still need another way to understand the world besides logic,' comments Sugimoto, 'and we're turning to art and spirituality to help us understand our environment and the world.'

▷ OLAFUR ELIASSON

DENMARK/ICELAND

The Weather Project, 2003–4
Monofrequency lights, projection foil, haze machines, mirror foil, aluminium, and scaffolding, 267 x 223 x 1554 cm (105⅛ x 87¾ x 611¾ in.)
Installation view, Turbine Hall, Tate Modern, London

Eliasson is adamant that however absorbing and engaging a work like *The Weather Project* might be, it must not descend into mere entertainment. '[O]ur ability to see ourselves seeing – or to see ourselves in the third person,' is crucial because it 'gives us the ability to criticise ourselves.' He adds elsewhere, 'This offsets the alarming sugar-coating of experiences developed by a world that. . .packages experiences for sale rather than insists on individual and collective responsibility for sensation and shared space.'

▽ **LEANDRO ERLICH** ARGENTINA

Dalston House, 2013

Print, lights, iron, wood, and mirror, 1200 x 600 x 800 cm
(472⅜ x 236¼ x 314⅞ in.)

Installation view, Hackney, London

By placing an architectural façade on the ground beneath an angled mirror, Erlich invites visitors to observe themselves in seemingly impossible, gravity-defying situations while simply sitting or standing on the ground. 'Perception is the inherited tool we are all born with and we use to understand the world and to achieve knowledge,' reflects the artist. 'I think illusion here acts as a trigger, seducing the viewer to participate in the experience while questioning their understanding of reality.'

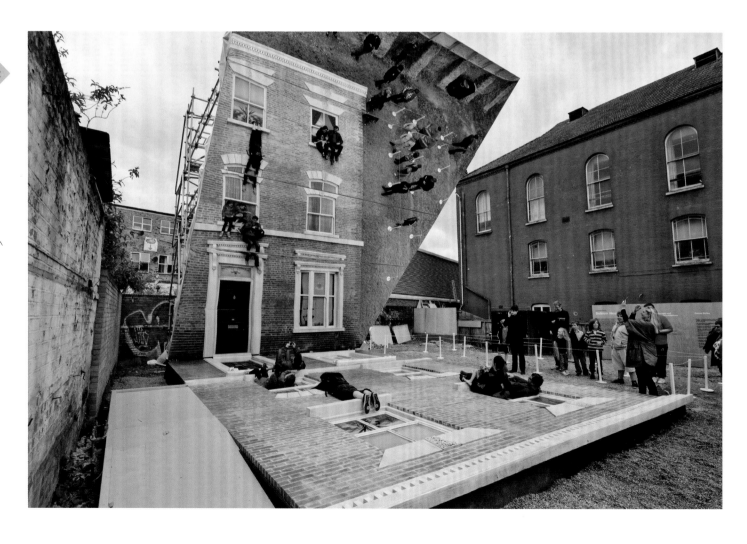

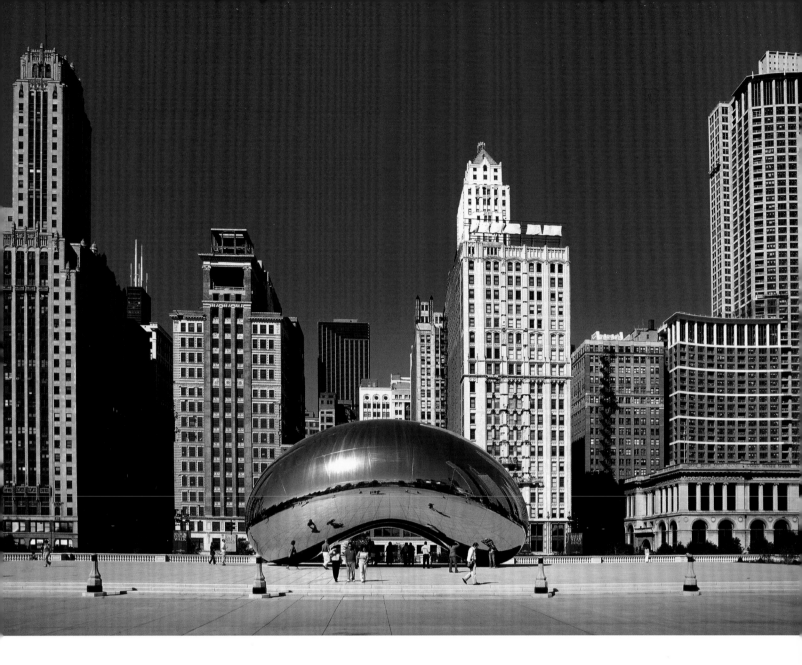

△ **ANISH KAPOOR** INDIA/UK

Cloud Gate, 2004–6
Stainless steel, 1000 x 2000 x 1280 cm (393¾ x 787⅜ x 503⅞ in.)
Installation view, Millennium Park, Chicago

Despite its technical innovations – new technologies had to be
invented to allow its seamlessly joined stainless-steel plates – *Cloud
Gate* resonates powerfully with both Kapoor's precursors and his own
earlier works. Thus, on the one hand it offers a fresh take on a long
tradition of landscape paintings, especially the cloudscapes of John
Constable and Jacob van Ruisdael. On the other hand, 'the Bean', as
Chicagoans affectionately call it, embodies the abiding tensions of
Kapoor's oeuvre: concave/convex, presence/absence, solid/immaterial.

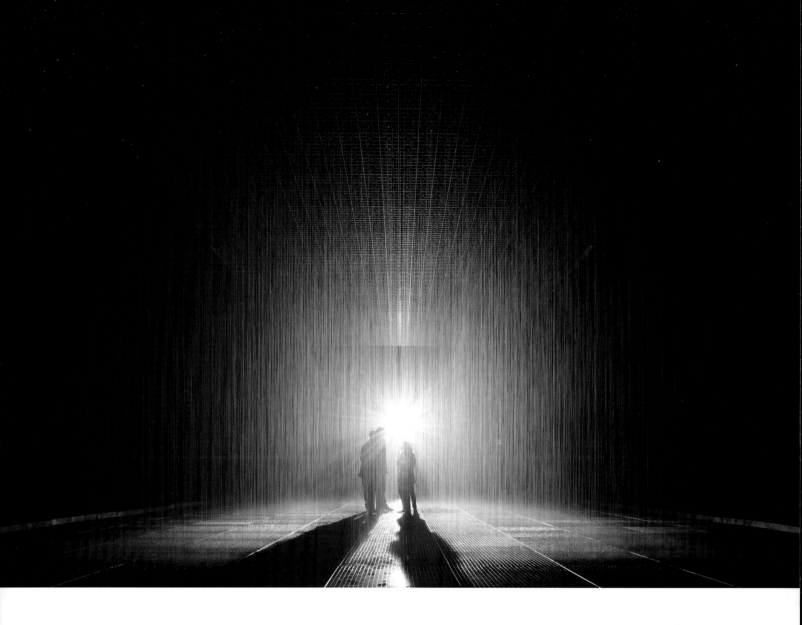

△ **RANDOM INTERNATIONAL** UK
Rain Room, 2012–13
Water, injection moulded tiles, solenoid valves, pressure regulators, custom
software, 3D tracking cameras, steel beams, water management system, and
grated floor, 100 sq. metres (1,076⅜ sq. feet)
Installation view, Museum of Modern Art, New York City, 2012

The miraculous conceit of the *Rain Room* – in which visitors can
stroll through the pouring rain while remaining completely dry, as if
surrounded by a protective force-field – is the result of meticulous
research, programming, and calibration. Cameras map the location
of moving bodies in three dimensions, with information fed to a grid
controlling water flow. Where many critics and philosophers have
theorized distinct categories of the sublime, from natural to artistic to
technological, in *Rain Room* all three converge.

▷ **ANTONY GORMLEY** UK
BLIND LIGHT, 2007
Fluorescent light, water, ultrasonic humidifiers,
toughened low iron glass, and aluminium,
320 x 978.5 x 856.5 cm (126 x 385½ x 337½ in.)
Installation view, Hayward Gallery, London

'Architecture is supposed to be the location of
security and certainty about where you are,'
writes Gormley. 'It is supposed to protect
you from the weather, from darkness, from
uncertainty. *BLIND LIGHT* undermines all of
that. You enter this interior space that is the
equivalent of being on top of a mountain or at
the bottom of the sea. . .[I]nside it you find the
outside. Also you become the immersed figure
in an endless ground.'

▷ **ANTHONY MCCALL** UK/USA

You and I, Horizontal, 2005
Institut d'Art Contemporain, Villeurbanne
(France), 2006
Mixed-media installation

In installations that are part cinema, part
sculpture, McCall projects oscillating beams
of light through a fine mist, creating planes
and chambers of light. 'For me,' says McCall,
'the sublime carries ideas of awe in the face of
unbounded, amorphous space. Perhaps some
of these impressions are encouraged by the
darkness, the scale, and by the mist, but then
surely they're contradicted, or at least kept in
balance by the geometry in the drawing, and
the precision of the structure.'

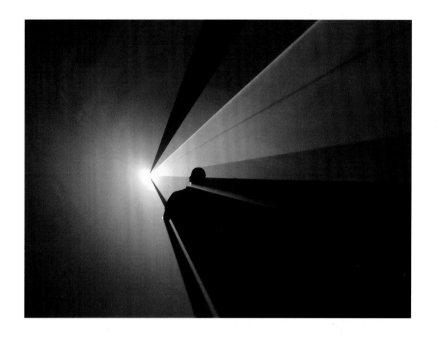

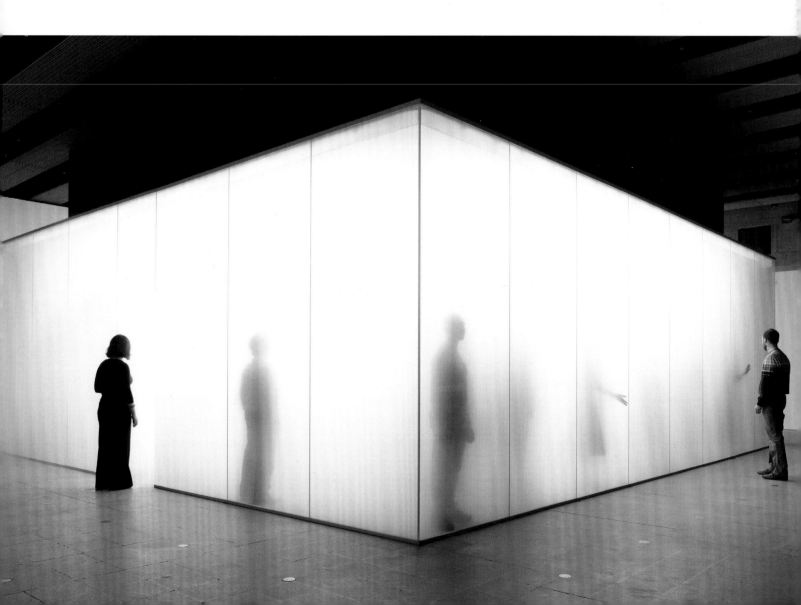

▽ CARLOS CRUZ-DIEZ VENEZUELA/FRANCE

Chromosaturation, 1965–2013
Fluorescent lights with blue, red, and green filters
Installation view, Hayward Gallery, London, 2013

For Cruz-Diez, colour is 'not simply the colour of things. . .[but]
an *evolving* situation, a *reality* which acts on the human being with the
same intensity as cold, heat, and sound'. *Chromosaturation* becomes,
in the first instance, a laboratory. The severe transition between
rooms of overpowering red, green, and blue create new colours as our
retinas struggle to adapt. Yet what transpires cannot be exhausted by
scientific explanation, it demands – as the artist recognizes – an
account in the 'phenomenological realm'.

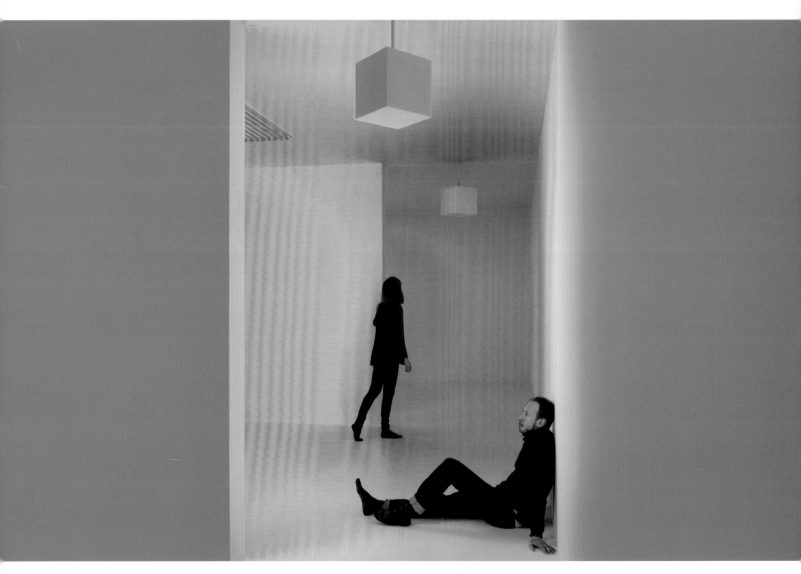

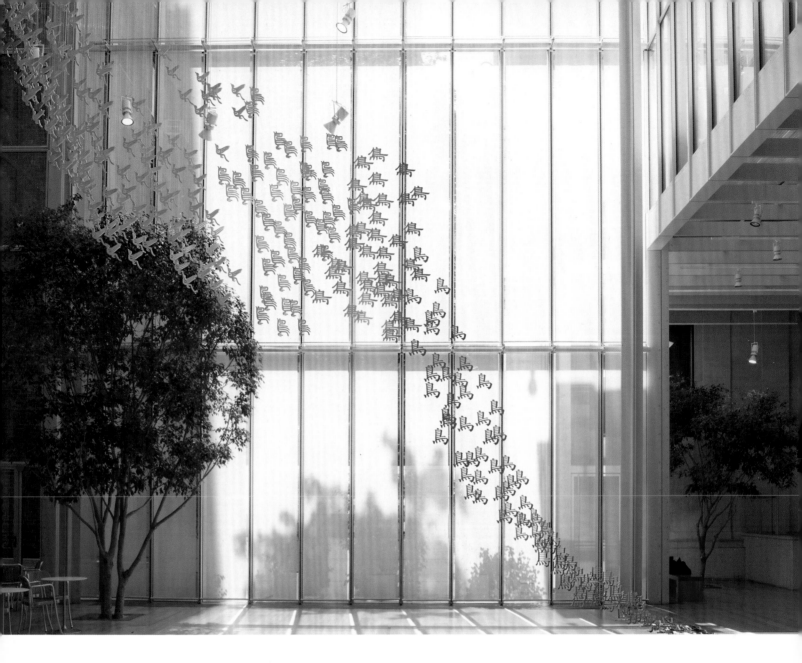

△ **XU BING** CHINA/US
The Living Word, 2001–11
Carved, painted acrylic characters, nylon monofilament, 23 x 23 cm (9 x 9 in.)
Installation view, The Morgan Library and Museum, New York City

Xu's works often question the reliability of language, a theme that
he connects to Zen Buddhism and the deconstructionist philosophy
of Jacques Derrida. 'No matter what outer form my works take,' he
notes, 'they are all linked by a common thread, which is to construct
some kind of obstacle to people's habitual ways of thinking. . . .These
obstacles derive from intentionally mixing up different received
concepts to create a sense of estrangement and unfamiliarity.'

▷ **YAYOI KUSAMA** |APAN

*Infinity Mirror Room – The Souls of Millions
of Light Years Away*, 2013
Wood, plastic, acrylic, LED lights, aluminium, and
mirror, 300 x 617.5 x 645.5 (118⅛ x 243⅛ x 254⅛ in.)

Kusama's mirrored rooms have their roots
in her signature net and polka-dot motifs.
These repeated forms, she states candidly,
are the products of 'the hallucinations and
obsessional images that plague me', and
constitute an attempt at curing both her
own mental illness and that of 'all mankind'.
Losing a sense of perspective, surrendering
to the illusions of the mirrored room,
believes Kusama, teaches self-abnegation.
'By obliterating one's individual self,' she
asserts, 'one returns to the infinite universe.'

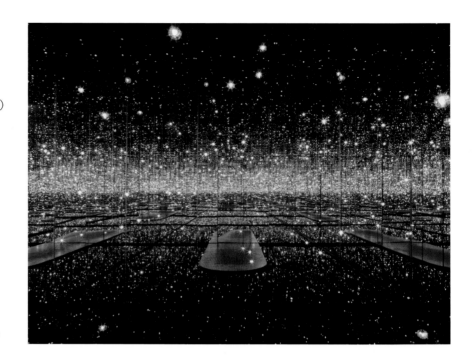

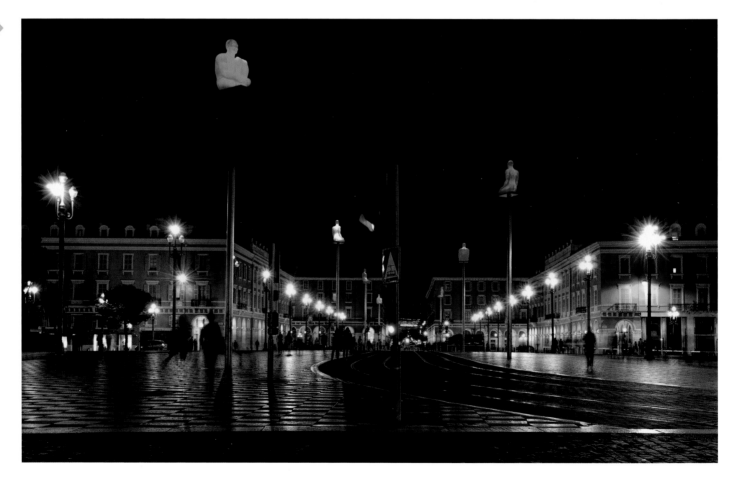

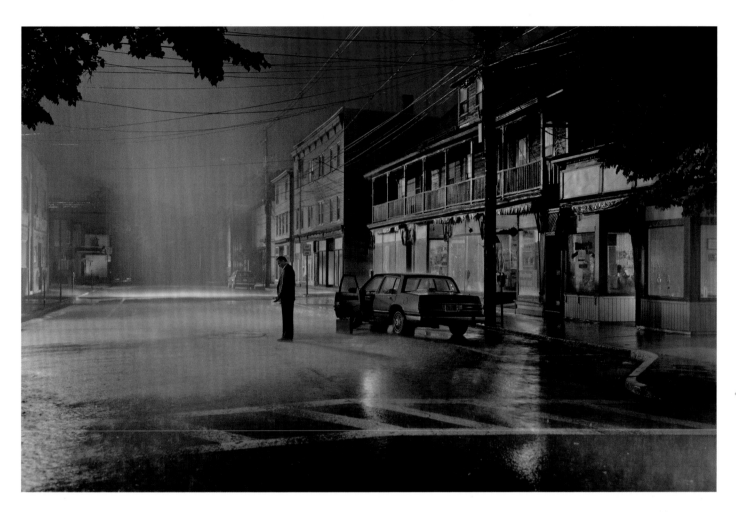

◁ **JAUME PLENSA** SPAIN

Conversation à Nice, 2007
Polyester resin, stainless steel and light, 7 elements,
height 1200 cm (472½ in.)
Installation view, Place Masséna, Nice

The fetal positions of these figures, Plensa says,
'are expressing an attitude of looking or facing
"inside". Many of my works pursue this idea that
people should face their interior selves rather than
the external world. We firstly have to understand
what is happening within ourselves in order to
conceive the universal. . . . And if we look deep
enough, we eventually touch upon a collective
memory, or the memory of others. We are all part
of one general memory.'

△ **GREGORY CREWDSON** USA

Untitled, 2004
Digital c-print, 144.8 x 223.6 cm (57 x 88 in.)

This photograph belongs to the series 'Beneath the Roses'.
Crewdson's elaborately staged photographs often feel like film
stills, stopped just before or after a crucial moment. 'I'm very much
interested in creating tension,' comments Crewdson, 'between
domesticity and nature, the normal and the paranormal, or artifice
and reality, or what's familiar and what's mysterious. We could call
that an interest in the uncanny: the terrifying and the familiar.
I intentionally ground all these mysterious or unknowable events
within a recognizable and iconic situation, which is the domestic
American landscape.'

◁ **G. ROLAND BIERMANN** GERMANY/UK
Apparition 17, 2001–2
Gelatin silver prints on aluminium dibond,
each: 150 x 50 cm (59 x 19⅝ in.)

Religious associations ripple through
Biermann's 'Apparitions', shown previously
at Bow Church in London. 'There's. . .
a contradictory element in them,' Biermann
tells me, 'where on closer inspection you think
there's something wrong with the picture.
Here, for instance, the feet in the top go
upwards but not the ones on the bottom, in the
mirror image. It defies the idea of ascension.'
The plasters on the feet add another layer of
ambivalence. Are these stigmata? Do the Band-
Aids heal or obscure?

PART II ⟩ wonder

▷ **OLIVER MARSDEN** UK
OM Halo I, 2013
Acrylic on linen, 100 x 100 cm (39⅜ x 39⅜ in.)

There is a meditative dimension to both the
creative process and the imagery of Marsden's
circular works. Painted with the aid of a
spinning machine, sometimes while listening
to recordings of Buddhist and Hindu chants,
the works emphasize the spiritual value of
mindful repetition. His goal is not so much
to produce single perfect works, but rather
'to make substance seem immaterial, to
create a virtual perceived space in the mind
of the viewer'.

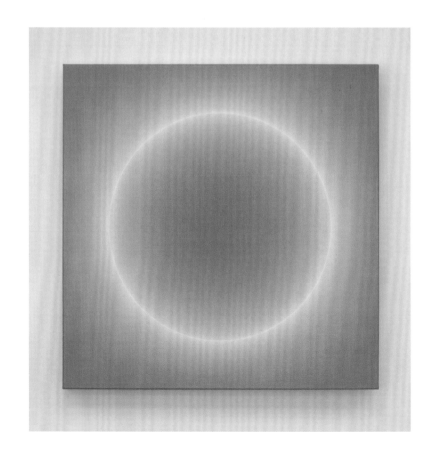

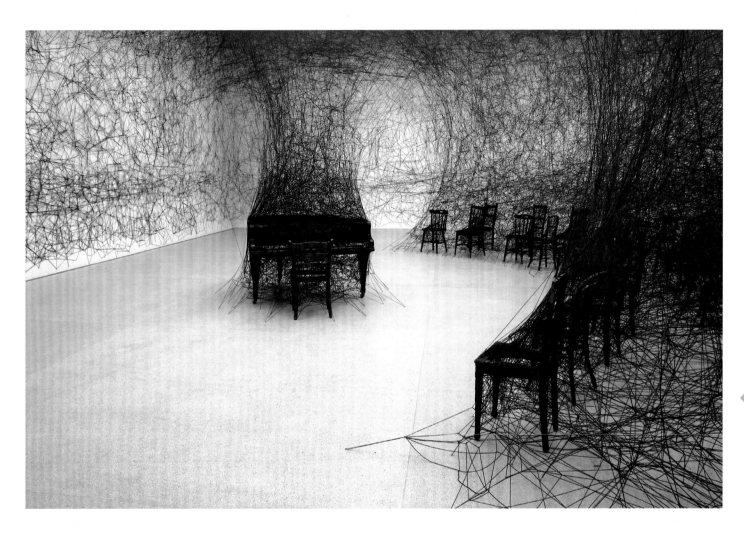

△ **CHIHARU SHIOTA** |APAN

In Silence, 2008
Vintage chairs, vintage piano, and wool, dimensions variable
Installation view, CentrePasquArt, Biel (Switzerland)

Shiota has ensnared everything from children's shoes to wedding dresses to herself. These works are intensely personal, evoking private fears and memories, and yet they also tap into archetypal experiences and emotions. The artist identifies a religious dimension in this uncanny sensation. Religious sites and relics, she says, evoke 'strong emotional reactions. I think those reactions are sacred, but not necessarily the objects. It is similar with my art work. It's the emotions that are sacred.'

4 ◆ HEAVEN AND
EARTHWORKS

+ From the sixties onwards, artists have looked at the landscape before them as an artistic medium, ready to be sculpted, shifted, or transformed. But while various terms have been christened to describe their practice – land art, earthworks, environmental art – they belong to a much longer lineage. Indeed, many of the most iconic works of environmental art, from Robert Smithson's *Spiral Jetty* (1970) to the boulder in Michael Heizer's *Levitated Mass* (1969–2012), take us back to ancient history, from the Native American mounds of Ohio to the megaliths of Stonehenge. What connects these primitive creations to modern art, however, is not just their formal similarities, or the staggering effort involved, but the religious questions they raise. Like our distant ancestors, we still have a fundamental need to make sense of creation, and our place within it, and one of the best ways we know how to do this is by creatively reshaping and reimagining the natural world around us. But while our religious impulses have remained remarkably similar, our planet has not. To ask what it means today to experience sublime wonder before the heavens, tranquillity on the edge of the ocean, or a sense of interconnectedness in the forest, is not the same as it was millennia, centuries, or even decades ago. As the earth buckles under the crushing weight of climate change, we must confront its radical ephemerality, and the potential eclipse of religious horizons we once took for granted. To make environmental art in the twenty-first century is not only religiously significant, it is ethically imperative.

In Chapter Three we considered the notion that modern technology, or even modern life itself, has become sublime. This may be true, and yet when it comes to the natural world, modernity might just as easily be responsible for destroying the sublime, at least as we know it. In the face of this possibility, creating works of environmental art can be profound, defiant acts of optimism. Perhaps no work embodies this continued quest for the natural sublime more than James Turrell's *Roden Crater*.

◁ **LEONARD KNIGHT**
Detail of *Salvation Mountain*, Niland, California, 1986–ongoing

For more than thirty years, Turrell has been directing a massive excavation and construction project designed to turn an extinct volcanic cinder cone in the Arizona desert into an observatory for the naked eye, in effect allowing him to curate the night sky. In their own ways, Andy Goldsworthy and Cai Guo-Qiang also open spaces for the miraculous in the midst of the everyday, from the gigantic snowballs Goldsworthy secretly deposited in London at the height of the summer (2000) to the nocturnal rainbow that Cai set off over New York City (2002). Together, Turrell, Goldsworthy, and Cai re-present the world to us as a gift, reminding us of its capacity to stun and befuddle.

Not only can the natural world overwhelm us with grandeur, it can also be a place for contemplation and introspection. Martin Heidegger wrote several of his most important works from a small hut in the Black Forest, and his daily experience of walking in the woods shaped the way he spoke about being. 'In the midst of beings as a whole an open place occurs. There is a clearing, a lighting,' he wrote in the 1930s, conjuring an image like one of Jitka Hanzlová's photographs from her 'Forest' series (2000–2005). 'Only this clearing grants and guarantees to us humans a passage to those beings that we ourselves are not, and access to the being that we ourselves are.' Walking through the forest can be both a method and a metaphor for the search for being. A similar insight runs through the art of Richard Long, from *A Line Made by Walking* (1967) to *Heaven and Earth* (2001), in which he recorded a hike through the wilderness with the words, 'THE WALK AS TRUE PATH SOME FALSE MOVES'. Yet self-discovery does not have to be a solitary activity, pursued alone in the dark wood. It can be made all the more powerful in the presence of others. As visitors wound their way through Christo and Jeanne-Claude's *Gates* (2005) in Central Park – itself an astounding work of land art – they were swept up in a sort of impromptu procession, as if joining a pilgrimage. Francis Alÿs reported a similar sense of 'social sublime' among the participants in *When Faith Moves Mountains* (2002). Volunteers may have only shifted a sand dune a few imperceptible inches with their shovels, but for many the work itself was uplifting.

Faith can not only move mountains, it can create them. In a stunning feat, with little assistance and no artistic training, Leonard Knight spent decades building *Salvation Mountain* (1986–2014) in the California desert: a literal Sermon on the Mount delivering the message 'God is Love'. Maybe the late

△ **CAI GUO-QIANG** CHINA

Transient Rainbow, 2002

Fireworks, opening of Queens Museum (MoMA), New York City

For a city still reeling from the attacks of 11 September 2001, Cai's rainbow evoked comparisons with the rainbow God produced after the Flood as a sign of his promise to humanity that he would never again destroy the world (Genesis 9.8-16). The transience of fireworks, Cai's signature medium, also has a religious significance for him, symbolizing the dynamism and impermanence of life. Drawing on Daoist philosophy, he comments, 'I am looking for the unchanging through the always changing.'

folk artist would have sensed a kindred spirit, half a world away, in Halil Altindere's *Carpet Land* (2012), in which the earth becomes the floor of a vast mosque, with mountains for minarets. The idea of worshipping God outside – in the midst of Creation – has struck many as the best place to experience God's presence. For the American philosopher Ralph Waldo Emerson, it was downright essential to leave the physical and conceptual confines of religious institutions to fully experience the divine. He wrote in 1836:

> Standing on the bare ground – my head bathed by the blithe air, and uplifted into infinite space – all mean egotism vanishes. I become a transparent eye-ball; I am nothing; I see all; the currents of the Universal Being circulate through me; I am part or particle of God.

This sense of interconnectedness is precisely what Mariko Mori aims to evoke in *Primal Rhythm*, intended to bring viewers into harmony with the natural cycles of the planet. There is a similar, albeit less mystical, sensibility at play in the landscapes of Charles Jencks. Together, the forms of his *Garden of Cosmic Speculation* (1989 onwards) and *Cells of Life* (2003–10) reflect his belief in a 'cosmic code' linking everything from the macrocosmic to the microscopic. God, in other words, becomes interchangeable with Nature; an idea famously asserted by the seventeenth-century Dutch philosopher Baruch Spinoza.

The question of what, if any, religious value we find in nature has profound practical implications for sustainability. In the United States, for example, the political debate over climate change has been increasingly framed in terms of faith, with a sizeable number of evangelical Christians denying or expressing strong doubts about global warming in the face of overwhelming scientific evidence. At the root of this reluctance seems to be a general anxiety about scientific discourse – especially its ability to challenge biblical accounts of creation – as well as a reflexive rejection of causes associated with the political left, seen as opponents of 'traditional' values. The irony is that refusing to acknowledge this man-made catastrophe actually runs counter to a key point of Scripture, which emphasizes human responsibility for the environment. In the Garden of Eden, for instance, humanity is entrusted with the stewardship of nature (Gen. 1.28–30), while Noah is charged with preserving the planet's biodiversity (Gen. 6.19–7.3). Building on such examples, there is a tremendous opportunity – as some artists have begun to recognize – to

reclaim environmental concern as a religious imperative. In 2010, Kevin Schmidt placed a sign inscribed with prophecies from the Book of Revelation – specifically resonating with the perils of global warming – on a shelf of ice in the Canadian Arctic, intended to spread its apocalyptic warning as the ice melted and drifted south. We can find prophetic warnings every bit as terrifying in the disintegrating glaciers photographed by Darren Almond or the stumps gathered by Angela Palmer from West Africa's dwindling rainforests. And if we are not sufficiently chastened, we need only consider Edward Burtynsky's God's-eye photographs of mines and oil spills to imagine how the Almighty might look down upon our depredations.

As powerful a jeremiad as art might deliver, it can provide an equally potent promise of redemption. The pioneering American environmentalist Rachel Carson once wrote: 'I believe that whenever we destroy beauty, or whenever we substitute something man-made and artificial for a natural feature of the earth, we have retarded some part of man's spiritual growth.' The opposite might also be true: whenever we recover natural beauty, we replenish our spiritual life. Giuseppe Penone speaks of the 'commonplace holiness' he discovers by carving back blocks of lumber to reveal the sapling inside; an act that suggests our own potential to discover 'The Hidden Life Within', to take the title of his 2008 exhibition. This intrinsic, natural dignity can be even harder to glimpse in material such as rotting plywood, or the polluted soil of a landfill, and yet in their own ways Henrique Oliveira and Jean-Paul Ganem also present us with unexpected examples of reuse and rebirth. The significance of such small reclamations should not be underestimated. When the floodwaters receded after forty days and forty nights, and he first set foot on dry land, Noah did two things: he offered thanksgiving to the Lord (Gen. 8.20) and planted a vineyard (Gen. 9.20). The second act was just as important as the first. It confirmed that Noah not only feared the Lord but that he believed his promise never again to destroy the earth. Today, it is we who must promise that 'As long as the earth endures, seedtime and harvest, cold and heat, summer and winter, day and night, shall not cease' (Gen. 8.22). But while our roles may be reversed, we can still seal this covenant with the same simple act of faith. Noah, of all people, would appreciate the hopeful symmetry of planting one of Sam Van Aken's 'Trees of 40 Fruit' in an age of catastrophe.

▽ **CHARLES JENCKS** USA/UK

Cells of Life, Jupiter Artland, Kirknewton, Scotland, 2003–10

'We live in a universe,' says Jencks, 'in which beauty naturally emerges – the ways flowers self-organize and the Fibonacci numbers produce beautiful forms. . . .So instead of living in the so-called meaningless universe we live in a much more interesting, creative and dynamic universe where meaning is emerging all the time. I have flirted with God, but I am not religious in the conventional sense. I do think there is a cosmic code that both has coherence and multiple directions.'

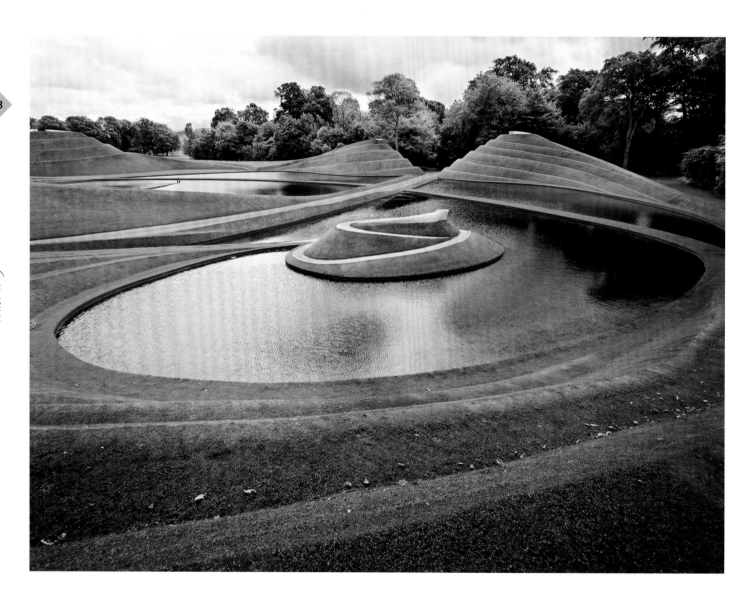

△ **EDWARD BURTYNSKY** CANADA

Silver Lake Operations #1, Lake Lefroy, Western Australia, 2007

While Burtynsky seeks to document the impact of human
development on nature, there is also a strong metaphorical content
to his work, as in this photograph evoking the circles of Hell.
Elsewhere, his *Nickel Tailings #34* (1996) recalls the rivers of blood
with which God plagues the Egyptians, while the abandoned quarry
in *Rock of Ages #26* (1991) ironically invokes the eponymous Christian
hymn. He says his works 'search for a dialogue between attraction
and repulsion, seduction and fear'.

GRANITE

A NINE-DAY WALK IN THE SERRA DO GERÊS/SIERRA DE XURÉS PORTUGAL AND SPAIN 2005

◁ **JITKA HANZLOVÁ** CZECH REPUBLIC
Untitled, 2005
C-print, 58 x 27 cm (23⅞ x 10⅝ in.)

In 1982, Hanzlová defected from
Czechoslovakia to West Germany. When
she was finally able to return after the
collapse of communism, she began sensitively
documenting the sights and residents of her
hometown of Rokytník in Eastern Bohemia.
She photographed the woods surrounding her
village, producing her 'Forest' series from 2000
to 2005. As the artist John Berger puts it, these
photographs 'have been taken from the inside.
The deep inside of a forest, perceived like the
inside of a glove by a hand within it.'

△ **RICHARD LONG** UK
GRANITE, from Stone to Stone, Portugal and Spain, 2005
Photograph, 87 x 127 cm (34¼ x 50 in.)

Long's works run the gamut from photographs of walks and
temporary interventions in the landscape to spare poetic
descriptions of journeys to a fusion of words and images like this
piece. 'The significance of walking in my work is that it brings time
and space into my art,' he says. 'A work of art can be a journey. . . .
It's like a way of measuring the world. I love that connection to
my own body. It's me to the world.'

▽ **MARIKO MORI** |JAPAN

Primal Rhythm (consists of *Sun Pillar* and *Moon Stone*), 2011
Sun Pillar: layered acrylic, 420 x 75.6 cm (165⅜ x 29¾) diameter
Installation view, Seven Light Bay on Miyako Island, near Okinawa, |apan

After researching ancient cultures from the Jōmon of Japan to
the Celts, Mori believed she discovered universal rituals and beliefs
rooted in the rhythms of the natural world. She hopes to recover
these for contemporary society, beginning with the cycles of the
sun and moon. While her translucent *Sun Pillar* reflects the sky,
the *Moon Stone* change colours according to the tides. During the
winter solstice, the pillar's shadow falls on the stone, creating
a sort of giant sundial.

▷ **CHRISTO AND JEANNE-CLAUDE**
BULGARIA AND MOROCCO

The Gates, Central Park, New York City, 1979–2005
7,503 gates, vinyl and cloth, each: 488 x 168–549 cm
(192 x 66–216 in.)

Stretching through twenty-three miles
of pathways in Central Park, *The Gates*
comprised 7,503 structures, festooned with
fabric the colour of Buddhist monks' saffron
robes. As Doug Adams reminds us, paths and
passageways are central images in multiple
religions. In Judaism, for instance, *halakha*
(Jewish law) literally means 'the way', while
Jesus declares: 'I am the way' (John 14.6). By
asking visitors to find their way, *The Gates*
evoke questions at the heart of religious life.

▽ **FRANCIS ALŸS IN COLLABORATION WITH CUAUH-TÉMOC MEDINA AND RAFAEL ORTEGA** BELGIUM AND MEXICO

Cuando la fe mueve montañas (When Faith Moves Mountains), 2002
Photographic documentation of an event in Lima, Peru

When Alÿs travelled to Peru in the middle of an economic meltdown he recognized 'a desperate situation that called for an "epic response", at once futile and heroic, absurd and urgent'. At his direction, 500 volunteers walked up a sand dune on the outskirts of Lima, shovels in hand, displacing the dune as they went. 'Sometimes, to make something is really to make nothing; and paradoxically, sometimes to make nothing is to make something,' reflects Alÿs.

▷ **HALIL ALTINDERE** TURKEY

Carpet Land, 2012
C-print, mounted on alu-dibond, 100 x 170 cm
(39⅜ x 66⅞ in.)

Altindere is a curator and editor in addition to an artist who works across multiple media. An ethnic Kurd, he often draws attention in his work to minority groups in Turkey, and tensions between East and West. This installation recalls the industry of local weavers as well as the parcelling out of farmland. But above all this multitude of carpets suggests the daily prayer of Muslims, playfully but profoundly engaging with the country's Islamic heritage.

▷ **LEONARD KNIGHT** USA

Salvation Mountain, 1986–ongoing
Adobe clay and paint
Intallation view, Niland, California

After a conversion experience in his mid-thirties, Knight spent the rest of his life looking for creative ways to proclaim his message of universal love. He began by creating a hot air balloon bedecked with prayers. When the balloon failed, he turned to building a mountain out of adobe clay, which he coated with paint donated by visitors. Until his eighties he lived in an old fire truck parked beside the mountain. His philosophy: 'Love Jesus and keep it simple.'

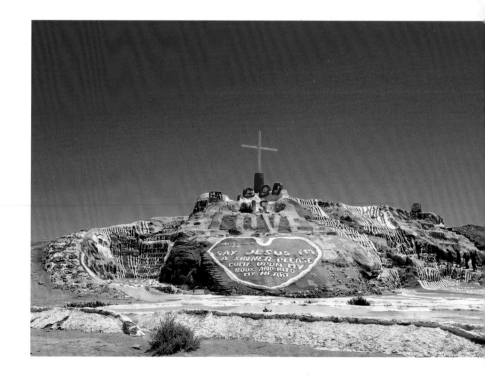

The sign reads:

MEN SLAY EACH OTHER — DEATH+HADES KILL BY SWORD, FAMINE, PLAGUE +WILD BEASTS — A GREAT EARTHQUAKE — THE SUN TURNED BLACK, THE MOON TURNED BLOOD RED — EVERY MOUNTAIN+ISLAND REMOVED FROM ITS PLACE — ⅓ OF THE EARTH, ⅓ OF THE TREES, AND ALL THE GREEN GRASS BURNED — ⅓ OF THE SEA TURNED INTO BLOOD, ⅓ OF CREATURES IN THE SEA DIED — A STAR FELL ON ⅓ OF THE RIVERS + SPRINGS — ⅓ OF THE WATERS TURNED BITTER, MANY PEOPLE DIED — ⅓ SUN, ⅓ MOON, ⅓ STARS — STRUCK — ⅓ DAY + NIGHT WITHOUT LIGHT — LOCUSTS GIVEN POWER TO TORTURE — 4 ANGELS KILL ⅓ OF MANKIND — FIRE, SMOKE, AND SULPHUR — A SEVERE EARTHQUAKE ¹/₁₀ CITY COLLAPSES — 7000 PEOPLE KILLED — LIGHTNING, THUNDER, EARTHQUAKE, HAILSTORM — UGLY+ PAINFUL SORES — THE SEA TURNED INTO BLOOD — EVERYTHING IN THE SEA DIED — RIVERS+ SPRINGS BECAME BLOOD — THE SUN GIVEN POWER TO SCORCH PEOPLE WITH FIRE — MEN GNAWED THEIR TONGUES IN AGONY — HAILSTONES OF 100 LBS — DEATH MOURNING +FAMINE — MERCHANTS WEEP — NO ONE BUYS THEIR CARGO ANY MORE — BIRDS EAT THE FLESH OF ALL

△ **KEVIN SCHMIDT** CANADA

A Sign in the Northwest Passage, 2010

The construction of Schmidt's sign, made to look like a relic,
takes us back to the Klondike Gold Rush, recalling our long history
of plundering the earth, including the contemporary search for 'black
gold' through arctic drilling. The sign's rudimentary handwriting
also recalls the works of folk artists such as Sister Gertrude Morgan
and Howard Finster, famous for their illustrations of Revelation.
Yet Schmidt has no need to conjure terrifying images, the spectre
of climate change does it for him.

△ **DARREN ALMOND** BRITISH

Present Form Exposed, 2013
C-print, left and right: 304.8 x 140.7 cm (120 x 55⅜ in.),
centre: 304.8 x 179.7 cm (120 x 70¾ in.)

Almond took this photograph at the Perito Moreno Glacier in
Argentine Patagonia during a journey in which he retraced parts
of Charles Darwin's voyage on HMS *Beagle*. 'This is a moment
when daylight has hit the ice for the first time,' explains Almond.
'The fresh reveal of ice and the blues that you see is the prehistoric
ice.' While enchanting on the one hand – like a Caspar David
Friedrich painting – the triptych conveys the haunting future of
a warming planet.

▽ **ANGELA PALMER** UK

Ghost Forest, 2009
10 rainforest tree stumps
Installation view, Trafalgar Square, London

'I found the huge great Denya [tree] lying by the roadside deep
in the forest,' recalls Palmer. 'Its root ball spanned nearly 30 feet.
I knew immediately that if I could somehow haul this magnificent
great beast to the feet of Nelson's Column in London it would be
electrifying. I thought the roots looked like the nerve endings of the
planet.' Palmer's description, and the trees themselves, are explicitly
anthropomorphic, encouraging us to mourn them, and the loss
they signify.

▷ **HENRIQUE OLIVEIRA** BRAZIL

Tapumes – Case dos Leões, 2009
Installation, plywood and PVC
VII Bienal do Mercosul, Porto Alegre

In Portuguese, *tapume* means 'wood
fencing' or 'boarding'. Oliveira first started
reassembling layers of discarded plywood
after noticing the material around
construction sites in São Paulo, and its use
by the city's poorer residents to cover houses
in the *favelas*. On the one hand, Oliveira's
method of 'transubstantiation' – as he called
a 2013 work – celebrates the ingenuity of the
favelas. On the other hand, says Oliveira, it
calls attention to the way some regard them
'as a kind of tumour'.

108

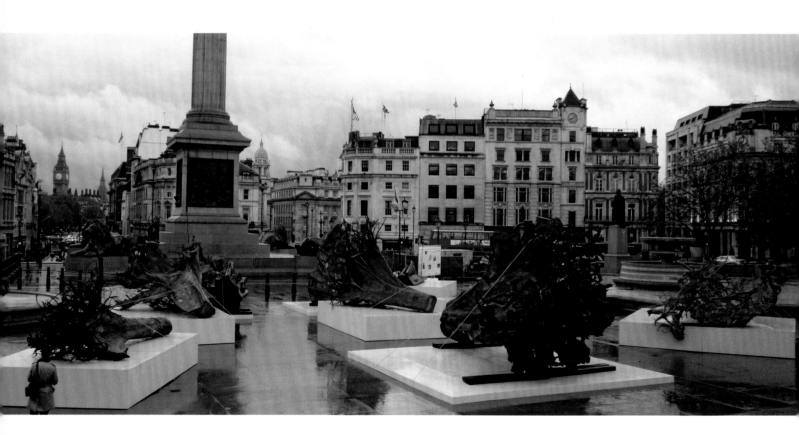

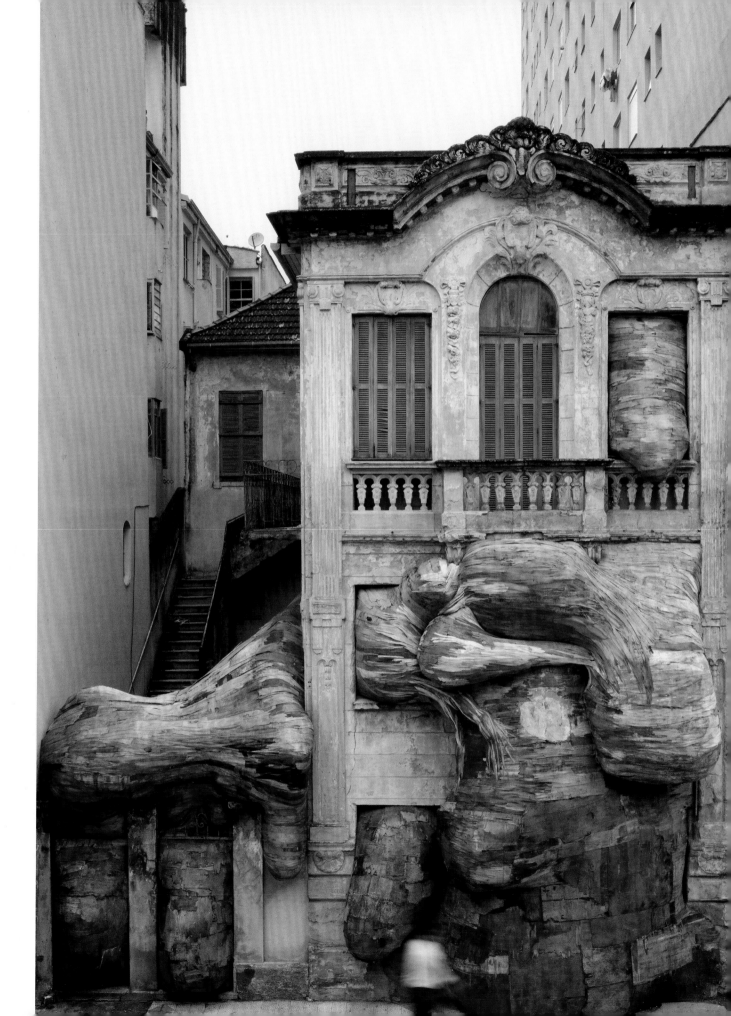

▽ **SAM VAN AKEN** USA

'Tree of 40 Fruit' project, 2008–ongoing
Artist's rendering of how one of the trees could look (16 real trees exist)

Sam Van Aken describes his work as 'sculpture through grafting',
in this case splicing together branches of assorted stone fruit trees
including plums, apricots, peaches, and nectarines. He explains
that the 'number 40 has been used throughout Western religion
to represent a number beyond counting', and hopes to convey
a similar 'idea of a bounty of fruit'. He also compares his process
to 'transubstantiation', invoking the sacrament of communion
in which bread and wine become the body and blood of Christ.

▷ **JEAN-PAUL GANEM** FRANCE

Le Jardin des Capteurs, 2000–2002
Agricultural composition spreading over 2.5 hectares
(6.17 acres), Montréal

The gardens occupy a landfill site containing human
waste, which still emits methane from pipes at the
centre of the multi-coloured circles. The artist
first assembled team of volunteers to clean up the
soil and make it suitable for planting. Community
and environmental regeneration become mutually
reinforcing. As Ganem says about another project,
'looking at a place that used to house something
completely contaminated and devastated and seeing
something beautiful works as an agent of change'.

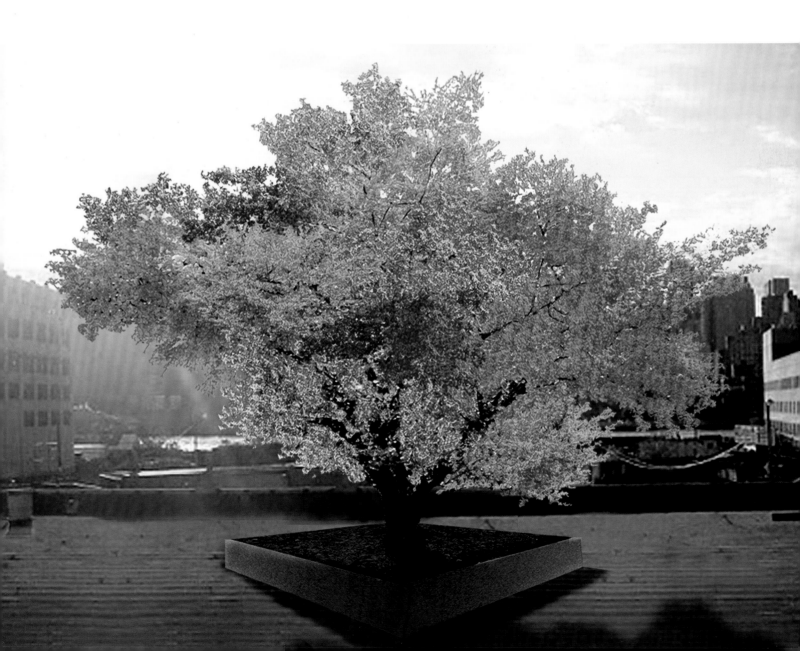

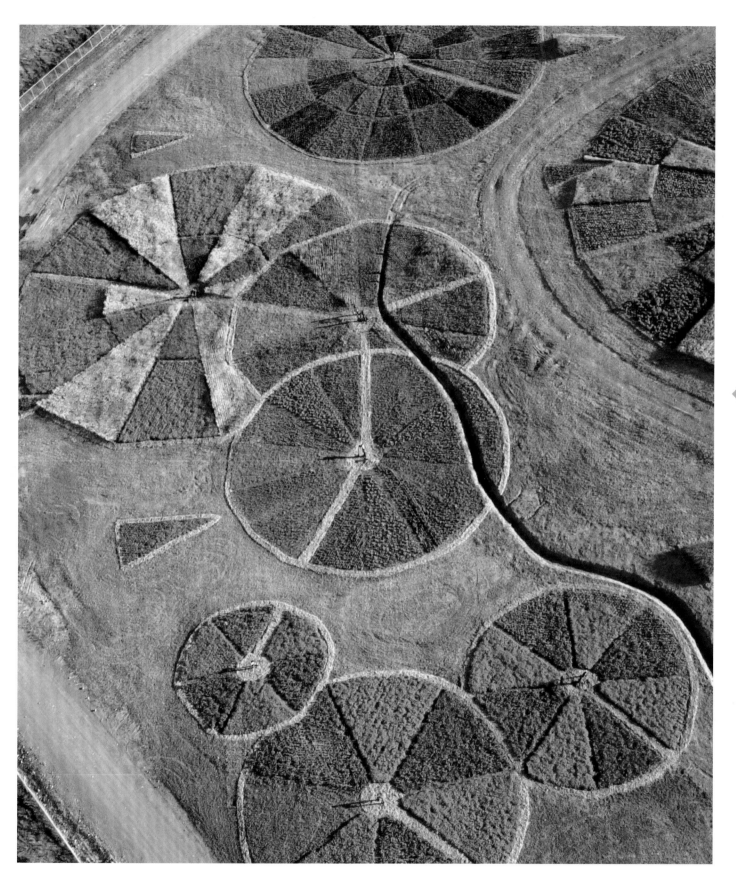

PART III) cultural identities

5 ♦ CREATIVE DIFFERENCES

6 ♦ CONFLICTING IMAGES

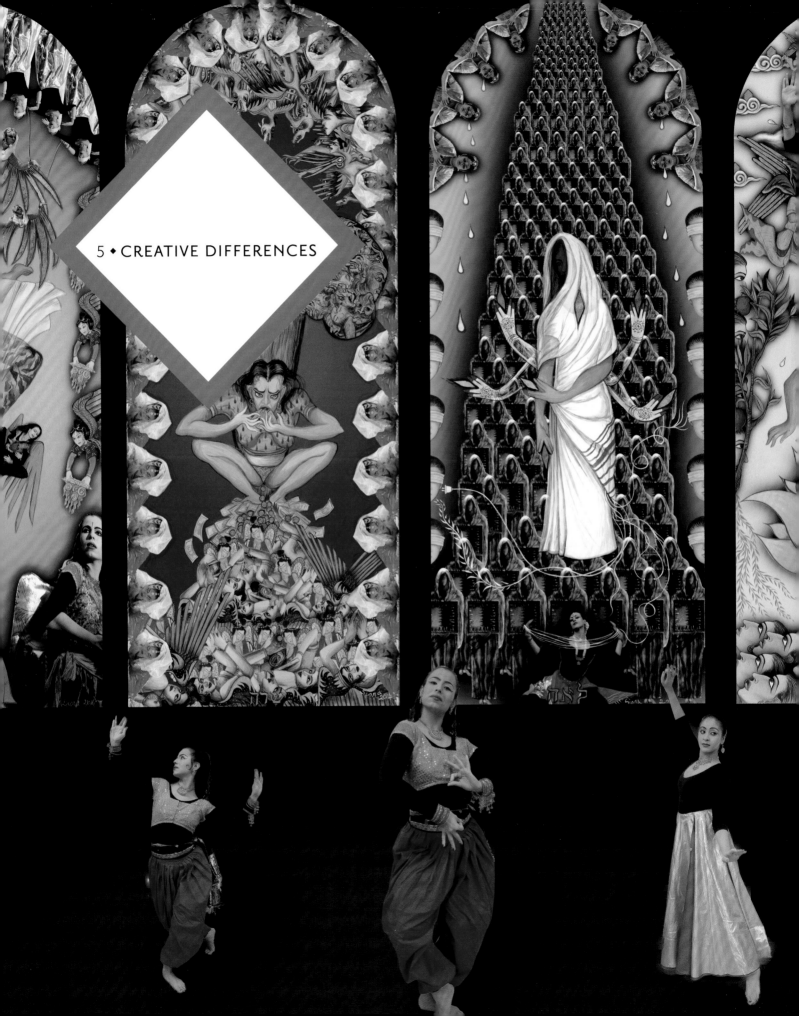

5 ◆ CREATIVE DIFFERENCES

+ In the preceding chapters, we let questions of cultural identity percolate while we trained our attention on theological and philosophical issues. Now it is time to deal with questions of culture more explicitly. But we need to tread carefully. The late Stuart Hall, a seminal figure in British cultural studies, reminds us that even the term 'cultural identity' is itself fraught with complications. He writes:

> Perhaps instead of thinking of identity as an already accomplished fact, which the new cultural practices then represent, we should think, instead, of identity as a 'production' which is never complete, always in process, and always constituted within, not outside, representation. This problematizes the very authority and authenticity to which the term 'cultural identity' lays claim.

Heeding Hall's advice, in this chapter I want to explore some of the ways in which contemporary artists have probed the processes of identity production. Our focus will be on those cultural dilemmas and encounters that fall under the umbrella of postcolonial studies, which in its broadest sense attempts to give voice to the experiences of communities that historically have been excluded or marginalized for being ethnically, religiously, or otherwise 'Other'. It would be painfully ironic if we set out by lumping all differences together, as if indigenous Australians and European Jews, for instance, share the same experiences. But it *is* possible to identify some related visual strategies and mechanisms for dealing with marginalization and disenfranchisement. In unique but related ways, the artists in this chapter destabilize designations like normal, pure, native, original, and authentic, engaging in a mixed and fluid process of identity-making. However static any culture might seem, we need only place it under the microscope – to borrow an image from Michal Rovner – to see it squirming with life in all its organic complexity.

115

◀ **SIONA BENJAMIN** INDIA/USA
Detail of *The Four Mothers Who Entered Pardes*, 2014

▷ **EL ANATSUI** GHANA

In the World But Don't Know the World, 2011
Aluminium and copper wire, 560 x 1000 cm
(220½ x 393¾ in.)

Anatsui began using bottle tops after
finding some discarded behind his
studio in Nigeria, near a large distillery.
These used caps might signify the
economic disenfranchisement of people
on the margins, and yet – woven into
Anatsui's tapestries – they also signal
transfiguration. To be in the world and
not know it may denote both absolute
rejection on earth and, at the same time,
absolute acceptance into a celestial
kingdom not of this world (John 18.36).

PART III 〉 cultural identities

No one inscribes their identity on a blank slate, least of all artists.
From the start, a host of preconceptions, stereotypes, and outright
prejudices ascribe value – both positive and negative – to every facet and
mode of representation. In some cases, we can identify an over-arching
ideology at play. One of the most pervasive is Orientalism, made infamous
by Edward Said in his eponymous monograph of 1978. While Said has
been challenged on various fronts, his central intuition remains relevant:
'as much as the West itself, the Orient is an idea that has a history and a
tradition of thought, imagery, and vocabulary that have given it reality
and presence in and for the West. The two geographical entities thus
support and to an extent reflect each other.' In other words, the West
needs the Orient – or more precisely its *fabrication* of the Orient – to
reinforce its own self-conception as rational, fair, and in every way
normative. For its part, the Orient – in particular the Middle East and the
Indian subcontinent – receives the dubious distinction of being exotic.
This prejudice has been particularly potent when it comes to visual art,
with traditional forms such as Mughal and Persian miniature painting
both celebrated and denigrated on the basis of their perceived exoticism.
Shahzia Sikander recalls that when she went to art school in Pakistan most
of her peers had thoroughly imbibed the notion that miniature painting
was outdated 'kitsch' for tourists. It 'supposedly represented our heritage
yet we reacted to it with suspicion and ridicule', she recalls. Studying a
tradition 'laden with issues of imperialism', and claiming it as a viable
form of modern art, she says, constituted 'an act of defiance'. For Siona
Benjamin, a Jewish artist who grew up and trained in Mumbai, there is an
added wrinkle. Frequently stereotyped in America as Hindu or Muslim,
Benjamin uses the language of miniature painting to affirm her Indian
heritage in a way that simultaneously celebrates her Jewish identity.

In some situations it is possible to contest the discourses of
discrimination directly. However, the capacity to identify these discourses
– let alone dispute them – already indicates a certain level of agency: one
unimaginable to many of the world's most marginalized populations. In
a celebrated essay first published in the mid-1980s, and revised multiple
times since, the philosopher Gayatri Chakravorty Spivak asks a profound

question: 'Can the Subaltern Speak?' By subaltern, Spivak means those beyond the excluded 'Other' usually envisioned by scholars (a designation she finds problematic in its own right). Spivak demands that we turn our attention to 'the margins (one can just as well say the silent, silenced centre). . .men and women among the illiterate peasantry, the tribals, the lowest strata of the urban subproletariat'. An increasing number of contemporary artists have been concerned with addressing just such populations, asking how – if at all – the voice of the powerless might be heard across the chasm of privilege, to use an image from Doris Salcedo. Jim Denomie paints an America overflowing with the peoples it uprooted and exterminated, inverting images of empty territory waiting to be colonized. Gordon Bennett, meanwhile, satirizes the 'primitive'

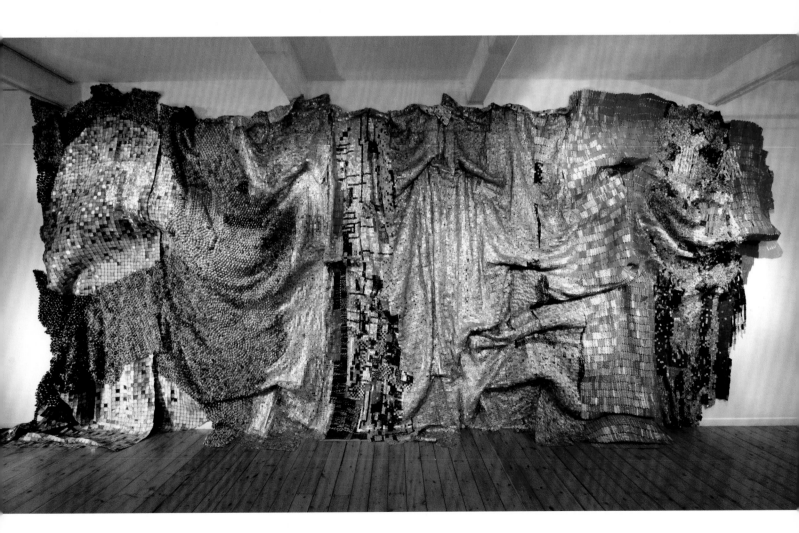

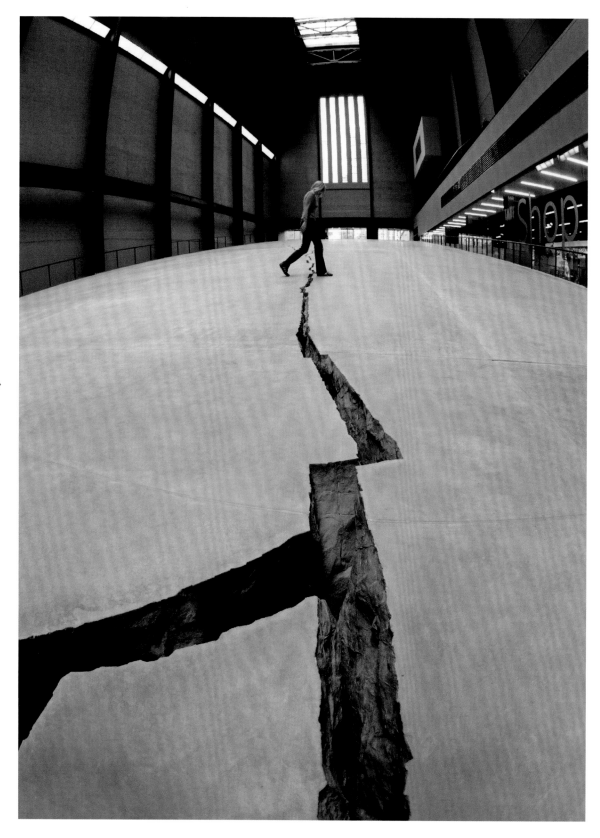

DORIS SALCEDO COLOMBIA

Shibboleth, 2007–8
167-metre (548-foot) long crack in the Turbine
Hall's floor, Tate Modern, London, 2008

Salcedo's fault line ran the length of Tate
Modern's Turbine Hall. Its path can still
be traced in the repaired floor, like scar
tissue. *Shibboleth* recalls the biblical
episode in which those unable to
pronounce 'shibboleth' correctly at a
border are slain as traitors (Judges 12.5-6).
Salcedo says the work 'represents
borders, the experience of immigrants,
the experience of segregation, the
experience of racial hatred. It is the
experience of a Third World person
coming into the heart of Europe.'

logic of racists in Australia, who equate aboriginals with animals. The paradoxical position of the subaltern is perhaps best expressed in the title of a work by El Anatsui: *In the World But Don't Know the World* (2011). While none of these artists answer Spivak's question, like her they find a way to speak about the incapacity to speak.

If the dilemma of the subaltern is whether one can speak at all, for other postcolonial communities the problem is *which* language to speak. Critical theorist Homi Bhabha draws our attention to the complicated position of such groups:

> [They] may be contingent to modernity, discontinuous or in contention with it, resistant to its oppressive, assimilationist technologies; but they also deploy the cultural hybridity of their borderline conditions to 'translate', and therefore reinscribe, the social imaginary of both metropolis and modernity.

As Bhabha recognizes, people can speak in multiple registers at the same time. They can reject and dispute the language of colonialism on the one hand, and find fresh ways of adapting it on the other hand. Borders can be exclusionary and oppressive, but they can also be sites of creativity, in which people act out their 'hybridity'. Visual art provides a plethora of examples. Harminder Judge depicts himself as both Hindu god and eighties rock star, while Romuald Hazoumè makes traditional Yoruba masks with industrial cast-offs. Diego Romero mixes Pueblo pottery with references to classical amphorae and modern comics, while Norman Akers and Shirley Purdie blend indigenous imagery with Christian iconography. Indeed, Purdie's matter-of-fact description of her practice provides the perfect synopsis of hybridity: 'Two-way is our culture'.

The challenge for many marginalized communities is not only external – how to relate to other groups, especially those in positions of hegemony – it is also internal. How, for instance, does a community maintain cohesion amidst adversity and diversity, especially far away from a self-conceived homeland? This is the domain of diaspora studies. The word 'diaspora' derives from the Greek, meaning a scattering or

119

5 ♦ CREATIVE DIFFERENCES

▽ **YAEL BARTANA** ISRAEL

Mary Koszmary, 2007
One channel super 16mm film transferred to video,
duration: 10 mins 50 secs

'My family comes from [Poland], but they
never talked about it. We were completely
cut from that history,' reflects Bartana,
'I had this idea of looking at ways to provoke
new thoughts about the situation today
between Poland and Israel. . .[and] the
Palestinian right of return.' In the film,
a Polish leader cries out to an empty stadium:
'Let the 3 million Jews that Poland has
missed. . .[return] to your country! . . .
Heal our wounds and you'll heal yours
and we'll be together again.'

dispersion. It was originally used to describe the situation of the ancient
Israelites following their captivity in Babylonia, but it has since come
to refer to Jews living anywhere in the world outside of Israel. For some
Jews, the diaspora has pejorative connotations, representing a state of
theological or cultural exile from a Jewish homeland. For others, it is
explicitly positive. Daniel and Jonathan Boyarin even go so far as to call
the concept of diaspora 'the most important contribution that Judaism
has to make to the world', praising the way it detaches the notion of
peoplehood from property and power. The painter R. B. Kitaj believed
diasporic Judaism was not only ethically commendable but creatively
fruitful too, coining the term 'Diasporist art'. Today, a number of artists
are answering his call for an art 'in which a pariah people, an unpopular,
stigmatized people, is taken up, pondered in their dilemmas'. Kehinde
Wiley addresses the complex issue of diasporic identity *within* Israel,
especially for Ethiopian Jews, for whom living in a Jewish state means

120

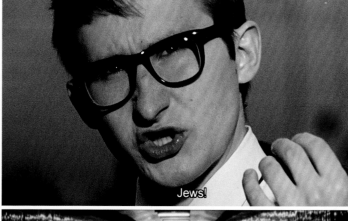

living in an Ethiopian diaspora. Aithan Shapira probes what it means to leave Israel, to belong not just to a Jewish diaspora, but to an Israeli diaspora, a relatively new phenomenon. Perhaps most challengingly, Yael Bartana imagines what the psychic repercussions would be if Israeli Jews suddenly returned *en masse* to Poland, where more than three million Jews were murdered during the Holocaust.

While Kitaj's concept of Diaporist art sprang from his sense of Jewish identity, he was always clear that Jews 'are not the only Diasporists by a long shot. They are merely mine.' Kitaj was particularly vocal about the need for art to address the African diaspora created by slavery, and would have immediately recognized the subversive subtext of Yinka Shonibare's *Nelson's Ship in a Bottle* (2010), displayed opposite Nelson's Column in Trafalgar Square. While Shonibare's replica of the *HMS Victory* honours Britain's naval triumphs, the African fabric of its sails signals the shameful flip-side of the country's maritime dominance: its leading role in the slave trade. In fact, Shonibare's sculpture tangibly embodies Paul Gilroy's suggestion of the ship as a symbol for the experiences of the 'black Atlantic'. For his part, Shaun Tan reminds us that even voluntary journeys can be painful, using wordless, surreal images to capture the unsettling experience of moving to a foreign land. If art attunes us to the traumas of displacement – whether of ourselves or others – it also provides reassurance. Thus, the jumbled letters of Jaume Plensa's *Nomade* (2007) evoke the disorientation of migration while holding us in an airy embrace. If dislocation breeds creativity, as so many of the artists and thinkers in this chapter propose, there is always hope. For in art we may create a home.

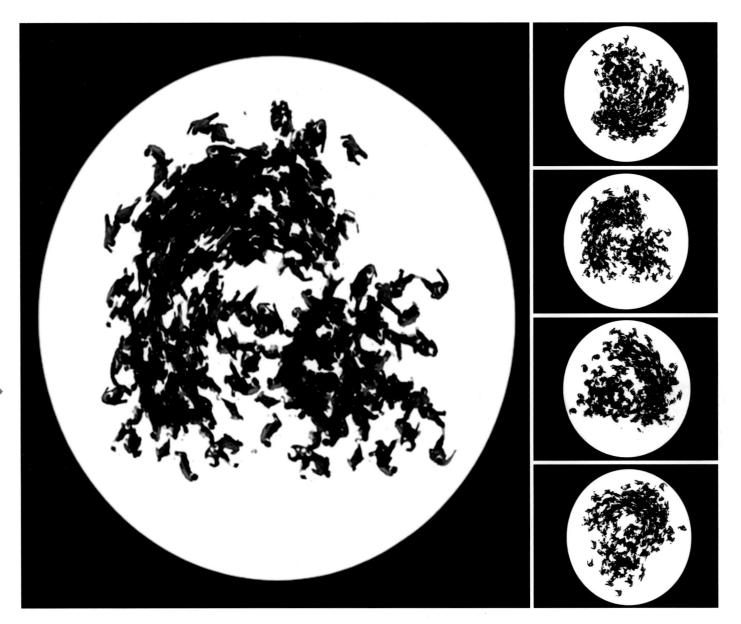

△ **MICHAL ROVNER** ISRAEL/USA
Culture Plate #4, 2003
Video projection, 121.9 cm (48 in.) diameter

Like a scientist placing a petri dish of 'live cultures' under a
microscope, Rovner turns a clinical eye on humanity, filming people
marching, dancing, and wandering like hundreds of tiny microbes.
In 'Notes', her condensed human figures on a musical notebook
appear like moving notes. In the series 'In Stone', human figures are
projected on old stone slabs, resembling a primitive script magically
come alive. Each reduction emphasizes her subjects' similarities,
while simultaneously inviting us to look for the slightest markers
of difference.

△ **SHAHZIA SIKANDER** PAKISTAN/USA

SpiNN, 2003

Video animation, duration: 6 mins 38 secs

'*SpiNN* (2003) is a pun on the cable channel CNN,' writes Sikander.
'It depicts a mass of spiraling, abstracted forms, hovering like a swarm
of angry black crows or bats that coalesce into the image of a Mughal
durbar hall (the space where the Indian emperor would meet his
ministers or subjects). The hall is incongruously populated by gopi
women (devotees of Krishna), whose black hairdos comprise the
central motif. This "hair bird" is a symbolic representation of
feminist agency.'

▷ **SHAUN TAN** AUSTRALIA

The Station, 2006

Pencil on paper from *The Arrival* (Hachette
Children's Books, 2006)

'I have a recurring interest in notions of
"belonging", particularly the finding or losing
of it,' reflects Tan. Half-Chinese, he grew up in
Perth with 'a vague sense of separateness, an
unclear notion of identity or detachment from
roots, on top of that traditionally contested
concept of what it is to be "Australian", or
worse, "un-Australian".' Echoing the Bible
(Exodus 2.22, 22.21), Tan suggests 'We might
do well to think of ourselves as possible
strangers in our own strange land.'

◄ **JIM DENOMIE** USA/OJIBWE

Eminent Domain: A Brief History of America, 2011
Oil on canvas, 213.4 × 365.8 cm (84 × 144 in.)

Calling himself 'a product of the assimilation campaign', Denomie grew up in Minneapolis with little knowledge of the traditions of his ancestors from the Ojibwe tribe in northern Wisconsin. Refusing to paint a stereotypical, romanticized Indian experience, Denomie found he had to develop his own way of articulating his identity. Here he skewers the false optimism of American multi-culturalism, painting an America whose real achievement is a 'diversity' of persecutions, from lynchings to forced conversions.

△ **SIONA BENJAMIN** INDIA/USA

The Four Mothers Who Entered Pardes, 2014
Mixed-media panels, four silk banners: each 213 × 91 cm (84 × 36 in.)
Artist residency, LABA, New York City, 2014

'Growing up in a predominantly Hindu and Muslim society, educated in Catholic and Zoroastrian schools, raised Jewish in India and now living in America,' writes Benjamin, 'I have always had to reflect upon the cultural boundary zones in which I have lived.' The artist routinely depicts herself in blue. On the one hand she evokes the cerulean skin of the deity Krishna, linking her to India, while also signifying her identity as a 'Jewish woman of colour' in America.

clan
breed
family
gens
house
kith & kin
nation
race
tribe
team

ancestry
descent
extraction
generation
birth
origin
genealogy
family tree
genealogical
tree
herd-book

studbook
pedigree
blood

heredity
inheritance
line

breed strain type

Animism, 2003
Acrylic on linen, 182 x 152 cm (71⅝ x 59⅞ in.)

Unaware of his indigenous heritage growing up, Bennett came to find it the orienting point of his identity. 'My mother is an indigenous Australian and her mother before that and so on for countless generations. My father was English. My work comes out of small town and suburban Australia. . .where attitudes to indigenous people still seemed entrenched to a social Darwinist level. From cocktail parties to workplace parties, predominantly derogatory opinions are exchanged about indigenous people with unquestioning ease and assurance.'

▷ **SHIRLEY PURDIE** AUSTRALIA

Stations of the Cross, 2007
Natural ochres and pigment on canvas,
213 x 115 cm (83⅞ x 45¼ in.)

In the 1970s, Catholic nuns began to work with elders from the Warmun community to found schools and foster worship that combined elements of *Ngarrangkarni* (Dreaming) and Catholic theology. This syncretism is embodied in the silhouette of the sacred stone formations that frame each Station of the Cross. The torments Purdie depicts are not those of Christ alone, they also refer to the trauma of her people, many of whom were massacred by white settlers in the 1920s and 1930s.

Self Portrait after Kali & Gene, 2009
C-print, 80 x 120 cm (31½ x 47¼ in.)

Judge was born in Britain into a Sikh family. He grew up fascinated
with Western popular culture and Eastern spirituality. He adds,
'I would cite religious symbolism, obscure historical figures and the
rituals of cults among my many influences, as well as science fiction,
Norwegian Death Metal, & Buddha.' Dressing as a mixture of Kali –
the goddess of death and destruction – and Gene Simmons of Kiss
(aka The Demon) – Judge parodies the tendency to see the 'Other'
as wild, threatening, and exotic.

▷ **ROMUALD HAZOUMÈ** BENIN
Liberté, 2009
Plastic, porcupine quills, and fabric, 31 x 51 x 25 cm
(12¼ x 20⅛ x 9⅞ in.)

'Today, if you want to see the old masks from
Africa,' says Hazoumè, 'you need to go to the
British Museum or shops in Paris and London.
So I make new ones with the rubbish people
send to us from Europe, and I send them back
to galleries with my culture inside them. We
in Africa are losing our culture and if we lose
it, we're dead.' His 'Lady Liberty' reproaches
Western capitalism while lending Africa a
crown of thorns.

▽ **AITHAN SHAPIRA** ISRAEL/USA
Migration, 2012
Oil with Israeli earth and olive tree ash on canvas,
167.6 x 276.9 cm (66 x 109 in.)

'My own heritage is rooted in Jerusalem,
where ten generations of my family have
lived,' says Shapira, who grew up in America.
Migration – created with paints mixed with soil
from the Judean desert – is a work about both
Jewish history at large and family history.
He recalls: 'I watched my mother failing to
replant her childhood Israeli garden for
nearly thirty years in the rejecting soil and
climate of our "temporary home" 40 km west
of New York City.'

▷ **NORMAN AKERS** USA
Rebirth 2000, 2000
Oil on canvas, 167.6 x 152.4 cm (66 x 60 in.)

The body of a mutilated oak tree – a central image in Osage creation
stories – hangs in the sky, while wooden telephone poles stretch
towards the horizon. Have connections to the past been severed
to create lines of communication in the present? Or perhaps the
telephone poles are really crucifixes. If so, are they sources of hope, or
is true rebirth to be found in the acorn in the foreground? In his words,
Akers gives us 'hybrid symbols'.

▽ **YINKA SHONIBARE MBE** UK/NIGERIA

Nelson's Ship in a Bottle, 2010
Fibreglass, steel, brass, resin, UV ink on printed
cotton textile, linen rigging, acrylic, and wood
290 x 525 x 235 cm (114⅛ x 206¾ x 92½ in.)
Fourth Plinth commission, Trafalgar Square, London

Asked about his experience living between
London and Lagos, Shonibare responds:
'Homi Bhabha's theories of hybridity come
to mind. None of us have isolated identities
anymore, and that's a factor of globalization
ultimately. I suppose I'm a direct product of
that.' His signature fabric, he says, also reflects
this hybridity. 'It was originally designed as an
Indonesian fabric, produced by the Dutch, and
the British sold it into the African market. It's
a perfect metaphor for multilayered identities.'

▷ **KEHINDE WILEY** USA

Alios Itzhak, The World Stage: Israel, 2011
Oil and gold enamel on canvas, framed 293.4 x 203.5 x 6.4 cm
(115½ x 80⅛ x 2½ in.)

In this series, 'The World Stage: Israel', Wiley wanted to 'chart the
presence of black and brown people throughout the world'. Here
he portrays an Ethiopian Israeli Jew against a backdrop of Jewish
ceremonial art. 'One of the interesting features of Israeli society is
that there are so many aspects to the diaspora,' he says. '[T]here
is a strong correlation between being on the margins of society as
a person of colour in America and that which we see in the streets
of Israel.'

Fallen, 2009
Earthenware, 12.7 x 34.9 x 34.9 cm (5 x 13¾ x 13¾ in.)

'Am I this white kid who grew up in Berkeley [California],' Romero
asks, 'or am I this Johnny-come-lately back to the village born-again
Indian? And I really think I'm neither and both.' He sees his work as
a postmodern take on the tradition of native pottery, which he says
'was primarily used for the spiritual needs of the people'. His fallen
angel reaches back to this sacred past while lamenting the present,
in which alcoholism is prevalent in indigenous communities.

△ **JAUME PLENSA** SPAIN

Nomade, 2007
Sculpture, painted stainless steel, 800 x 550 x 530 cm (315 x 216½ x 208⅝ in.)
Installation view, Bastion Saint-Jaume, Musée Picasso, Antibes (France)

Plensa comments: 'My dream. . .in that piece was to try to show that
our body is a very beautiful architecture itself and it's a container. . .
[like] skin, with all our memories [and] culture inscribed like tat-
toos. . . .When people walk inside they have this beautiful feeling
that [they're] protected like a big mum. . . .In every place the piece
is changing, the piece is new. . . .It represents quite well our world
which is a bit [like] nomad people travelling around.'

6 • CONFLICTING IMAGES

+ Wars have always been waged through images. The technological wizardry of today – with slick, high-resolution videos of missile and drone strikes beamed across the globe – may be new, but the impulse to broadcast missions (un)accomplished hardly began with George W. Bush. Long before America crowed over the success of its 'Shock and Awe' campaign in Iraq, the Assyrian King Sennacherib chiselled his conquests into the Lachish reliefs (710–692 BC), just as centuries earlier the Sumerians celebrated their own military might in the *Standard of Ur* (2600–2400 BC). But while artists of the past had little choice but to recapitulate official narratives, modern artists have – at least at times – found ways to take a more critical approach to the conflicts around them. A watershed moment arrived in the nineteenth century, when Francisco de Goya depicted the atrocities in Spain following the French invasion. Goya's painting *The Third of May 1808* (1814) and his print series, 'The Disasters of War' (1810–20), set an uncompromising artistic and moral standard for future artists, some of whom have adapted (Yan Pei-Ming), and even physically altered his works (Jake and Dinos Chapman).

What is particularly noteworthy for us is the way in which Goya treated religion and violence. On the one hand, Goya delivered a withering critique of the role religious figures and ideologies played in war. On the other hand, he employed religious iconography to honour those who had sacrificed their lives for others. Goya would probably have agreed with the words of the contemporary theorist René Girard: 'Religion shelters us from violence just as violence seeks shelter in religion.' It is precisely this ambivalence that I want to explore through the works of art in this chapter.

137

◁ **SHILPA GUPTA** INDIA
Blame, 2002–4

▷ **HASSAN MUSA** SUDAN/FRANCE

The Good Game I, 2008

Assembled textiles, 212 x 142 cm
(83½ x 55⅞ in.)

Echoing his personal history in France and the Sudan, Musa renders Eugène Delacroix's *Jacob Wrestling with the Angel* (1850–61) using patterns from African military flags. The title is ironic, for what Musa depicts is anything but a fair fight. The angel's unsportsmanlike move – dislocating Jacob's hip – receives a contemporary update, metamorphosing into the infamous head-butt delivered by Zinedine Zidane in the 2006 World Cup. Violence, Musa suggests, simmers beneath every aspect of human culture, from our myths to our pastimes.

According to the American scholar Regina Schwartz, we can trace the roots of much of the violence in Western history, and the way we talk and think about it, to a vocabulary we have uncritically inherited from scripture. 'Violence is not what we do to the Other,' she contends, '[it] is the very construction of the Other,' going on to cite various ways in which the Bible inculcates a discourse of exclusion. The Israeli philosopher Adi Ophir makes an even bolder claim. The God of the Hebrew Bible, he argues, engineers catastrophes in order to force people to turn to him for help, a pattern that Ophir believes the modern nation state has both inherited and perfected. While it can be reductive to read scriptural narratives as a direct cause of contemporary violence, Schwartz and Ophir successfully draw our attention to the multifarious forms of violence in scripture. The underlying question, of course, is what to do with this violence once we identify it. Our hermeneutic decisions (how we choose to interpret these texts) are – at the same time – ethical decisions. As Broomberg & Chanarin and Mounir Fatmi caution, the way in which we read a single passage of the Bible or the Qur'an has the possibility to ignite or defuse violence. In *Temptation* (2008) and *Tree of Life* (2005), we are forced to consider whether our original sin lies not in eating the forbidden fruit but rather our insatiable appetite for violence. And it is not just our relationship with one another that is violent. Even our relationship with God, Hassan Musa reminds us, can be one of struggle: bodily blows dealt and received like blessings (Gen. 32.22–32).

Nowhere has religion fed conflict more often and more directly than in the Holy Land, and especially the city of Jerusalem, sacred to Jews, Christians, and Muslims. As Wael Shawky and Kris Kuksi playfully reveal by reimagining the Crusades, the conflicts of the middle ages still reverberate in the present. Today the region continues to smolder, with the flames of the Arab-Israeli conflict fanned by both ancient claims of belonging and recent acts of aggression. While artists from both sides have dealt with the conflict for decades, in recent years they have played an increasingly visible role. There are a growing number of initiatives that aim to foster collaborations between Israeli and Palestinian artists, and in 2005 the Museum on the Seam was founded in Jerusalem with the

aim of 'advancing dialogue in the face of discord and encouraging social responsibility that is based on what we all have in common rather than what keeps us apart'. A number of public works have specifically tackled the separation barrier erected by Israel along the West Bank border, begun in 2002. Some, like Banksy, Yoav Weiss, and JR, have created works on the wall itself. Others have parodied the practices of boundary-making more generally, from imagining a fashion show at a checkpoint (Sharif Waked) to forging a fence from a giant cheese grater (Mona Hatoum). What is remarkable is just how funny many of these recent works are. In fact, this may be their greatest asset. What American art critic and philosopher Arthur Danto calls the 'philosophical disenfranchisement

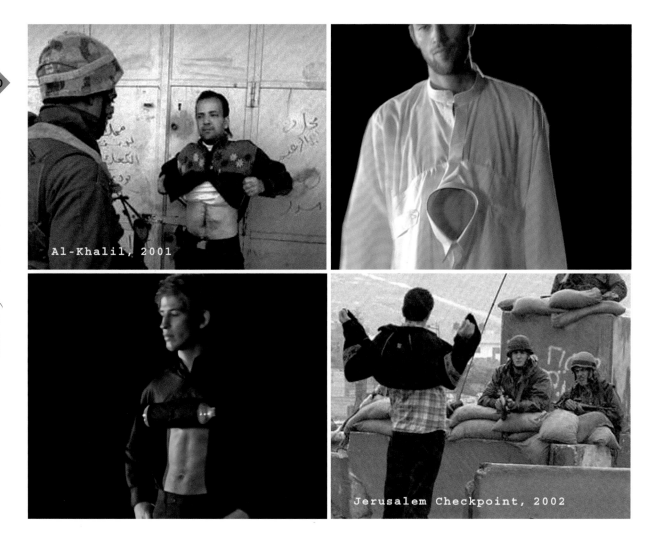

Al-Khalil, 2001

Jerusalem Checkpoint, 2002

◄ SHARIF WAKED PALESTINE

Chic Point: Fashion for Israeli Checkpoints, 2003

Video, colour, sound, duration: 5 mins 27 secs

Interspersed with photographs taken at real checkpoints, *Chic Point* shows models strutting along a catwalk wearing clothes intended to deconstruct what Waked calls the image of 'the body of the Palestinian. . .as a dangerous weapon'. While ostensibly aiding the Israeli military by designing easy-to-access shirts, Waked turns a humiliating routine into an absurd game of his own invention, in which the joke is on the soldiers, or in this case the viewer. *Haute couture* becomes political satire.

of art', which consigns art to mere entertainment, can in reality open a fresh space for dialogue, in which the stakes seem deceptively lower, and genuine dialogue can flow more easily.

A new challenge for twenty-first-century artists has been how to confront the spectre of religious extremism in the wake of the World Trade Center attacks of 11 September 2001. While an iconography for depicting the atrocities of war has existed for generations, passed down from Goya to Pablo Picasso to Leon Golub, by comparison artists have only recently begun to grapple with how to visualize terrorism. One response has been to play upon the very difficulty of depiction itself, particularly the way in which terrorist attacks today are immediately subsumed by their representation and replication across multiple media, a dynamic to which the philosopher Jean Baudrillard has called attention. Joan Snyder, Shilpa Gupta, and Imran Qureshi have each used simulated blood to speak of the trauma of terrorism, while also exposing the difference between real violence and its reproduction. Snyder takes the metaphor of *Blood on Our Hands USA* and turns it almost – but not quite – into reality, with smeared red handprints evoking the sectarian strife that followed the 2003 invasion of Iraq. Prompted by attacks and reprisals between Hindus and Muslims in India – particularly the mass murder of Muslims in Gujarat in 2002 – Shilpa Gupta seeks to expose the economy of *Blame*, by which every drop of blood, real or imagined, demands another. Imran Qureshi, meanwhile, exposes the tendency to represent Pakistan, and other Muslim countries, merely as sites of violence. From a distance, Qureshi's courtyard seems to represent the gory aftermath of a bomb blast. Yet closer examination reveals something different. What appear to be blotches and splatterings of blood delicately sprout into vines, leaves, and flowers, disclosing a land of love and beauty.

Much like the ambivalent role it has played in public, in the closed, secretive world of torture, religion has nourished captors and captives alike, inspiring equally unthinkable acts of both barbarism and resistance. But if our capacity for cruelty has remained similar throughout history, its theological value may have shifted. The philosopher Jean Améry, repeatedly tortured by the Nazis, explains:

Grater Divide, 2002
Mild steel, 204 x 3.5 cm (80⅜ x 1⅜ in.),
variable width

'[M]y family is Palestinian,' says Hatoum.
'I grew up in Beirut in a family that had
suffered a tremendous loss and existed with
a sense of dislocation.' Settling in London,
she says, 'created another kind of dislocation.
How that manifests itself in my work is as
a sense of disjunction.' *Grater Divide* could
be seen to be hinting at divisions in today's
Middle East. At another level, it speaks to
the uncanny intrusion of violence into
the everyday.

Modern police torture is without the theological complicity
that, no doubt, in the Inquisition joined both sides; faith united
them even in the delight of tormenting and the pain of being
tormented. The torturer believed he was exercising God's justice,
since he was, after all, purifying the offender's soul; the tortured
heretic or witch did not at all deny him this right. There was
a horrible perverted togetherness.

Modern torture eats away at these last vestiges of meaning: the
righteous conviction of the torturer and the consoling faith of the martyr.
In its place, suggests Améry, a more terrifying theology takes root. The
torturer's 'orgy of unchecked self-expansion' nullifies all but himself.
'For is not the one who can reduce a person so entirely to a body and
a whimpering prey of death, a god or, at least, a demigod?' Contemporary
artists have found evidence of this dark drive in many contexts, but
especially in the War on Terror. In a Guantánamo prison cell, Edmund
Clark photographed an arrow pointing simultaneously towards Mecca
and a ring for leg irons, redirecting submission from Allah to the
American military. Jonathan Hobin and Fernando Botero, meanwhile,
turn their attention to the torture of detainees in Abu Ghraib. Where
Hobin attempts to get inside the mind of the persecutor, Botero seeks
to inhabit the body of the victim. The God-complex of the tormentor,
discloses Hobin, is nothing more than a demented, childish illusion.
True divinity lies in the suffering of the innocent. However brutalized
and humiliated, Botero's detainees retain an ineradicable dignity, like
canonical images of the flagellated Christ. Religion may not be able to
end violence, but it can provide an indispensable language of lament.

△ **YAN PEI-MING** CHINA

Exécution, après Goya, 2008

Oil on canvas, 280 x 400 cm (110¼ x 157¼ in.)

In *The Third of May 1808* (1814) Goya used the iconography of the crucifixion to highlight the sacrifice of Spanish fighters. Yan not only executes his painting 'after Goya', his blood red canvas recalls the real 'execution' of political prisoners in his native China. '[Goya] allows the viewer to connect with both sides of the story,' says Yan. 'One understands the motivations of the executioners [believing they're] acting on behalf of freedom [and] the victims who sacrifice themselves for their cause.'

Insult to Injury, 2003

Francisco de Goya 'Disasters of War', from a portfolio of eighty etchings
'reworked and improved', each: 28.3 x 38.1 cm (11⅛ x 15 in.)

Too controversial to be published during Goya's lifetime, the
'Disasters of War' exist only in posthumous editions printed from his
plates. After acquiring one of the most significant editions – issued in
1937 as a protest against the fascist aggressions of the Spanish Civil
War – the Chapman brothers set about 'rectifying' the series (their
words), adding garish masks over the faces of the victims. They claim
the work exposes Goya's hypocritical pleasure, his 'predilection for
violence under the aegis of a moral framework'.

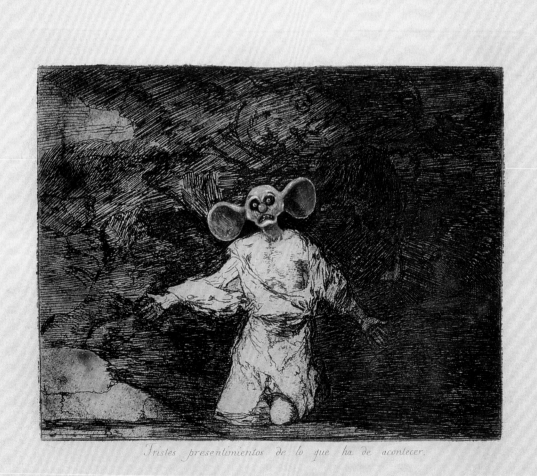

Tristes presentimientos de lo que ha de acontecer.

Connexion (Nouveau Testament), 2004–7
C-print, 75 x 100 cm (29½ x 39⅜ in.)

'The religious question is above all a question of connections,'
reflects Fatmi. 'The work plays with a paradox: danger does not seem
to lie in reading the Qur'an alone, but in connecting it with other
books. Do you risk explosion in making these connections? There is
furthermore an idea of transmission between these books. You have
the impression that there is energy passing from one book to another,
that the work generates energy.'

'Life for life, {21:24} Eye for eye, tooth for tooth, hand for hand, foot for foot, {21:25} Burning for burning, wound for wound, stripe for stripe.' Exodus 21:23. Holy Bible, Adam Broomberg and Oliver Chanarin (MACK/AMC, 2013)

Printed book

Recalling Bertolt Brecht's annotations of his personal Bible, the duo Adam Broomberg and Oliver Chanarin pasted photographs from the Archive of Modern Conflict, London, into the King James Bible. Here they respond to the punishments for crimes against people and property outlined in Exodus. What does 'eye for eye' really mean, they ask? Can we even tell victim from perpetrator? In a world of nuclear weapons, they seem to suggest, retributive justice will end with the destruction of life on earth.

◁ **KESTER, HILARIO NHATUGUEJA,**
FIEL DOS SANTOS, AND ADELINO
SERAFIM MATÉ MOZAMBIQUE
Tree of Life, 2005
Sculpture made from decommissioned weapons in
Maputo, Mozambique, height 350 cm (137¾ in.)

This sculpture belongs to a series of works
created through 'Transforming Arms into
Tools'. Founded by an Anglican bishop and
supported by Christian Aid, the initiative
encourages Mozambique's citizens to trade in
weapons from the country's devastating civil
war (1976–92) for domestic and agricultural
implements. This fulfils the biblical prophecy:
'they shall beat their swords into plowshares,
and their spears into pruning hooks; nation
shall not lift up sword against nation, neither
shall they learn war any more' (Isaiah 2.4).

▽ **AWST & WALTHER** WALES AND GERMANY
Temptation, 2008
Sculpture, plaster and gold leaf, 20 x 10 x 8 cm (7⅞ x 3⅞ x 3⅛ in.)

The husband and wife team Manon Awst and Benjamin Walther are
known for both their performance pieces and sculpture. According
to the artists, they were drawn to the 'ambivalence surrounding the
apple, [which] represents an act of corruption, the fall from grace, but
also the beginning of civilisation and the birth of love.' Which is the
greater temptation, they seem to ask, lust or violence? Are the two
connected? And how do we gild and glamorize them both?

Cabaret Crusades: The Path to Cairo, 2012
HD Video, colour, sound, duration: 59 mins

This film is the second in a trilogy in which marionettes act out episodes from Amin Maalouf's study, *The Crusades through Arab Eyes* (1984). While its songs and dialogue are recorded in classical Arabic – even the speeches by popes – and its scenery is inspired by medieval Islamic miniatures, it was filmed in a chapel in Aubagne, a French city known for producing nativity figurines. Through this admixture, Shawky claims that he critiques 'the way history has been written and manipulated'.

The Crusades Are Coming to Town, 2010
Mixed-media assemblage, 39.4 x 38.1 x 7.6 cm (15¼ x 15 x 3 in.)

Kuksi describes his intricate assemblages of toys, dolls, and knick-knacks as 'grotesque tableaux that look a bit like an explosion in Hieronymus Bosch's attic'. He often melds religious and military motifs, most obviously in his recent 'Churchtank' series (see half-title page). According to Kuksi, 'the ideological fanaticism that humans engage in, political or religious,' can only be combated by 'embrac[ing] those dark elements, that's the only way you can know them and understand them and initially overcome them'.

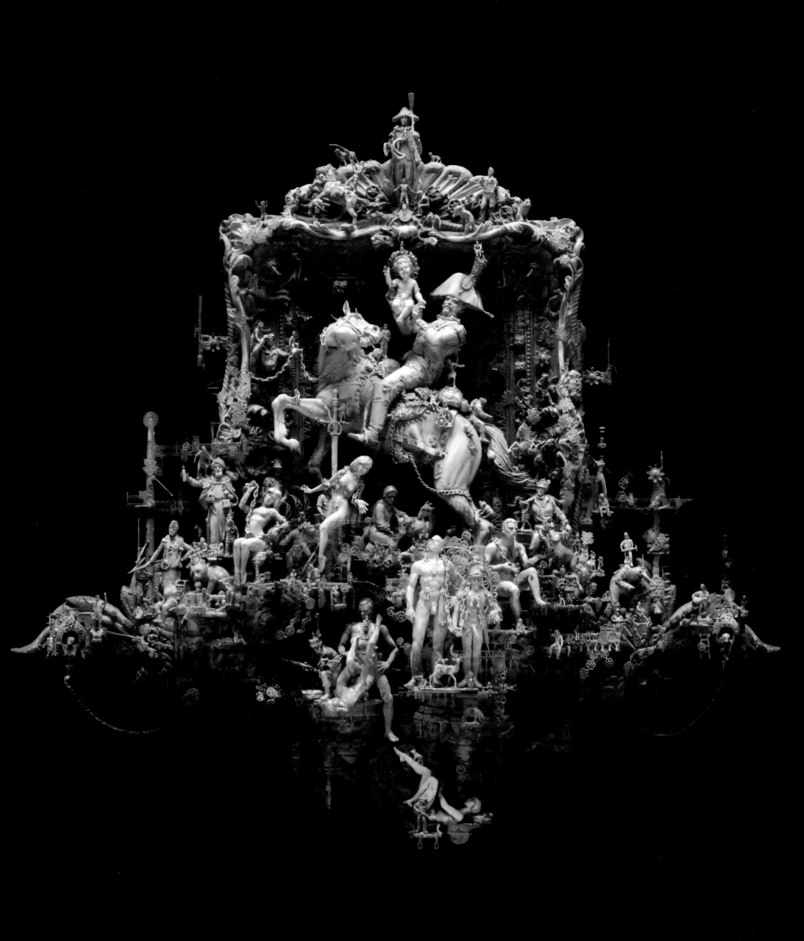

▽ **JR** FRANCE

Face2Face, 2007
Separation Wall, Palestinian side in Bethlehem,
March 2007

Noting that Israelis and Palestinians usually
only see each other through the distorting
lens of the media, JR photographed people
on opposite sides of the separation barrier
between Israel and the West Bank who
held the same jobs and would otherwise be
neighbours. '[M]ost of the time people can't
recognize who is the Israeli and who is the
Palestinian, so they couldn't recognize who
they were supposed to be,' says JR, 'they're
much more open than you think they are.'

▷ **BANKSY** UK

Graffiti on Barrier Wall, 2005
Graffiti on the West Bank barrier in Bethlehem, West Bank

This is one of nine images Banksy painted on the Palestinian side of
the barrier, which also included the trompe-l'oeil of a landscape seen
through a window and another of the barrier cracking into rubble.
The artist has spoken in general about the way graffiti can be a form
of retribution or possession, in this case allowing Palestinians to
reclaim territory, at least imaginatively.

▷ **YOAV WEISS** ISRAEL

www.BuytheWall.com, 2008–ongoing

Imagining a future in which the separation barrier will eventually
come down, Weiss invites viewers to buy sections much as tourists
today buy pieces of the Berlin Wall. Tongue-in-cheek he declares:
'If you attach legs to your section, you can make a very impressive
coffee table. Or, if you reserve a few sections, you can build a wall for
yourself in your garden, say, as a conversation piece, or if you have
a disagreement with your neighbor.'

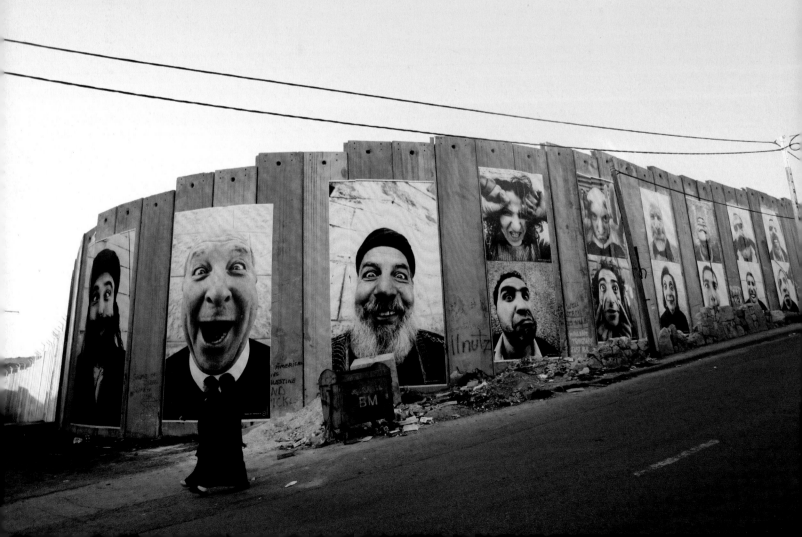

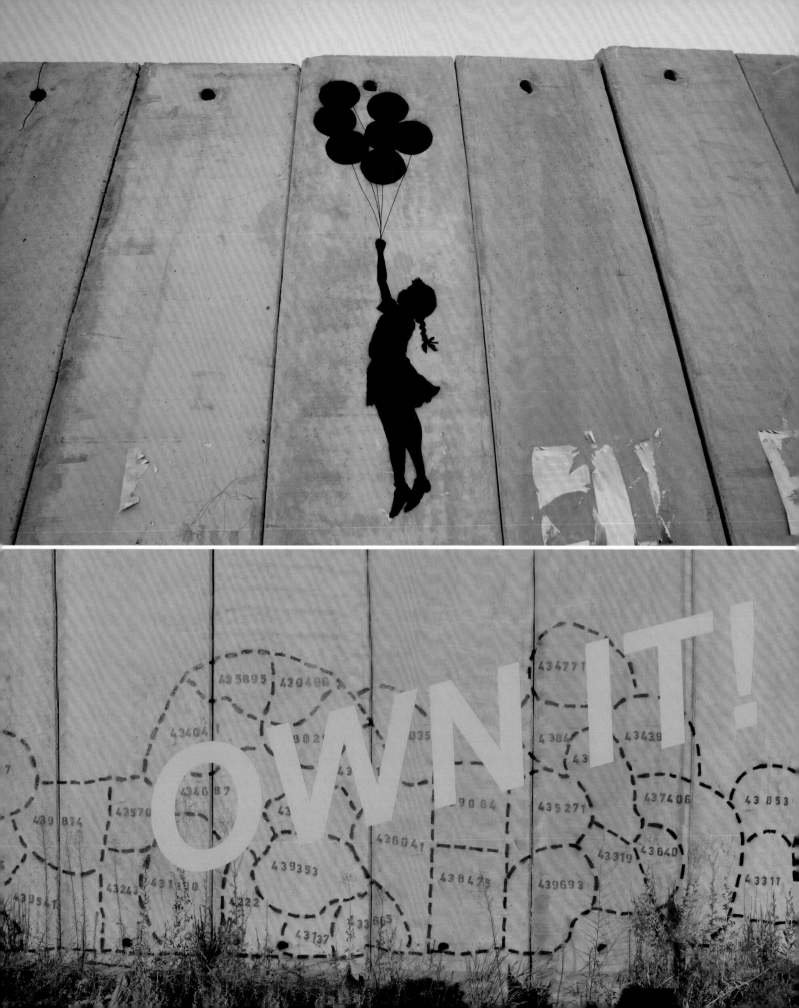

Blood on Our Hands USA, 2003

Acrylic, cloth, glitter, pencil, and photograph on panel, 40.6 x 40.6 cm (16 x 16 in.)

With all the righteous fury of a biblical prophet, Snyder cries out against the sins of her countrymen, laying blame for Iraq's sectarian violence on the US-led invasion. She has drawn explicitly on her Jewish heritage in several works, including *Morning Requiem with Kaddish* (1987–88) and *Women in Camps* (1988), referencing the Holocaust. Critics have taken issue with Snyder's political stance in some works, as well as her directness, which purportedly compromises its value as art.

PART III ⟩ cultural identities

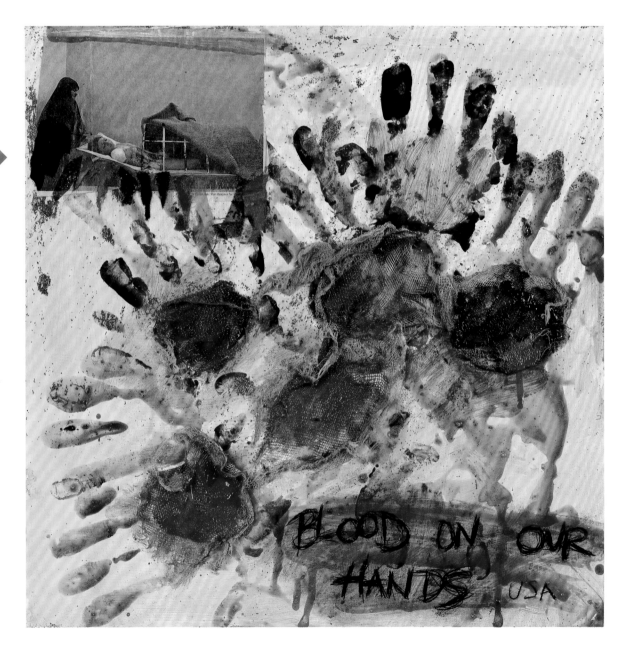

△ **IMRAN QURESHI** PAKISTAN

Blessings Upon the Land of My Love, 2011
Acrylic and emulsion paint
Installation view, Sharjah Art Biennial 10

'[The] red that I have been using in recent years can look so real, like blood,' says Qureshi. 'The red reminds me of the situation today in my country, Pakistan, and in the world around us, where violence is almost a daily occurrence. But somehow, people still have hope. The flowers that seem to emerge from the red paint in my work represent the hope that – despite everything – the people sustain somehow, their hope for a better future.'

▷ **SHILPA GUPTA** INDIA

Blame, 2002–4
Mixed-media assemblage, including simulated blood,
300 x 130 x 340 cm (118⅛ x 51⅛ x 133⅞ in.)

Gupta filled hundreds of medicine bottles with simulated blood, which she passed around public spaces in Mumbai. The labels on the bottles read: 'Blaming you makes me feel so good! So I blame you for what you cannot control: your religion, your nationality.' Gupta exposes the tendency of violence to displace and conceal the real objects of animosity. Rather than simply treating the symptoms of religious violence, Gupta encourages us to diagnose and cure the cancer at its root.

A Boo Grave, 2010
C-print, 98.5 x 138 cm (38⅛ x 54⅜ in.)

In his series 'In the Playroom', Hobin photographs kids re-enacting a range of disturbing events, from the attacks of 9/11 to the murder of JonBenet Ramsay. '[N]ews stories have become our fairy tales,' says Hobin, 'and nothing is private now, there are cameras everywhere. Play is how kids process information. By making these pictures, I and they are trying to make sense of what the media shows us. . . .And these pictures serve a purpose, as a moral, as a warning, just the way nursery rhymes did.'

△ **EDMUND CLARK** UK

Camp 4, arrow to Mecca and ring for ankle shackles, 2009

This photograph belongs to the series 'Guantánamo: If the Light
Goes Out', which Clark began by photographing former Guantánamo
detainees – many of whom had been held for years without evidence
– in their homes. Later, he began shooting the detention camp itself.
'We've seen lots of pictures of people in orange jumpsuits,' he says,
'[which] just reinforces our paranoia, our fear and our suspicion.
I wanted to go and photograph areas of personal space. . .[to make]
people think beyond the representations, the demonizations, and the
process of dehumanization that these people went through.'

PART IV) ritual

7 ◆ PERFORMANCE RITES

8 ◆ STRUCTURE AND LOSS

7 ◆ PERFORMANCE RITES

+ The line between art and ritual has always been muddy. The painter Barnett Newman once declared that 'the first man was an artist', positing that our first words were poems, our first creations sculptures. While Newman clearly took some poetic license, there is a certain truth to his remarks. From the cave paintings of Lascaux to the figurines of the Cyclades, the early remains of human civilization are steeped in mystery, and it is difficult to determine whether they belong to the domain of art, religion, or both. This complicated relationship persists in the modern period. When the ceremonial art of ancient cultures and native peoples were widely exhibited in ethnographic exhibitions during the late nineteenth and early twentieth centuries, they had a profound effect on avant-garde artists – an admiration of the 'primitive' satirized by the Chapman brothers. In the same period, artists also began to assist and emulate scholars in the nascent fields of anthropology and sociology; a tradition echoed today in Jordi Pizarro's photographic series, 'The Believers Project'. And while artists have long created works of art for use in religious rites and practices, modern artists have often set out to create their own rituals, as Joseph Beuys did in a 1974 performance when he dressed as a shaman and danced around a gallery with a coyote for three days. Altogether, whether artists join, record, simulate, or create rituals, they can provide valuable insight into how, when, and why we ritualize. 'Today,' suggested theorist Catherine Bell, 'scholars may be at the point of relinquishing the idea that there can be a single theory of ritual, for ritual may not be any one thing.' As our conception of ritual becomes more elastic and encompassing, art may have more to tell us than ever before.

While early studies of ritual tended to focus on its symbols and conceptual 'content', in the 1970s and 1980s the field began to shift towards an emphasis on embodied action. A key figure in this transition

◁ **WOLFGANG LAIB** GERMANY
Detail of *Without Place–Without Time–Without Body*, 2007

▽ **AVDEY TER-OGANYAN** RUSSIA/
CZECH REPUBLIC
Young Atheist, 1998
Performance at the Art Manezh Centre, Moscow

In this now notorious performance,
Ter-Oganyan chopped up mass-produced
Orthodox icons with an axe before being
assaulted by onlookers, including fellow
artists. The piece led to charges of inciting
religious hatred, forcing him to flee the
country to avoid prison. While the work
takes inspiration from early Soviet anti-
religious propaganda – which sometimes
encouraged the destruction of icons – it
might equally be interpreted as an extreme,
prophetic act in line with Russia's long
tradition of holy fools.

was the anthropologist Victor Turner, whose study of tribal ritual –
especially among the Ndembu in Zambia – as well as modern theatre,
helped initiate a fruitful exchange between anthropology and theatre
studies; this conversation was continued in the field of performance
theory by the director and theorist Richard Schechner. Contemporary
artists have probed this interdisciplinary territory extensively, illustrating
both the theatricality of ritual and the ritual of performance. In the
bacchanalian productions of his *Orgy Mystery Theater*, involving days of
animal sacrifices, copulation, and crucifixions, Hermann Nitsch attempts
to redirect the power of ancient Greek mysteries and medieval Passion
plays towards 'deeper realms'. There is a similar, albeit less gory, mix of
reverence and iconoclasm in the actions of Avdey Ter-Oganyan and Zhan
Wang, whose destructions of icons and idols both re-enact and mourn the
destruction of religious heritage. By reconfiguring and recombining ritual
instruments – including the body itself – James Luna and Chitra Ganesh
investigate whether syncretism strengthens or dilutes religious rituals.
Perhaps no artist has stated the ritual significance of their work as boldly
as Marina Abramović, the high priestess of performance art. 'There are no
firmly established religious structures any longer,' she declares. 'Artists
accompany us on our search for a new order.'

If the artists above help us understand the intensity and theatricality
of ritual, others encourage us to plumb the more subtle sides of ritual.
As the philosopher Michel de Certeau reminds us in *The Practice of
Everyday Life*, even such quotidian acts as reading, cooking, or walking
can constitute 'tactics' of appropriation and expression. Our daily rituals,
conscious or unconscious, mark out space for creative existence amid
the systematizing 'strategies' of institutions. In Angela Strassheim's
photograph, for instance, a family saying grace in a McDonald's is not just
bowing before the 'golden arches', they are creating their own private,
sacred space. The simplest of tasks, performed with concentration,
can take on a sacramental character, as Jackie Nickerson shows us in
her photographs of Irish monasteries. Sometimes, we perform rituals
almost unwittingly, like the skinny-dipping travellers in Tom Hunter's
photograph. At other times we take part in public rituals more akin to

the 'strategies' described by de Certeau. The sociologist Robert Bellah calls attention to the 'civil religion' reinforced by activities from parades to pledges of allegiance to memorialization. Today, there might even be a sort of global civil religion, fed by the proliferation of images on the Internet. In the wake of tragedies, for instance, our acts of public mourning are remarkably similar. Thomas Demand's *Tribute* (2011) could take place almost anywhere.

Not only can art disclose new insights about how we ritualize in our private and public life, making art can itself constitute a form of spiritual ritual. The Trappist monk Thomas Merton – a close friend of the painter Ad Reinhardt – understood this well. In *Thoughts in Solitude*, Merton draws together insights from both Catholicism and Zen Buddhism, which he studied extensively. He writes:

> Our five senses are dulled by inordinate pleasure. Penance makes them keen, gives them back their natural vitality, and more. . . it is the lack of self-denial and self-discipline that explains the mediocrity of so much devotional art, so much pious writing, so much sentimental prayer, so many religious lives.

From mandalas to icons to the abstractions of his friend Reinhardt, Merton believed that art could be both beautiful and strict; and indeed, that it was most beautiful, and most spiritually rewarding, when it was most disciplined. Despite the libertine stereotype of contemporary artists, such rigorous self-discipline is evident in the practices of a range of artists, including Idris Khan, Sam Winston, Wolfgang Laib, and Michael Landy. This meditative quality is perhaps best embodied in Landy's *Break Down* (2001). Over the course of a fortnight, the artist laboriously catalogued and destroyed all of his earthly possessions – from his toothbrush to car and passport – literally leaving him with only the clothes on his back. While Landy recalled a profound sense of emptiness in the wake of this great renunciation, even this void might be spiritually significant. 'Do you think your meditation has failed?' writes Merton. 'On the contrary: this bafflement, this darkness, this anguish of helpless desire is a fulfilment of meditation.'

△ **JAMES LUNA** USA/MEXICO
Emendatio, 2005
Performance

Luna is best known for *Artifact Piece* (1987), in which he lay motionless in a display case, like an anthropological exhibit, at the San Diego Museum of Man. In this performance piece, which takes its title from the Latin for emendation or alteration, Luna mixes together references to traditional native customs and contemporary American culture. During the performance he lays out a sacred circle of stones together with Spam, sugar packets, and other staples of low-income food in today's reservations.

▷ **MARINA ABRAMOVIĆ** SERBIA

Holding the Goat, 2010
Colour-pigment print, 125 x 125 cm
(49¼ x 49¼ in.)

Abramović began her 'Back to Simplicity'
series in rural Italy after a three-month
performance piece at the Museum of
Modern Art called *The Artist is Present*,
in which she sat at a table staring silently
at a succession of more than a thousand
visitors. After this work, she said, 'I had
a need to go to nature, I had a need for the
ritualization of the simplicity of everyday
life. . . .If your state of mind is clear it's
a kind of spiritual matter.'

In different ways, each of the artists in this chapter circle around a
fundamental question: where does the power of ritual come from? For
some, its wellspring is action, for others habit or meditation. Another
answer, of course, is belief. Lachlan Warner and the final three artists in
this chapter tackle this aspect directly. Drawing on disparate traditions,
they create ritual objects that seem to wait for us to activate them.
Lachlan Warner's piece belongs to a series of Stations of the Cross
produced for Easter prayers in an Australian church. Marta María
Pérez Bravo uses her body to mirror the cultic devices used in Santería.
Tapfuma Gutsa echoes objects used by shamans in East Africa, while
John Feodorov ironically 'updates' Native American rituals. What would
it take for one of these objects to '[speak] down to us', to borrow the
title of Gutsa's gadget? And who, or what, does the speaking? For the
great sociologist Émile Durkheim, and many who have followed him,
the answer is clear: it is we who speak to ourselves. Through ritual, we
do commune with God. But God, Durkheim insists – be he Yahweh,
Jesus, or a totem animal – turns out to be nothing more and nothing
less than an expression of society itself. To some, this explanation of
ritual would seem to rob religion of all its power and majesty. And yet,
if Durkheim is correct, perhaps this only makes our rituals all the more
remarkable. After all, what act could be more creative than to forge our
own gods? And what could be more important than to learn to listen to
our innermost hopes and convictions? Explaining our oracles does not
have to kill them.

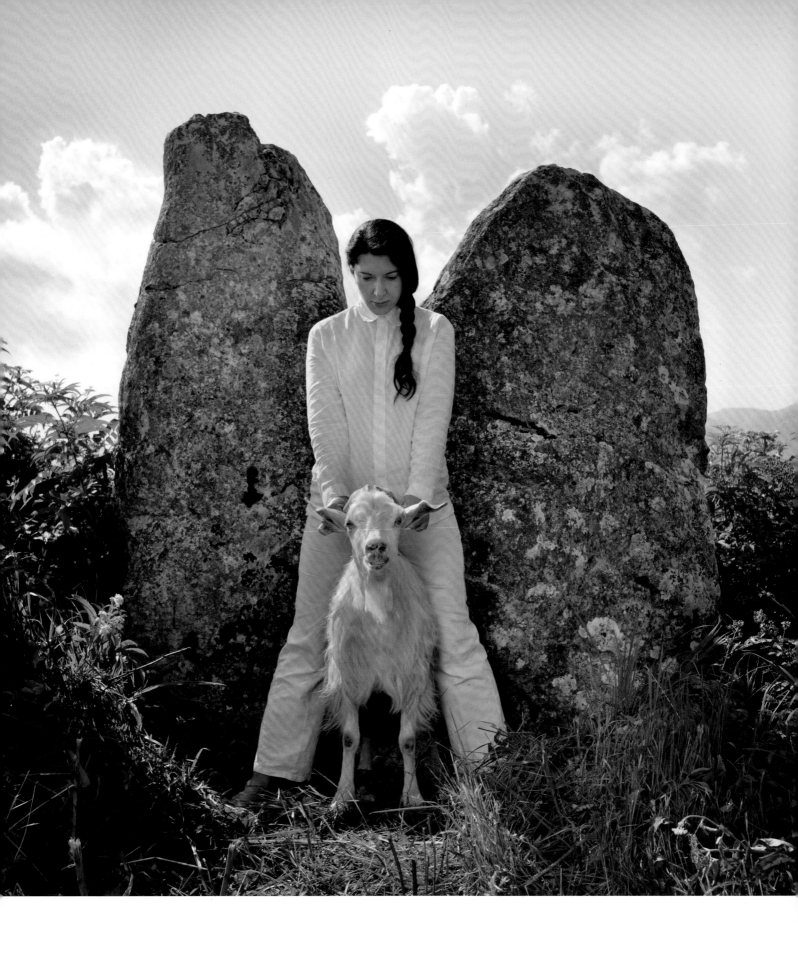

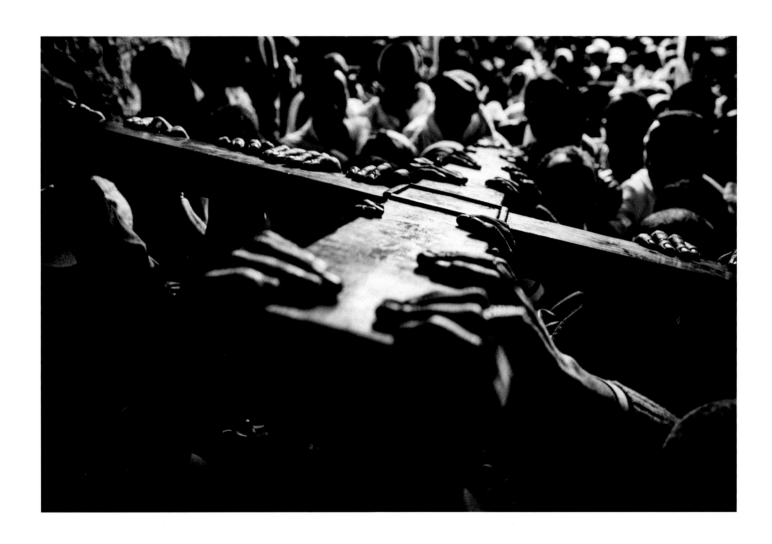

△ **JORDI PIZARRO** SPAIN/INDIA

Untitled, 2012

Black-and-white photograph, 90 x 110 cm (35⅜ x 43¼ in.)

This photograph is from his series 'Othodox in Jerusalem'.
In addition to this image taken in the Church of the Holy Sepulchre,
Pizarro has also photographed Orthodox Christian pilgrims in
Poland, Hindu ascetics in India, and syncretic Afro-Caribbean rites in
Cuba as part of his 'Believers Project'. He aims for an 'anthropological
perspective' in these works, adding that his 'main goal is to aid
and increase awareness of issues affecting people and their
environments', while providing opportunities for 'critical reflexion'.

△ **JAKE & DINOS CHAPMAN**

The Chapman Family Collection, 2002

34 sculptures on plinths, wood, paint, and mixed media, dimensions variable

The press release for this exhibition cheekily announced that this venerable collection represented a trove of objects from the former colonial regions of Camgib, Seirf, and Ekoc. Spelled backwards, these regions turn out to be the components of a McDonald's Happy Meal: Big Mac, fries, and Coke. And what at first glance might look like Yoruba masks are in fact icons of global capitalism, mocking the Western tendency to monopolize other cultures and admire them merely as mirrors of consumption.

▽ **HERMANN NITSCH** AUSTRIA
122nd Action, 2005
Video

'People always ask me why I deal with blood,
entrails, and so on,' says Nitsch. 'I say: Look,
there are artists who are all about landscapes.
For others it is portraits or still lives. I am the
artist who is into meat and blood, which is
an incredibly interesting field. . . .Some of my
colleagues worked a lot with feces. I didn't.
Just like Monet didn't paint many portraits
. . . .I always looked for intensity. . . .I'm very
interested in taboos, mostly in their origins.'

▷ **CHITRA GANESH** USA
Hidden Trails 2, 2007
C-print, part of photographic triptych, each panel: 61 x 63.5 cm (24 x 25 in.)

While Ganesh often explores her South Asian heritage, she also
draws on Western religions, myths, and folklore. Commenting
on the violence and eroticism in much of her art, she explains:
'as much as [the body is] a space in which violence is inscribed,
it's simultaneously like a space for transformation and evolution
and transgression, and liberation. . . .I'm interested in blurring the
distinction between inside and outside. . .through the wound, or
through dismemberment, the reconfiguration, the multiplication
of the body parts.'

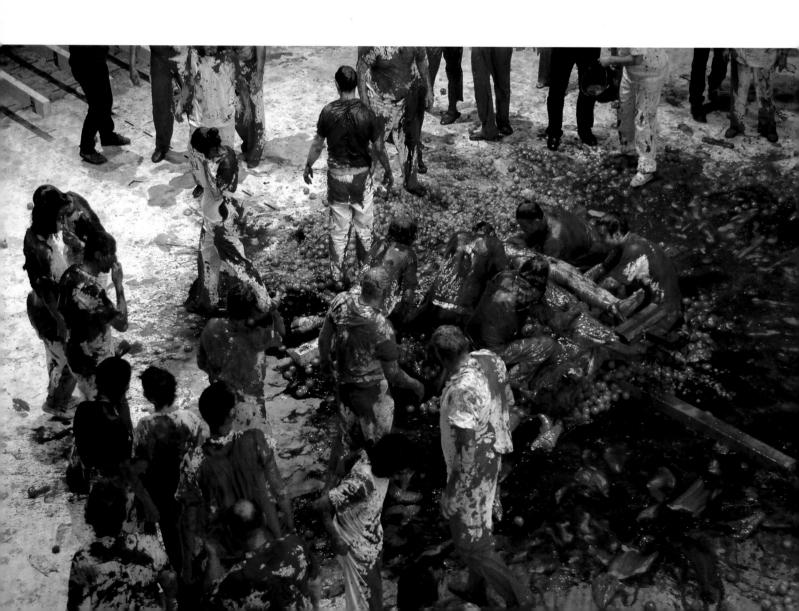

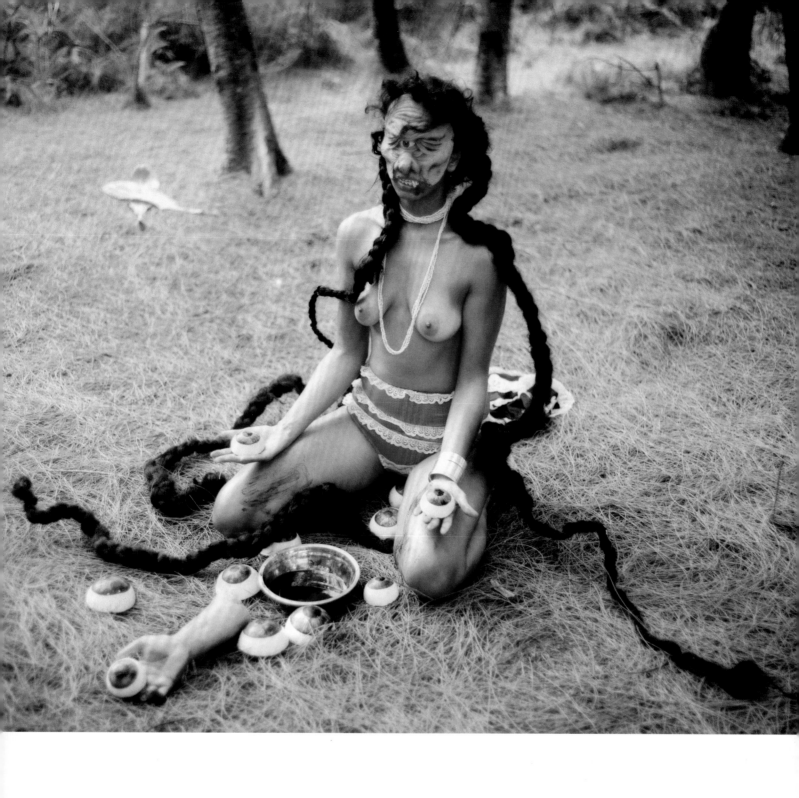

◁ **ZHAN WANG** CHINA
86 Divine Figures, 2008
Performance at the Long March Space, Beijing

Zhan often investigates issues surrounding the destruction and preservation of China's cultural heritage, including an installation in which he 'repaired' the Great Wall. In this piece he created and subsequently demolished sculptures of his ancient ancestor, the Confucian sage Zhan Jiqin (Liu Xiahui), whose temple sculptures have been destroyed across his native Shandong Province. Zhan left the final statue untouched, donating it to his hometown temple along with images of the previous eighty-five, reduced to rubble.

▷ **LACHLAN WARNER** AUSTRALIA
Station 10: Jesus is Stripped, 2010
Cloth, acrylic paint on MDF board, 175 x 150 cm (68⅞ x 59 in.)

In 2001, Warner won the Blake Prize for Religious Art. While he comes from a Catholic background and teaches at a Catholic university, his work often displays his deep study of Buddhism. Here, he combines both. The clothing of the stripped and tortured Jesus is dyed the saffron colour of the robes worn by Buddhist monks in Southeast Asia. The absence of a body might symbolize the Risen Christ, yet it also resonates with the Buddhist doctrines of impermanence and emptiness.

▽ **MICHAEL LANDY** UK

Break Down, 10–24 February, 2001
Two-week performance, C&A building, Oxford Street, London

'It felt like I was attending my own funeral,' Landy says of
methodically destroying each of his 7,227 belongings for *Break Down*.
'After you've destroyed everything you own, there comes a big full
stop, both as a consumer and a person. . . .What I had done was so
destructive and nihilistic; for about a year I didn't make any art.
I didn't do anything. . . .I do wonder if I'm just trying to destroy
myself. Maybe one day I'll work out how.'

△ **ANGELA STRASSHEIM** USA

Untitled (McDonald's), 2004
C-print, 101.6 x 127 cm (40 x 50 in.)

A key theme in Strassheim's photographs is her exploration of her born-again Christian upbringing. 'Jesus never made any sense to me, yet one is supposed to learn from one's parents,' she muses. 'I am always looking for the one, usually a girl, who seems to be off in another place within this framework because that is how I always saw myself.' Works like this remain steadfastly ambivalent, refusing an obvious polemic against American capitalism and religion.

△ **TOM HUNTER** UK

After the Dragon, 2000
Cibachrome print, 50.8 x 61 cm (20 x 24 in.)

While Hunter is best-known for depicting his neighbours in east London, this photograph arose from a meeting with an old friend in southern Spain after the Dragon Festival, a gathering of New Age travellers. With a wink to Edward Burne-Jones's *Pan and Psyche* (1872–4), Hunter poses his friend as the Greek god consoling the lovelorn Psyche. Yet this modern-day Pan also becomes a sort of John the Baptist, encouraging his companion to emerge from the waters as a new woman.

Washing Eucharist Vessels, Poor Clare Monastery, Belfast, 2006
Photograph, Fuji-crystal archive print, 79 x 99 cm (31⅛ x 39 in.)

Nickerson spent more than two years photographing everyday life
in more than sixty religious spaces in Ireland, including convents
and monasteries like the one here. 'These are individuals and
communities which are steeped in an interiority,' says Nickerson,
'which they have discovered is not their own but something wider
and deeper than themselves, of which they are a part.' In this image
she captures the private moments after the public rite of communion,
revealing them to be no less spiritual.

△ **IDRIS KHAN** UK

Every. . . page of the Holy Qur'an, 2004

Lambda digital C-print mounted on aluminium, 136 x 170 cm (53½ x 66⅞ in.)

In his signature process, Khan digitally scanned and overlaid each page of the Qur'an into a single image. Although he is no longer observant, the artist identifies parallels between his artistic process and the repetitions of Islamic ritual. In other works, he has overlaid the pages of Sigmund Freud's *The Uncanny*, superimposed the musical compositions of Frédéric Chopin, and layered sixty self-portraits of Rembrandt. 'I am searching for a kind of sublime,' says the artist.

▷ **THOMAS DEMAND** GERMANY

Tribute, 2011

C-print, Perspex, 166 x 125 cm (65⅜ x 49½ in.)

Demand characteristically creates works by reconstructing a particular scene using a life-size paper or cardboard model, from which he carefully deletes information, for instance scrubbing away the text in *Tribute*. He then photographs the model and destroys it, leaving behind only the mediated image of the 'original' subject. The results are images that somehow triangulate their way towards what is most essential about a given event or action, which is, in this case, the drive to ritualize in response to loss.

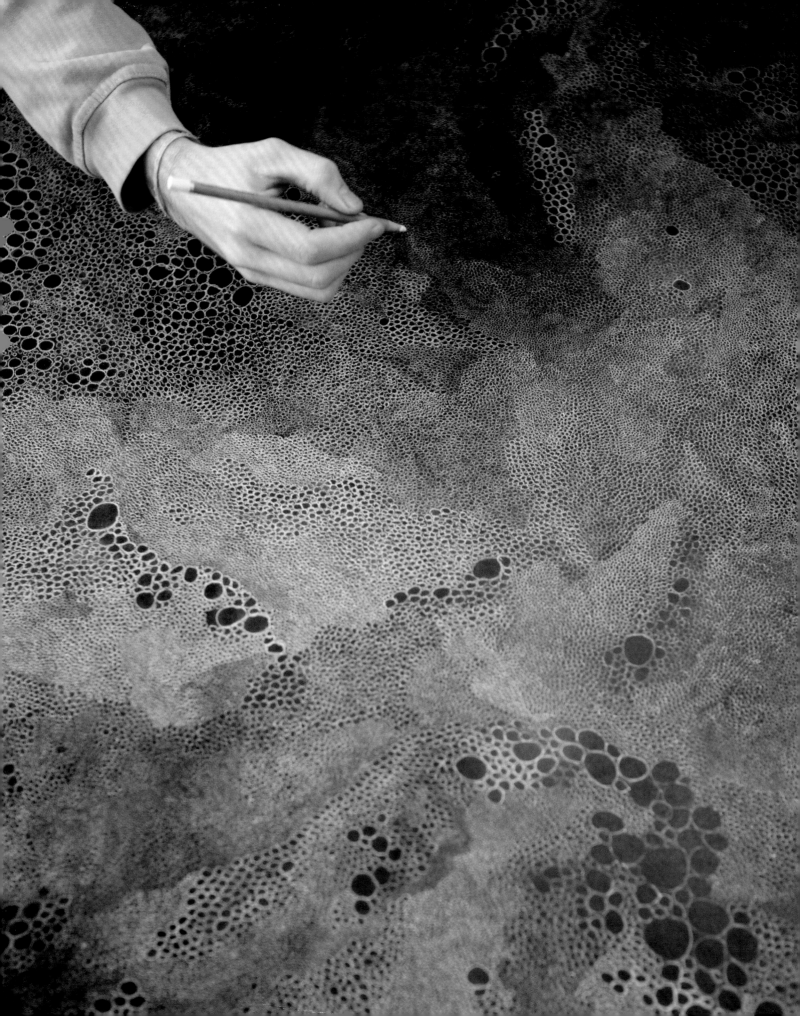

◁ **SAM WINSTON** UK

Birthday, 2010

White pencil drawing on black inked paper,
183 x 400 cm (72 x 157½ in.)

Winston writes: 'By the time you've read this
sentence three people have been born into
the world. By the time you've read this
sentence two will have passed away. *Birthday*
is a work which sets out to record every
individual birth and death over a twelve-hour
period. . .with a small circle.' After recognizing
the immensity of the task before him, Winston
opened the process to the public, turning this
private meditation into an act of collective
commemoration and memorialization.

▽ **WOLFGANG LAIB** GERMANY

Without Place–Without Time–Without Body, 2007

Installation, mountains of rice, 3 mountains of hazelnut pollen,
dimensions variable

Laib originally trained as a medical doctor before turning to art,
informed by his study of Hinduism. He works characteristically
in simple, natural materials, including rice, pollen, and milk. All of
his pieces, he says, seek 'the concurrence of motion and stillness,
of material and immaterial, of the durable and the ephemeral,
with balance and transformation, with the attempt to explore the
irrational or the impossible, and with the search for an entrance
or a passage to another world'.

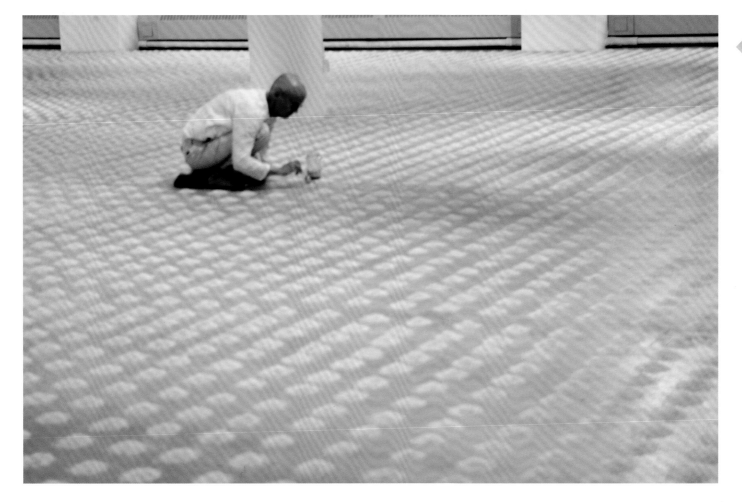

Ver y Creer (Seeing and Believing), 2005
Gelatin silver print, 50 x 40 cm (19⅝ x 15⅝)

'Black and white photography is capable
of giving the whole an oneiric [dreamlike]
feeling,' reflects Bravo. '[Cultic objects] can
be extremely appealing in terms of colour, yet
this appeal often distracts from, or dilutes,
the true meaning of the objects. But that, the
meaning, is precisely what I am interested in;
I want to bring out the very essence of the
object I recreate, without adulteration. . . .
In terms of the concept, the private ritual is
also part of the work.'

180

PART IV 〉 ritual

◁ **TAPFUMA GUTSA** ZIMBABWE
He Speaks Down to Us, 2002
Sculpture, serpentine, Kudu horn, and basket,
97 x 140 x 90 cm (38½ x 55⅛ x 35⅜ in.)

According to Gutsa, 'objects such as buffalo
horns are used by medicine men to empower and
strengthen the warrior before battle – in this sense
the shaman creates an object that can acquire
meaning and influence people, just as an AK47
or a Bible can wield influence and power –
I am therefore interested in creating "gadgets of
influence" – enigmatic forms that are intrinsically
functional, in the sense that medicines or weapons
are functional. It is a kind of alchemy.'

▷ **JOHN FEODOROV** USA

Oracle, 2011

Fur, aluminium, speakers, wire, choke chain, cone, acrylic, and gesso, 101.6 x 61 x 20.3 cm (40 x 24 x 8 in.)

'Western culture likes to castrate the powerful, maybe because it doesn't want to be less powerful,' muses Feodorov. Capitalism, he says, attempts to control things by turning them into objects that can be purchased, like this spirit animal choked and pierced by technology in an effort to enhance it. Feodorov attempts 'to infuse the intimidating back into the spiritual. Spirituality should be intimidating', he says. '[P]eople have no business being on a buddy-buddy basis with God.'

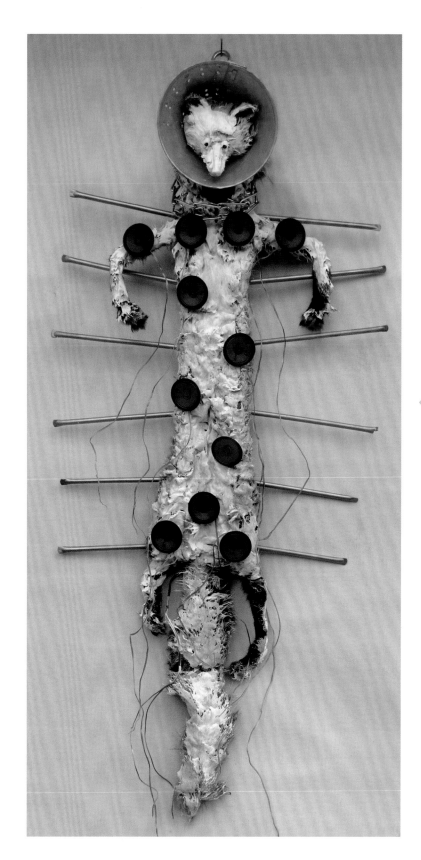

8 ♦ STRUCTURE AND LOSS

+ In the previous chapter, we witnessed a variety of ways in which art creates, participates in, and helps us understand ritual. We discussed Robert Bellah's concept of 'civil religion', which offers a useful way to think about how societies utilize ritual to shape collective identity. This chapter provides us with an opportunity to delve more deeply into one particular aspect of civil religion, namely how art helps us to remember the past. The impulse to make monuments, especially in memory of the dead, is nothing new, as seen in the pyramids of ancient Egypt or the Terracotta Army of ancient China. Today, we continue to carve massive memorials to our heroes, from the Martin Luther King, Jr Memorial in Washington, DC (2011) to the towering statue of Nelson Mandela in Pretoria (2013). However, alongside this tradition another mode of remembrance has gained momentum in recent decades: one that focuses less on valorization and more on engagement. Maya Lin's Vietnam Veterans Memorial (1982) epitomizes this shift. Inviting visitors to trace individual names of deceased servicemen – often literally by making rubbings – the black granite wall, once bitterly controversial, has become a cathartic site for Americans to work through the legacy of a deeply unpopular war. In the ensuing years, artists have continued to test the conventions of memorialization, creating a genre that the scholar James Young terms 'counter-monuments'. While coined in reference to Holocaust memorials, the traits Young identifies can be applied to a wider group of works, which aim 'to challenge the very premises of their being . . .[opting] not to console but to provoke. . .not to accept graciously the burden of memory but to throw it back at [visitors'] feet'. In this chapter we will examine works that continue this self-interrogation, fostering new rituals of mourning and remembrance in the process.

The first assumption we often jump to about monuments is that they should make present what is absent. There is a compelling rationale

◁ **FAM ARQUITECTURA Y URBANISMO S.L.** SPAIN
Detail of 11 March Memorial for the Victims, Madrid, 2007

for this. Faced with the danger of forgetting, it makes sense to try to moor memory to something solid and imperishable. And yet, there is a compelling argument that monuments should do just the opposite: not so much filling a void as making it palpable. One of the most prominent advocates for this line of thinking is the deconstructionist architect Daniel Libeskind. At the Berlin Jewish Museum (2001), in a project he called 'Between the Lines', Libeskind creates an uncanny space in which we are forced to confront the irreparable absence of German Jews murdered during the Holocaust. At the centre of this jagged, disorienting edifice, Libeskind places an empty, sepulchral space. He explains:

> [T]he void was something that has never been [built] before. Usually the centre of a building is where you find an atrium, you find something for people to enter, but I thought there must be a place in the museum that, even for a second, there is nothing. . . .[T]hat is part of what the building communicates. . .across the fragments of what remains. You have to think of those people who are not there with their stories and that moment of silence is what also creates the memory of what it is.

Related tensions between absence and presence surface in Rachel Whiteread's Holocaust Memorial (2000) – suggesting the negative space of a library – and the empty chairs of the Oklahoma City National Memorial (2000). Representations of September 11th have also emphasized absence, drawing upon depictions of previous tragedies as well as the nature of the attacks themselves, which erased the Twin Towers from the New York City skyline. From Art Spiegelman's black-on-black silhouette of the towers for the cover of the *New Yorker*, just after the tragedy, to Iván Navarro's mirrored abyss produced on the tenth anniversary, the fallen towers have increasingly been treated by artists not just as a physical but metaphysical void. Ensuring that it remains that way, New York has chosen public memorials that enshrine the memory of September 11th using the most evanescent of materials: water and light.

While contemporary monuments have challenged many taboos, some questions remain risky for public memorials, and have been addressed more

directly in installations and exhibitions. What happens, for instance, when memory falters, fails, or simply melts away? Or when the serious and tragic becomes funny or irrelevant? How, in other words, do we cope with the instability and impermanence of memory? These are the sorts of questions raised by Anselm Kiefer, James Balmforth, Kathy Temin, and Néle Azevedo. Kiefer, born in the decimated Germany of 1945, asks whether it is possible to rebuild and remember at the same time, leaving open the possibility that rubble may be the most appropriate monument. Yet however precarious, Kiefer's structures – like the charred, crumbling surfaces of his paintings – are still grand, weighty statements of will. Even in their shaky state, they impose themselves in a way that is impossible for Balmforth's *Failed Obelisk* (2009), a jiggling icon of impotence. At first glance, Temin's monument might also seem like a playful swipe at human hubris. What could be less monumental, after all, than fake fur, the stuff of soft furnishings and children's toys? And yet, on closer inspection, Temin's monument reveals a child's sense of awe and mystery in the face of suffering, in her case her father's memories of the Shoah. Trauma also seeps unexpectedly from Azevedo's ice sculptures, which recall the fate of South America's countless 'disappeared'. We are left with an uncomfortable truth: even memory itself can vanish.

Although the risk of amnesia may be clear, the remedy is uncertain. Take for example the disparate strategies employed by two Holocaust memorials, both dedicated in 2005: Gyula Pauer and Can Togay's *Shoes on the Danube* in Budapest and Peter Eisenman's Memorial to the Murdered Jews of Europe in Berlin. While both remind us not to forget, they present radically different tactics of remembrance: one figurative and symbolic, the other abstract and non-discursive. Eisenman seems to have something like the Danube memorial in mind when he asserts:

> From the beginning the project attempted to refrain from banal references through symbolism or figuration, to stay in the realm of what one would call 'the real', that is, without any representation of names, directions, or narrative references. . .[as] a place that was both different from the experience of the everyday but also had the possibility of the ordinary. . . .

While Eisenman's approach might work for some viewers, for others an imaginative identification with the victims of the Shoah – literally stepping into their shoes in the case of the Budapest memorial – might provide a stronger impulse to remember. Just as abstraction and figuration each have their advantages, they also have their respective hazards: above all, alienation and sentimentalization. There are, however, ways to mitigate these pitfalls. The layout of the 7 July Memorial (2009) encourages visitors to pick their way slowly, contemplatively amid its minimalist pillars. On the opposite end of the spectrum, Louise Bourgeois' *Memorial to Victims of Witch Trials* (2011) wards off maudlinism by uncannily evoking the experience of both the torturer and the tormented. In a world that incessantly creates 'Scaffolds Today, Monuments Tomorrow' – to take the sobering title of a sculpture by Nika Neelova – it is worth remembering that whatever representational decisions we make, our memorials must open wounds as much as heal them.

Increasingly, designers of public memorials have begun to conceive of visitors not only as passive recipients but active performers of memory. Monuments do not have to be places in front of which we simply grieve, they can also be objects and sites we create together. Sometimes this participation is closely timed and structured, as when thousands of volunteers commemorated the centenary of the First World War by planting ceramic poppies in the moat surrounding the Tower of London, or when hundreds gathered on the beaches of Normandy to stencil the silhouettes of the dead onto the sand in memory of D-Day. In the case of the 11-M memorial in Madrid, people began building a monument even before they realized it. The messages of grief and support left at Atocha Station in the aftermath of the 2004 terror attacks became building blocks for the memorial's architects, who engraved them onto the walls of the monument. The memorial thus sought to commemorate not only the tragedy of the event itself, but also the communal grieving process that followed. As designers continue to find new ways to challenge the canons of commemoration, from presence to permanence to passive spectatorship, what today we call counter-monuments may eventually come to represent a new norm. The test, as it often is for ritual, will be whether future memorials can provide sufficiently for both continuity and creativity. A good memorial should push people, but not too far, not too fast.

△ **PAUL CUMMINS AND TOM PIPER** UK

Blood Swept Lands and Seas of Red
Ceramic poppies
Installation view, Tower of London, 2014

Cummins, a ceramics artist, created the poppies for the memorial, while Piper, a theatre designer, choreographed their planting. The installation consists of 888,246 flowers, representing the number of British servicemen who died during the War, including the anonymous poet who penned the phrase 'Blood Swept Lands and Seas of Red' in the trenches. While gathering to plant poppies, participants retraced the last days in Britain for many soldiers in the Pals' battalions, who met up at the Tower before deployment.

▽ **RACHEL WHITEREAD** UK

Nameless Library: Holocaust Memorial, 2000
Steel and concrete, 380 x 700 x 1000 cm
(149⅝ x 275⅝ x 393⅝ in.)
Installation view, Judenplatz, Vienna

Whiteread's hermetic library seems to seal
suffering within it. It pays tribute to Jews
– including Vienna's own Sigmund Freud –
as the 'people of the book', while also evoking
the poet Heinrich Heine's admonition that
where books would be burned – as they
were under Hitler – people would follow.
'I tried to make something sombre and
poetic,' comments Whiteread. 'I've since
been asked to make several other memorials
but I've turned them down. I'm not in the
memorial business.'

▷ **DANIEL LIBESKIND** POLAND/USA

Holocaust Tower, Jewish Museum Berlin, 1999 (opened 2001)
Empty silo, bare concrete, height 2400 cm (944⅞ in.)

'The reasons my designs may appear futuristic or even jarring,' says
Libeskind, 'is because memory is something that has to be awakened
in a very radical way. It can be compared to tradition. Tradition can
be a rote ritual without any meaning unless, with each action of the
individual, there is a connection to the flame of why that tradition
started in the first place. This is the urgency that memory represents
for me.'

▽ **PETER EISENMAN** USA

The Memorial to the Murdered Jews of Europe, Berlin,
2003–4 (dedicated 2005)
Concrete stelae, length 238 cm (93¾ in.), width 95 cm (37⅜ in.),
height from 20 to 480 cm (7⅞ to 189 in.)

Created near Nazism's administrative nerve centre, not far from
the site of Hitler's bunker, Eisenman's memorial consists of 2,711
concrete stelae, stretching over 19,000 square metres (4.7 acres).
The pillars vary in height. Their concrete masses tower over visitors
towards the centre, creating the disorienting sense of travelling amid
innumerable, anonymous tombs. 'I don't want people to weep and
then walk away with a clear conscience,' comments Eisenman, who
says it has become as much a 'warning' as a memorial.

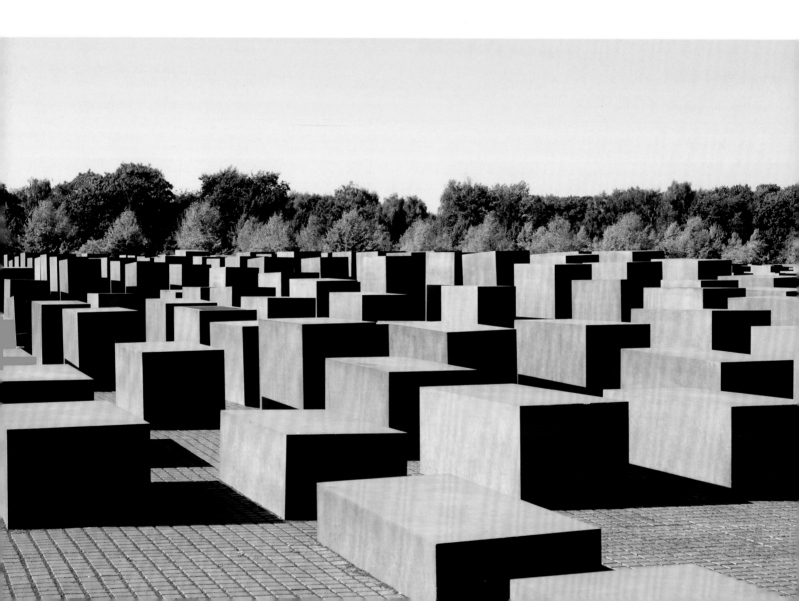

▽ **BUTZER DESIGN PARTNERSHIP** GERMANY/USA

Oklahoma City National Memorial, Oklahoma City, 2000

The monument commemorates the morning of 19 April 1995, when Timothy McVeigh detonated a truck loaded with explosives in front of the city's Federal Building, leading to the deaths of 168 people in the building and the vicinity. *The Field of Empty Chairs*, with named seats arrayed in rows to represent the floors of the building, and smaller chairs for the nineteen children lost in the blast, are spread out across the footprint of the former building.

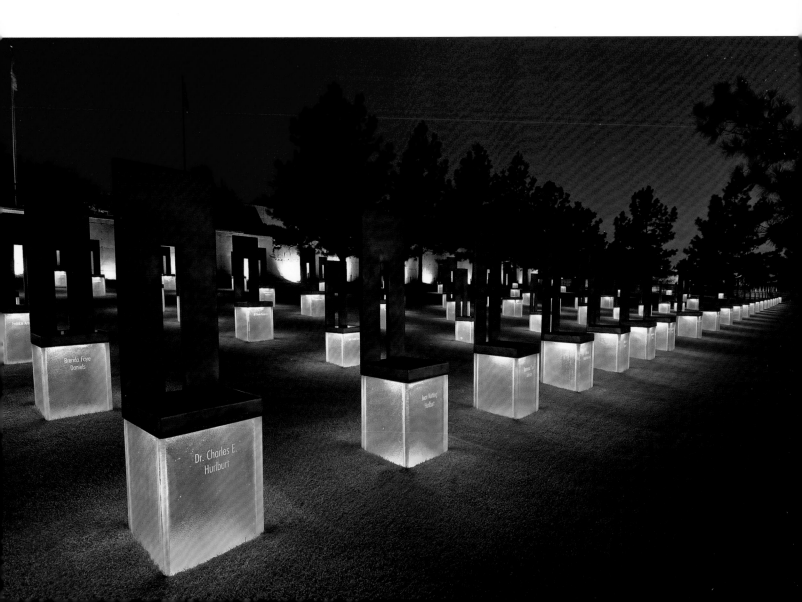

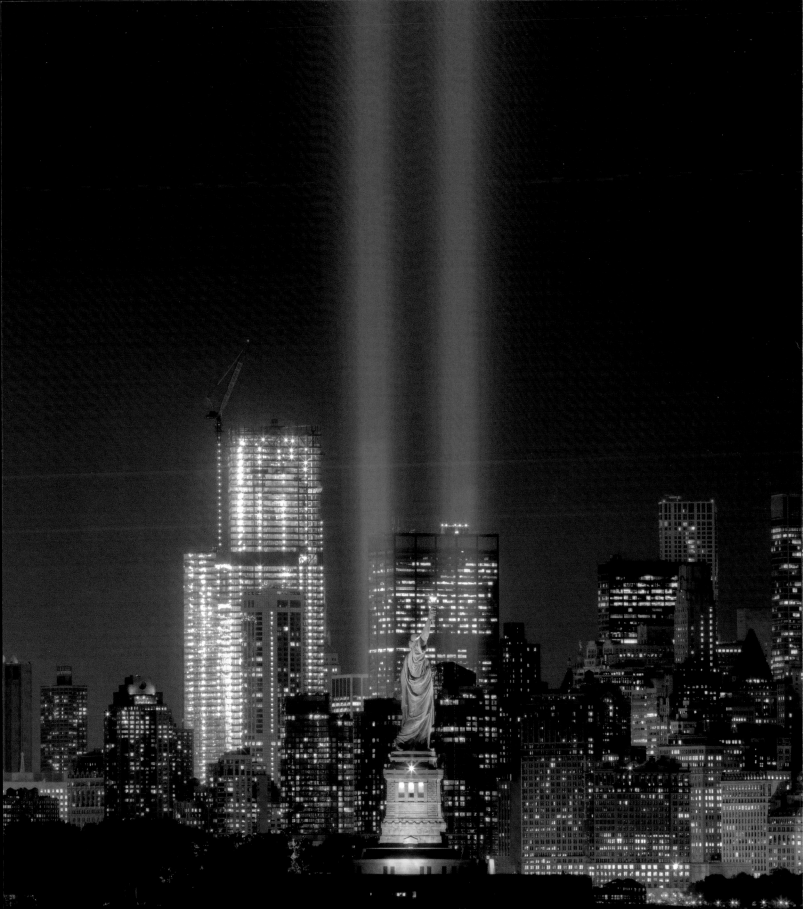

◁ **THE MUNICIPAL ART SOCIETY** USA

Tribute in Light, New York City, projected
annually on 11 September from 2002 onwards

Each beam in the *Tribute* is projected from
eighty-eight powerful searchlights, evoking
the desperate twenty-four-hour searches for
survivors in the rubble of the World Trade
Center, which consumed the days after 9/11.
Initiated on 11 March 2002, the six-month
anniversary of the attacks, the twin beams of
light are now recreated annually from dusk on
11 September until dawn the next day, marking
out sacred time much as the memorial
delineates sacred space.

▽ **MICHAEL ARAD AND PETER WALKER** ISRAEL/USA
AND USA

Reflecting Absence: National 11 September Memorial, New York City,
2011

After witnessing the events of 11 September firsthand, Arad began
sketching memorial designs even before a design competition was
announced. He recalls: 'it was important to think of this not just as
a point of memory but as a living part of the city that would connect
this back into the life of lower Manhattan'. He imagined each element
of the memorial complex taking on liturgical significance, referring to
the visitors' arrival at the plaza as sort of a 'processional experience'.

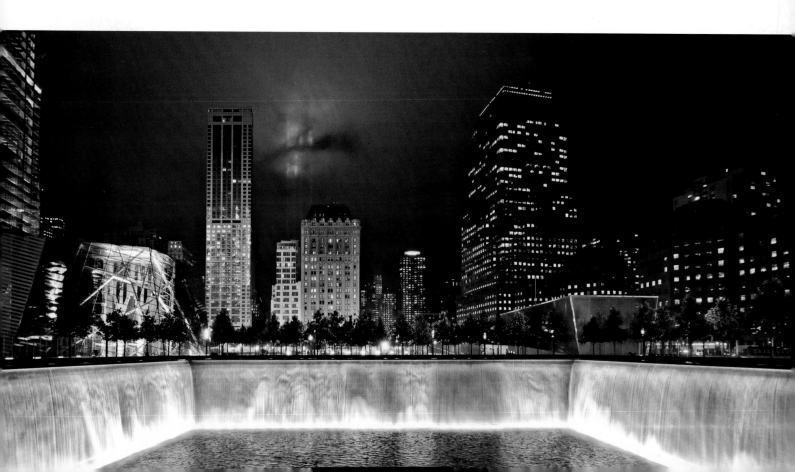

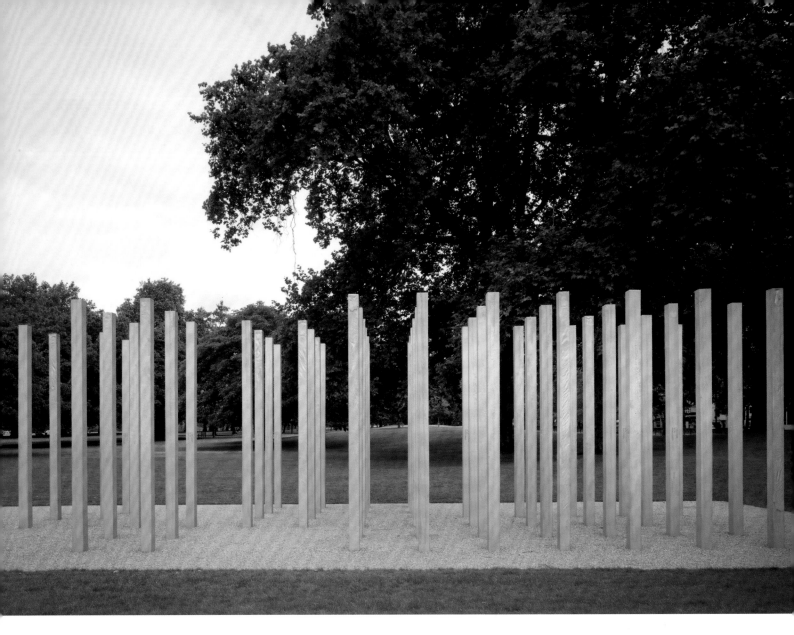

△ **KEVIN CARMODY AND ANDREW GROARKE** UK

7 July Memorial, Hyde Park, London, 2009

52 850-kg (1874-lb) stainless steel cast vertical pillars, height of each: 350 cm (137⅞ in.)

The memorial's pillars (or stelae) are clustered in groups of six, seven, thirteen and twenty-six, representing the victims who perished at each of the four locations bombed on 7 July 2005. 'We wanted to capture the randomness of the killings,' Carmody comments, 'the sense that it could have been you, that it could have been anyone in London on that day'. The final design arose from discussions with victims' families. 'We are enablers of the memorial as much as designers,' adds Groarke.

▷ **IVÁN NAVARRO** CHILE

Untitled (Twin Towers), 2011

Neon lights, wood, paint, glass, mirror, each tower: 20.3 x 146.7 x 146.7 cm (8 x 57¾ x 57¾ in.)

Navarro uses neon lights and one-way mirrors – the same type used in the reflective façades of skyscrapers – to create the illusion of infinitely receding space. He has acknowledged the formative impact that growing up in Pinochet-ruled Chile has had on his work, and it is possible that the attacks of 9/11 in his adopted city of New York triggered associations with the military coup d'etat staged in his home city of Santiago on 11 September 1973.

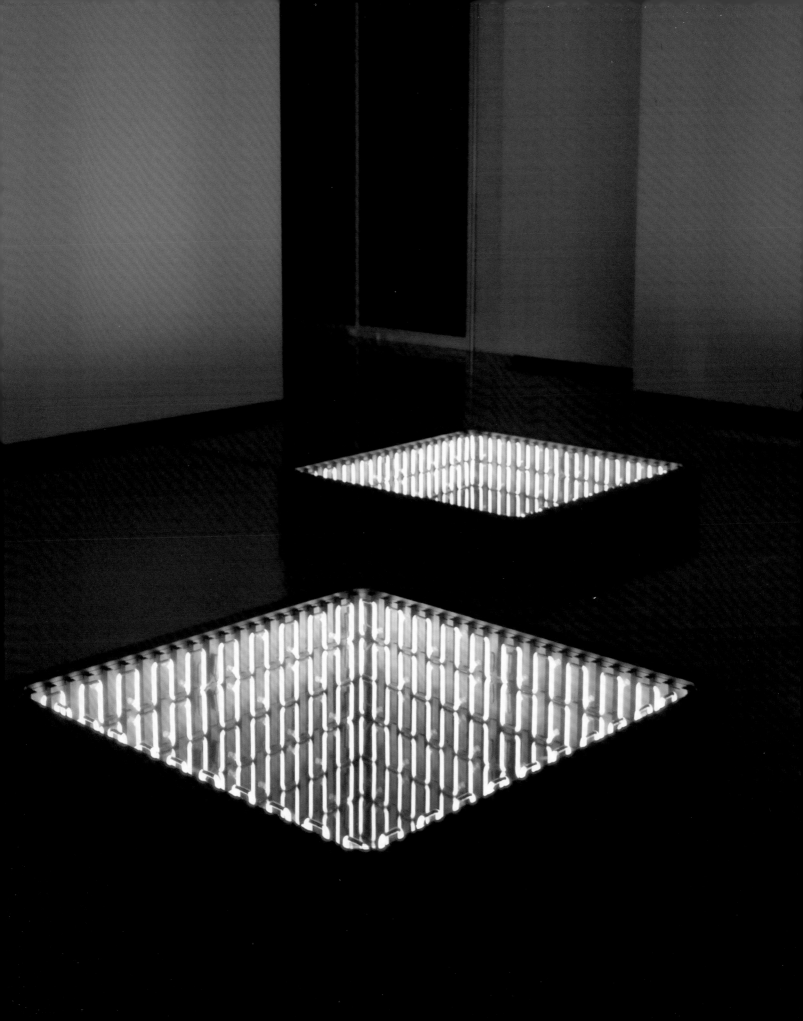

▽ **NÉLE AZEVEDO** BRAZIL

Minimum Monument, 2005-present
Ice sculptures of figurines, height before melting *c*. 20 cm (7⅞ in.)
Installation view, Belfast, Northern Ireland, October 2012

'In a few-minute action,' writes Azevedo, 'the official canons of the monument are inverted: in the place of the hero, the anonym; in the place of the solidity of the stone, the ephemeral process of the ice; in the place of the monument scale, the minimum scale of the perishable bodies. . . .It concentrates on small sculptures of small men, the common men.' The series has also been heralded as a warning against global warming, an association the artist has embraced.

▷ **ANSELM KIEFER** GERMANY

Jericho, 2007
Concrete slabs held together with steel cable and iron bars, heights 14 and 16.5 metres (46 and 54 feet)
Installation view, Royal Academy, London

While these biblically titled towers evoke the World Trade Center, Kiefer has been constructing similar, shaky edifices for years in the fields surrounding his studio in Barjac, France. For Kiefer, these towers – some of which have already fallen down – recall the Germany of his birth, just before the end of the Second World War. '[A]s a child I played in ruins, it was the only place,' he recalls. 'But I also like ruins because they are a starting point for something new.'

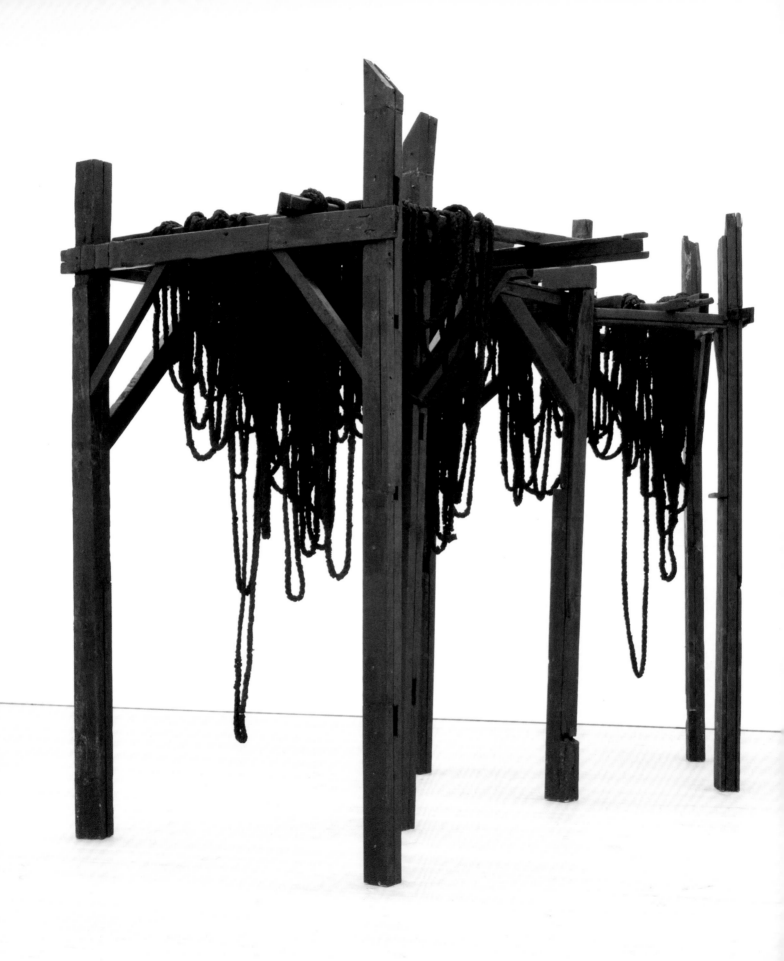

◁ **NIKA NEELOVA** RUSSIA/UK

Scaffolds Today, Monuments Tomorrow, 2011
Burnt and waxed wood, paper and ink,
200 x 150 x 400 cm (78¾ x 59 x 157½ in.)

All is not what it seems. The coiled ropes
are made from paper, while the wooden
gallows have been scarred and burnt to
resemble a grisly antique from some bygone
revolution. 'The large scale of the piece
points to an obvious monumentality,'
writes Neelova, 'whereas the fragility of the
materials underlines the transient nature of
commemoration and celebration of certain
historical events and people'. There is a
'concealed history', in Neelova's words, but
also a fabricated one. Relics can lie.

▽ **KATHY TEMIN** AUSTRALIA

My Monument: Black Cube, 2009
Synthetic fur and filling, wood, 355 x 370 x 370 cm (139¾ x 145⅝ x 145⅝ in.)

In her soft sculptures, says Temin, 'there is an oppositional
dialogue that combines remembrance and play, minimalism
and sentimentality. I am interested in absence (white) and
impenetrability, loss, and seduction (black)'. In this work, filled
with black, fluffy 'fur trees', she channels memories from a trip to
Eastern Europe, during which she visited forests where thousands of
Jews had been murdered and buried in mass graves. Like the woods
themselves, her monument is 'both idyllic and sinister'.

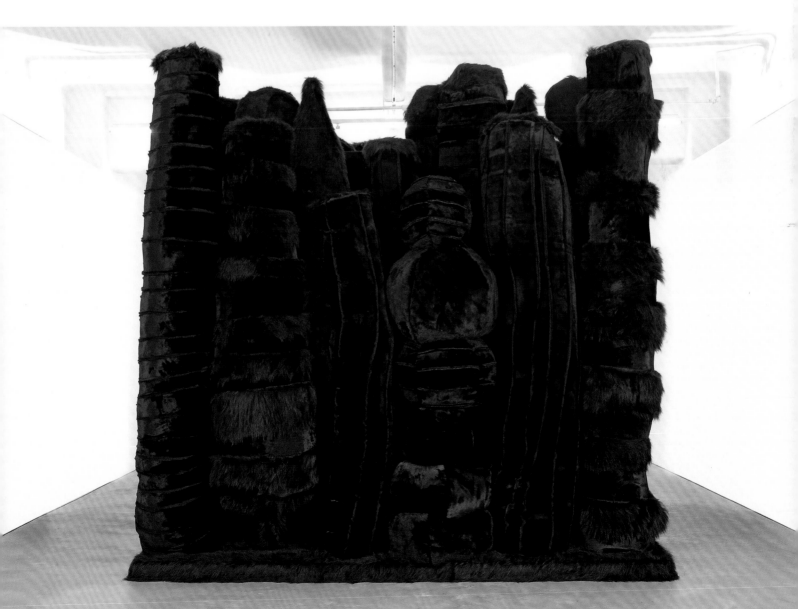

GYULA PAUER AND CAN TOGAY
HUNGARY
Shoes on the Danube, 2005
Installation view, Danube embankment, Budapest

In the waning months of the Second
World War, the fascist Arrow Cross militia,
supported by the Nazis, murdered thousands
of Budapest Jews. Their preferred method of
execution was to line up Jews on the banks
of the Danube, forcing them to remove their
shoes before shooting them into the icy
river, which swept away the bodies. The sixty
pairs of iron shoes sculpted by Pauer serve as
vessels of memory, into which visitors often
place flowers and candles.

SAND IN YOUR EYE (ANDY MOSS AND JAMIE WARDLEY) UK
The Fallen, 2013
Visual representation of 9,000 people drawn in the sand,
Arromanche, Normandy, France, 21 September 2013

On International Peace Day 2013, the artistic group Sand in Your Eye
worked with hundreds of local and international volunteers to create
a temporary memorial to the 9,000 people – from all sides – who
perished on the beaches of Normandy on D-Day, 6 June 1944. Using
stencils of fallen bodies, volunteers raked the sand to reveal soldiers'
silhouettes, before the evening tide poignantly washed away the
figures. While honouring the Allied Victory, the work underscores
the tragedy of every lost life.

▽ **FAM ARQUITECTURA Y URBANISMO S.L.**
SPAIN
11 March Memorial for the Victims, Madrid, 2007
Oval-shaped glass cylinder, weighs 140 tons, 1100 x 80 x
105 cm (433⅛ x 31½ x 41⅜ in.)

The ten bombs planted on 11-M, as the day is called
in Spain, killed 191 people and injured roughly
1,800, many in the midst of their morning commute.
Visitors approach the monument through an
underground passageway that opens skywards into
a tower of glass bricks bearing the messages of
condolence left in the wake of the attacks.

▷ **JAMES BALMFORTH** UK
Failed Obelisk, 2009
Mortar, wood, steel, and foam board, 450 x 80 x 80 cm (197 x 32 x 32 in.)

Where Barnett Newman, the consummate Modernist, gave us the
Broken Obelisk (1963–7), dedicated to the assassinated Martin Luther
King, Jr, Balmforth delivers a *Failed Obelisk* for a post-modern age.
Balmforth writes: 'Intended as powerful symbols of permanence,
control, stability and a connection to the divine, the Obelisk now
fails in its function, affirming instead that everything, including
power itself, is constructed and transient, and that the partition
between presence and absence remains precarious.'

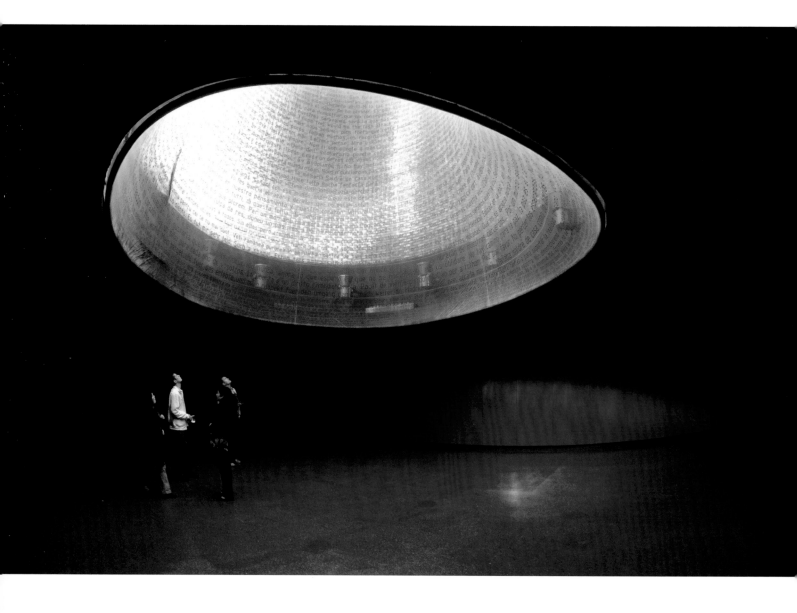

PART V) indwelling

9 ◆ EMBODIMENT

10 ◆ GALLERIES AND SANCTUARIES

9 ◆ EMBODIMENT

+ There is a prevailing assumption that religions seek to deny the body and its desires at all costs, confining it with an endless litany of laws and customs. The reality, of course, is far more complicated. Instead of a straightforward story of sensory deprivation, we would do better to think of an intricate dance between denial and affirmation, set to different tunes within disparate contexts. We can feel this tension palpably in the visual arts. From medieval manuscripts to contemporary paintings, artists have found ways to give voice to the Song of Songs as both a romantic encounter between two lovers and an allegory of religious devotion. At times, spiritual and sexual exhilaration appear almost indistinguishable or interchangeable, whether in Bernini's orgasmic *Ecstasy of St Theresa* (1647–52) or the glistening, awestruck teens in Angelica Mesiti's *Rapture* (2009). And it is not just in the realm of desire that we find conflicting or ambivalent attitudes towards the body. When Jesus rises from the tomb in the Gospel of John he both forbids and beckons touch. To Mary Magdalene, he declares 'Do not hold on to me' (John 20.17), or *Noli me Tangere*, to take the title of Titian's masterpiece (*c.* 1514), in which Jesus arcs away from Mary's outstretched arm. Later, when his disciple Thomas refuses to believe he has returned, Christ instructs him: 'Reach out your hand and put it in my side. Do not doubt but believe' (John 20.27). During the Reformation, many Protestants argued vociferously that Thomas believed without actually touching, while Catholics stressed the importance of physical confirmation, epitomized by Caravaggio's *Incredulity of St Thomas* (*c.* 1600), in which the disciple slides his finger knuckle-deep into the Saviour's flesh – a scene given a fresh twist by contemporary artists Nazif Topçuoğlu and Ron Mueck. If at times, then, the body is a source of religious discomfort, it can also be a conduit for faith. In this chapter we will harness approaches from several disciplines to explore how religious possibilities surface through the body.

207

◀ **SIGALIT LANDAU** ISRAEL
Detail of *DeadSee*, 2005

▷ **ANGELICA MESITI** AUSTRALIA
Rapture (silent anthem), 2009
Single-channel high-definition video, 16:9,
colour, silent, duration: 10 mins 10 secs

Mesiti filmed this scene at a rock
concert, capturing the adulation of
teens as they gazed at the stage. And
yet, by slowing the speed of the footage
and removing the blaring music, she
leaves us with a gauzy, almost celestial
reverie. It is as if these adolescents
have been transported not just into
an emotional state of rapture but into
Heaven itself, in the rapture that some
Christians believe will accompany the
end of days.

We take our first approach from phenomenology. Where previous
philosophical schools tended to follow Descartes, treating the body as
a device for gathering sensory data, which is then analysed by the mind,
phenomenology emphasizes the body itself as a primary site of encounter
with the world. As Maurice Merleau-Ponty argues, we are always in tactile
contact with the world around us, which we 'grip' through our 'flesh'. In
Phenomenology of Perception, he explains how this tactile experience connects
us not only to objects but to one another:

> [I]t is precisely my body which perceives the body of another,
> and discovers in that body a miraculous prolongation of my own
> intentions, a familiar way of dealing with the world. Henceforth, as
> the parts of my body together comprise a system, so my body and the
> other's are one whole, two sides of one and the same phenomenon. . .
> [which] inhabits both bodies simultaneously.

Echoes of Merleau-Ponty's insights can be found in Sigalit Landau's
performances, in which she opens her naked body to the wounding presence
of the world around her, or Byron Kim's *Synecdoche*, which records the
world through the skin tones of the people he encounters, from strangers
to loved ones. Perhaps most clearly, we can feel the mutual 'grip' our bodies
have on one another in the photographs of Spencer Tunick, in which he
gathers thousands of nude participants until, in his words, 'the body becomes
one organism'. The full implications of Merleau-Ponty's phenomenology,

so palpably embodied in works of contemporary art, are still only just beginning to be felt in theology. Traditional divisions between immanence and transcendence, for instance, might need to be rethought if we consider flesh rather than spirit to be the pervasive, unifying reality of our world. Likewise, a revaluation of our 'miraculous' interconnection might lead to new understandings of peoplehood for Jews, while Christians might think afresh about what it means for God to be incarnate in the person of Jesus Christ.

While phenomenology can help attune us to how we make sense of our bodies, and our place in the world, its pursuit of universal dilemmas and questions can risk reducing all bodies to a single – usually male – archetype. To treat embodied experience more fully we must also take account of sexual and cultural difference. Within both religious studies and art history, some of the greatest advances in this direction have come from feminist scholarship. While early feminist efforts often focused on rectifying the omission or neglect of women in the canon – whether scriptural or art historical – the ambitions of the feminist project run much deeper. As the art historian Griselda Pollock puts it:

> Feminist interventions take part in the profound attempt to shift the very bases of our thought and knowledge systems towards not merely a polite acknowledgement but a deep, self-transforming and culturally shifting recognition of the power politics of Eurocentric, phallocentric, heteronormative universalization by which anyone other than the white, straight, European Christian is an other.

In practice, such interventions can, and do, take place in various ways. Utilizing the resources of contemporary art, we might think, for instance, about the restrictive as well as affirmative implications of wearing the veil in Islam (Marjane Satrapi, Aidan Salakhova, Rashid Rana, Güler Ates, and Kader Attia); or the problematic celebration of sexual 'modesty' or 'purity' in Judaism (Jacqueline Nicholls) and Christianity. One of the most pressing needs is to combat violence against women, whether through acknowledging the persecutions of the past (Kiki Smith) or the ignominies of the present, epitomized by the beatings and 'modesty checks' of female protestors during the Arab Spring and Green Movement (Ghada Amer and Shirin Neshat). While some might view the production and analysis of such art 'as a kind of contamination, soiling [art's] transcendent beauty with the messy business

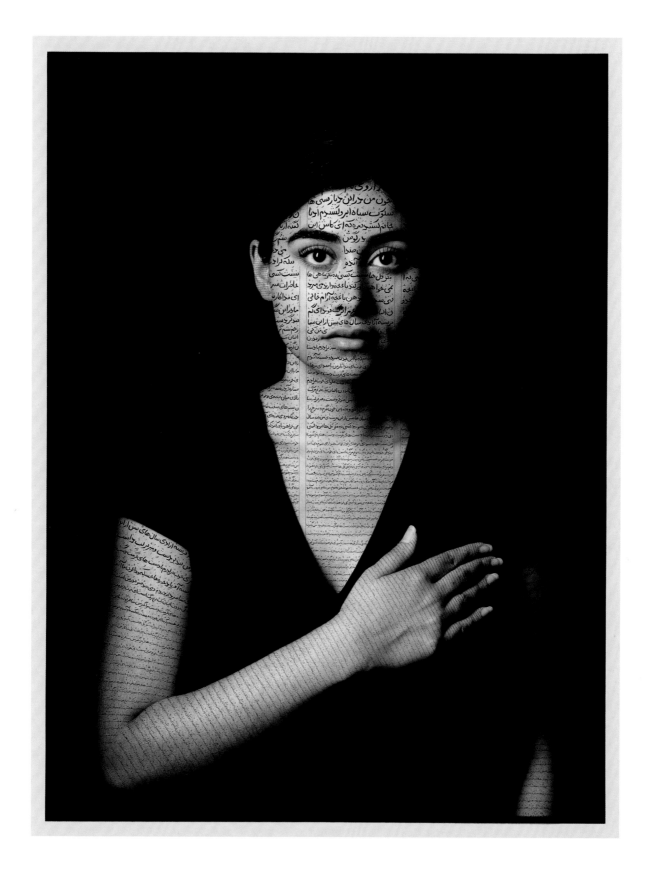

of life', writes Pollock, it may instead reveal the very 'source of its complexity and social effectivity'.

As Pollock suggests, the study of gender has become increasingly nuanced in recent decades, recognizing the urgency of addressing the marginalization of sexual minorities, including gays, lesbians, bisexuals, and transgendered individuals. One of the key catalysts in this development, now a classic in the field of queer studies, was Judith Butler's *Gender Trouble*, published in 1990. There, Butler introduced her influential, yet often misunderstood notion of 'performativity'. In her subsequent volume, *Bodies that Matter*, she explained:

> There is a tendency to think that sexuality is either constructed or determined; to think that if it is constructed, it is in some sense free, and if it is determined, it is in some sense fixed. These oppositions do not describe the complexity of what is at stake in any effort to take account of the conditions under which sex and sexuality are assumed. The 'performative' dimension of construction is precisely the forced reiteration of norms. . . Performativity is neither free play nor theatrical self-presentation; nor can it be equated with performance.

In other words, while we cannot simply wish away the norms of a given cultural context, neither are we doomed slavishly to repeat them. In our constant performance of gender and sexuality we enact, adapt, and at times challenge the norms that condition us. Religion generates and sustains some of the most visible norms, and it is no wonder that artists seeking to destabilize these expectations have often revisited the heroes and saints of the religious past in order to read them, for instance, as icons of homosexual desire (Adi Nes and Yves De Brabander). Artists have also toyed with Orientalist tropes. Thus, Taner Ceylan disrupts the heterosexual fantasy of the exotic, veiled female with a nude male, literally uncovering a repressed homosexuality. In the end, we are all caught up, one way or another, in the performance of a *Fake World*. It may not be possible to escape the conforming pressures of cultural norms, but it should not stop us from declaring, alongside Greer Lankton: when it comes to our bodies, *It's all about ME, Not You.*

◄ **SHIRIN NESHAT** IRAN/USA
Nida (Patriots), 2012
Ink on LE gelatin silver print, 152.4 x 114.3 cm
(60 x 45 in.)

Using her signature process, Neshat applies texts to photographs and then re-photographs them, indelibly fusing image and text. The title of this series 'The Book of Kings' – and indeed much of the calligraphy – derives from the *Shahnameh*, or *The Book of Kings*, the epic tenth-century poem celebrating the history of Persia from its birth up to the Islamic conquest of the seventh century. Her portraits link the bravery of pro-democracy demonstrators during Iran's recent Green Movement to the heroic exploits of Persia's past.

▷ **RON MUECK** AUSTRALIA

Youth, 2009

Mixed media, 65 x 28 x 16 cm (25⅝ x 11 x 6¼ in.)

Many of Mueck's works have their roots in religious subjects, especially following his two-year period as artist-in-residence at the National Gallery in London, where he studied the iconography of the old masters. No disciples accompany this small, vulnerable Jesus, incarnated as a contemporary black adolescent. In fact, Jesus seems to examine himself, as if requiring confirmation of his own (im)mortality, perhaps in the wake of a knife attack.

△ **NAZIF TOPÇUOĞLU** TURKEY

Is it for Real?, 2006
C-print, 112 x 133 cm (44⅛ x 52⅜ in.)

Topçuoğlu re-stages Caravaggio's *Incredulity of St Thomas* (*c.* 1600) exclusively with women. Whereas Caravaggio's disciples peer at Christ's wound with stern, scientific rigour, Topçuoğlu's disciples seem to regard their compatriot's scar (perhaps from heart surgery) more out of empathy and concern. One of the women lovingly cradles the elbow of the central figure as she reveals her trauma. Would it be different if all Jesus's disciples had been women? Would they have reacted with Mary's devotion instead of Thomas's doubt?

△ **BYRON KIM** USA

Synecdoche, 1991–present

Oil on wax on luan, birch plywood, and plywood, each panel: 25.4 x 20.32 cm (10 x 8 in.), overall: 305.4 x 889.6 cm (120¼ x 350¼ in.)

Kim challenges traditional conceptions of abstraction as 'pure' or detached from the world, creating monochromes that are inseparable from questions of ethnicity and culture. '[E]very part of [*Synecdoche*] represents the whole,' writes Kim, 'and the whole piece represents all of us in a way. . . .For the infant child the mother's skin is sort of like a universe, and that's exactly what my work came to be eventually; work that was concentrating on something very small to evoke something very large.'

▽ **SPENCER TUNICK** USA

Sydney 1, 2010
C-print mounted between plexi, 121.9 x 152.4 cm (48 x 60 in.)

'Some of my most memorable works,' says Tunick, 'are when the
bodies are very close together, sort of forming a sea of flesh as
opposed to seeing sand or pavement between the bodies.' His 'work
is not about sex', he insists. 'Any eroticism in my work tends to exist
before and after [a shoot] but very rarely during it.' In fact, he says,
'It can be a very spiritual experience for [participants].'

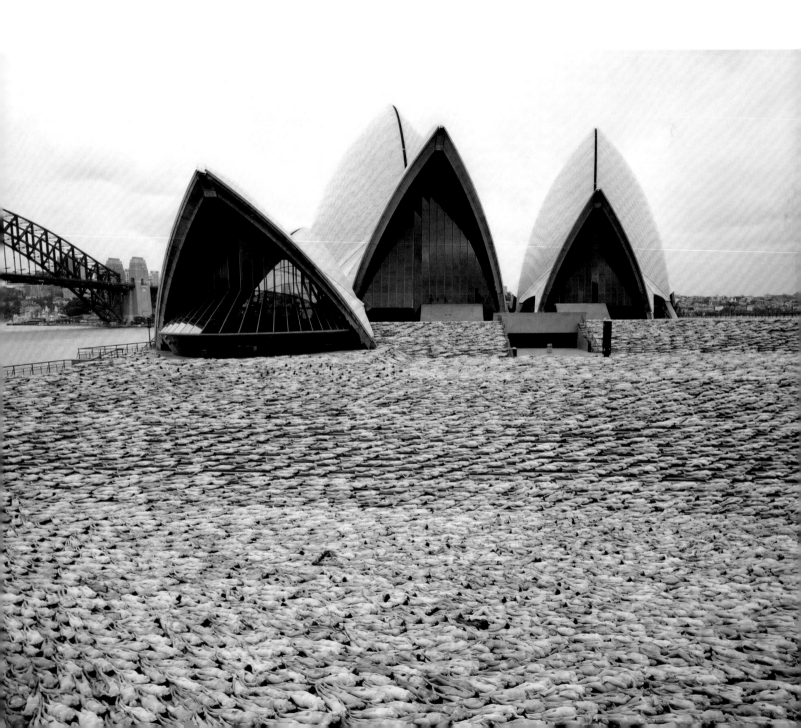

216

△ **AIDAN SALAKHOVA** AZERBAIJAN/RUSSIA

Waiting Bride, 2010–11

Marble sculpture

'When the woman covers herself with the veil it has two meanings in one,' says the artist. 'First the woman feels free inside. But at the same time she has repressions of [*sic*] herself from the outer world.' In 2011, this work – and an accompanying sculpture *Black Stone* (2011) – became the first works of art censored by a country in its own pavilion at the Venice Biennale. Ironically, the veiled *Bride* was covered with cloth by government officials before being removed.

▽ **MARJANE SATRAPI** IRAN/FRANCE

The Veil, 2000

Illustration from *Persepolis I* (English translation: Pantheon, 2003)

Satrapi takes inspiration from the self-reflective style of Art Spiegelman's graphic novel *Maus*. 'I'm not a moral lesson giver,' she says. 'It's not for me to say what is right or wrong. I describe situations as honestly as possible. . . .That's why I use my own life as material. . . .Because the world is not about Batman and Robin fighting the Joker; things are more complicated than that. And nothing is scarier than the people who try to find easy answers to complicated questions.'

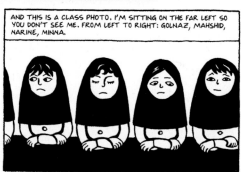
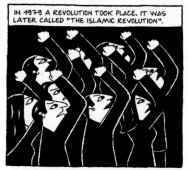
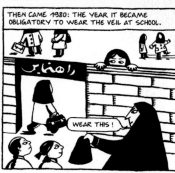
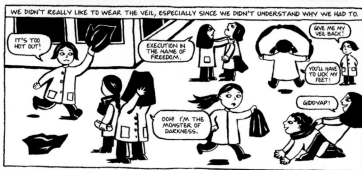

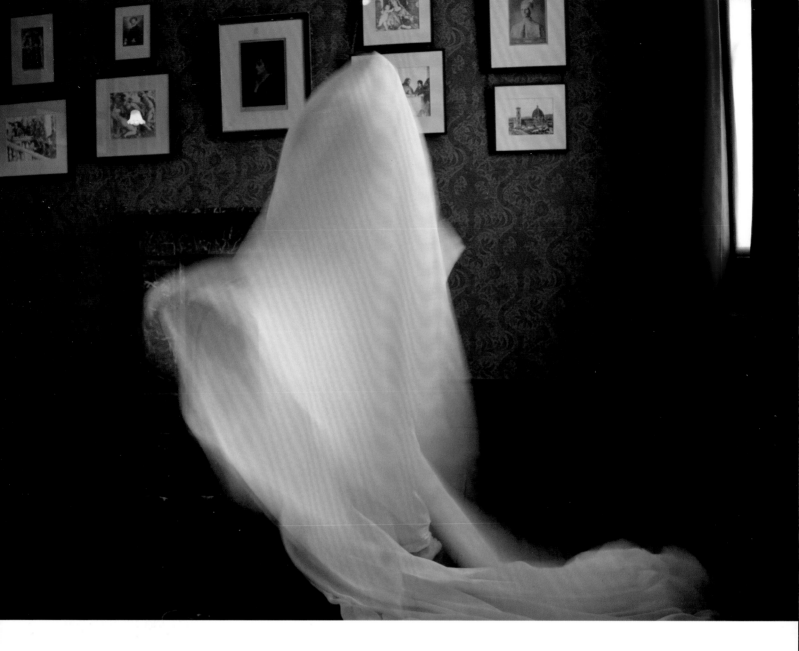

△ **GÜLER ATES** TURKEY

Purged of Sensuality, 2010
Archival digital print, 60 x 82 cm (23⅝ x 32¼ in.)
Photograph taken at Leighton House Museum, London

Ates's works evoke associations across multiple periods and places,
from Ottoman Turkey to Victorian England. She chooses the models
behind her diaphanous figures carefully, working with people from
various religious and cultural backgrounds. In doing so, she aims to
unsettle prejudices and presumptions about who we might think
lies behind this or any other veil. Ironically, her veiled figure is not
'purged of sensuality' at all.

△ **KADER ATTIA**

Ghost, 2007

Aluminium foil in 264 parts, dimensions variable

'My aim is to reveal that there is a cultural gap between the Western and non-Western worlds through different understandings of the aesthetics of the human body,' says Attia. From behind, we seem to see women in chadors, kneeling in prayer; from the front, only emptiness. 'The more I created,' he recalls, 'the more I felt a void, in both its physical and temporal dimensions. . .the viewer is just in front of a representation of his fragility and his finiteness.'

▷ **GHADA AMER** EGYPT/USA

The Blue Bra Girls, 2012

Stainless steel, 185.4 x 152.4 x 137.2 cm
(73 x 60 x 54 in.)

This sculpture, Amer explains, 'refers to the incident that took place during an uprising in Egypt in which a female protestor wearing a veil was beaten by the police and had her clothes torn. A photograph. . .revealed she was wearing a blue bra.' Amer says she wanted to create 'a sculpture in which women would look defiantly at the public. . . I also wanted the women standing, instead of lying down. . .[in] homage to all those women who stand up for themselves and fight.'

▷ **RASHID RANA** PAKISTAN

Veil Series I, II, and III, 2004

3 C-prints, diasec, each: 51 x 51 cm (20⅛ x 20⅛ in.)

The burqa in Rana's composite photo-based
work is comprised of thousands of tiny
pornographic photographs. 'Westerners
think all Muslim women are veiled,' he says.
'Many men in non Western culture associate
Western women with pornography. I wanted
to challenge these prejudices from both sides.'
He adds, 'Today, every image, idea and truth
– whether in ancient mythology or the news
of the day – encompasses its opposite within
itself. We live in a state of duality. . . .My works
are an effort to represent this complexity.'



△ **JACQUELINE NICHOLLS** UK

Modesty Kittel, 2012

White cotton with embroidery, 45 x 9 cm (17¾ x 3⅝ in.); pencil on paper,
42 x 29.5 cm (16⅝ x 11⅝ in.)

Modesty Kittel belongs to a series of works in which Nicholls radically
refashions the robes worn by Orthodox Jewish men for High
Holidays, weddings, and burial. Here she pinpoints the hypocrisy
that underlies demands for *tzniut*, or modesty, among Jewish women.
Pornographic images sown in white thread across the white blouse,
invisible at first glance, pull us in and then indict us for our lascivious
gaze. To wear the garment would be to don a straightjacket, complete
with padlock.

Untitled (David and Jonathan), 2006
C-print, 140 x 180 cm (55⅛ x 70⅞ in.)

In his 'Bible Stories' series, Nes uses models dressed as homeless
people to critique social injustice in contemporary Israel. Here, two
bedraggled young men – perhaps cast out of their homes for their
sexuality – are endowed with dignity by comparing them to David
and Jonathan. The Bible tells us 'the soul of Jonathan was bound
to the soul of David, and Jonathan loved him as his own soul'
(1 Samuel 18.1) – a relationship we might well read as romantic.

▽ **YVES DE BRABANDER AND DAVE SCHWEITZER** BELGIUM

Saint Sebastian, 2008
Dibond print, 180 x 120 cm (70⅞ x 47¼ in.)

In his '*Ecce Homo*' series, De Brabander re-imagines religious figures in modern settings with homoerotic undertones. In casting St Sebastian as an object of homoerotic desire, De Brabander takes inspiration from a long line of masters including Andrea Mantegna, El Greco, and Guido Reni, who often depict the saint with little or no clothing, writhing towards the viewer as arrows pierce his flesh.

△ **TANER CEYLAN** GERMANY/TURKEY

Yalan Dünya/Fake World, 2011
Oil on canvas, 160 x 130 cm (63 x 51½ in.)

Like many of Ceylan's works, *Yalan Dünya* draws upon popular sources, including an eponymous Turkish song, as well as art historical references, such as Alexander Roslin's *The Lady with the Veil* (1768). Ceylan's photorealist painting style adds a further layer to the theme of misleading mimesis. Sexual desire is also a recurring theme for the artist, who connects it to spirituality. He says he often uses 'the body as a tool to pray, as a tool to reach God'.

◁ **VICTOR MAJZNER** AUSTRALIA

A Seal upon Your Heart, 2011
Synthetic polymer on canvas, 160 x 145 cm
(63 x 57⅛ in.)

This piece was inspired by a story I told the
artist about the loss of my sister Whitney, and
the importance for my family of the promise
of the Song of Songs: 'Love is as strong as
death' (8.6). But there are other ways to pick
one's path through this forest of symbols.
Following the *tefillin*, or phylacteries, which
wrap around Hebrew letters like tendrils,
we might also find a story about the love for
Jewish tradition.

△ **SIGALIT LANDAU** ISRAEL

DeadSee, 2005
Video, duration: 11 mins 39 secs

Formally, Landau's *DeadSee* recalls Robert Smithson's massive *Spiral
Jetty* (1970), constructed in Utah's Great Salt Lake. Unlike Smithson's
monumental earthwork, however, the focus of Landau's piece is her
own naked body; its vulnerability accentuated by the wounded flesh
of the floating watermelons. The Dead Sea, she says is 'so extreme,
it's like a text. Something that is so lifeless and so physical'.

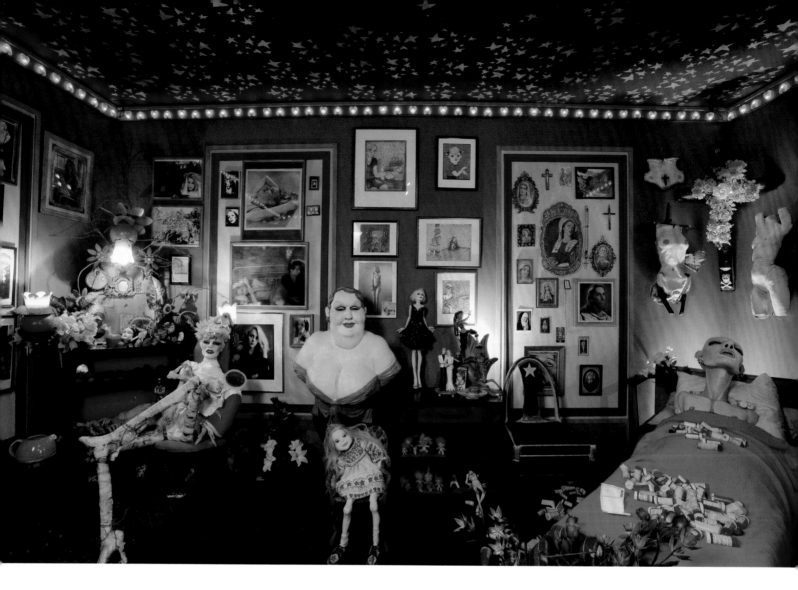

△ **GREER LANKTON** USA

It's all about ME, Not You, 1996
Wood, vinyl siding, Astroturf, and paint
Permanent installation, Mattress Factory, Pittsburgh, PA

Lankton was born Greg, the son of a Presbyterian minister, and
it was with the financial assistance of the congregation that Greg
underwent a sex change at the age of twenty-one, thereafter
identifying as Greer. The installation replicates Lankton's final
apartment, stuffed with shrines recalling her life at the heart of the
eighties East Village art scene, replete with her signature dolls, which
she continually cut and reassembled like a plastic surgeon. She died
shortly after seeing this work installed.

Pyre Woman Kneeling, 2002
Bronze and silica bronze, 94 x 154.9 x 83.8 cm (37 x 61 x 33 in.)

Smith hopes such sculptures will be placed in cities across Europe
in commemoration of the murder of suspected witches. Raised as a
Catholic, Smith says she has always 'wanted to believe in a God, find
some kind of God that I could make a shrine to. But I can't.' She does,
however, succeed in finding saints, taking the memory of alleged
female heretics and celebrating them as martyrs. 'Their arms are out,
like Christ saying, "Why have you forsaken me?"'

10 ◆ GALLERIES
AND SANCTUARIES

+ Ever since the first art museums sprung up during the Enlightenment, visitors have compared them to religious spaces. In the eighteenth century, after visiting the Dresden Gallery, Johann Wolfgang von Goethe declared that 'the profound silence that reigned, created a solemn and unique impression, akin to the emotion experienced upon entering a House of God'. When the National Gallery opened in London in the nineteenth century, the writer William Hazlitt declared it a veritable 'holy of holies', remarking that visiting felt 'like going on a pilgrimage. . .[to] the shrine of Art'. In the twentieth century, the French writer and statesman André Malraux famously speculated that museums would become the cathedrals of the modern age – an idea echoed this century by the writer Alain de Botton. If museums can function like sacred spaces, so too can sanctuaries resemble museums.

Today, many of the world's great religious sites, from Angkor Wat to St Peter's Basilica, are visited and venerated as much for their artistic merit as their spiritual significance. The sociologist Graham Howes observes that while in many places, particularly in England, 'public observance is contracting, church, and especially cathedral, *visiting* is expanding', as they 'become sites of essentially *secular* pilgrimage'. For those involved in the heritage sector, this can be welcome news. Simon Jenkins, for instance, declares in a popular guide to English churches that 'The Church of England is the true Museum of England'. For religious institutions, however, such conflations can be troubling. Remarking on a spate of new churches erected in Rome, one Vatican official observed recently that 'At best, these are like museums, spaces that do not suggest prayer or meditation.' Ultimately, whether critics are excited or appalled by such resemblances, sacred spaces and museums are probably in no danger of swapping places any time soon. What is most interesting is not whether the two are – or indeed should

◁ **GERHARD RICHTER**
GERMANY
Detail of Kölner Domfenster (Cologne Cathedral window), 2007

St Paul and the Huia, 2008
Tempera on wood, 80 x 65 cm (31½ x 25⅝ in.)
St Paul's Cathedral, London

In the 1980s, the Church of England
made an historic declaration approving
the use of icons in churches, marking a
new era in its historically complicated,
ambivalent relationship with images. Since
then, there have been several significant
icon commissions, as well as devotional
books about the use of icons published by
the former Archbishop Rowan Williams.
O'Callaghan's icon draws on his experience
as an ordained Anglican priest, and his Maori
heritage, evident in the sacred Huia bird,
now extinct.

be – the same, but rather in what circumstances they borrow the modes
and strategies of the other, and why.

While many early galleries were stacked wall-to-wall like treasure
chambers, in the twentieth century galleries became increasingly spare,
culminating in what the critic Brian O'Doherty christened 'the white
cube'. Today, these pristine spaces – and the rarified, disembodied
viewing experience that they encourage – have become the norm.
Over the past two decades, however, a new aesthetic – or, rather, an
updated version of an old one – has begun to gain traction. Through
a series of blockbuster exhibitions including *Seeing Salvation* (2000),
The Sacred Made Real (2009–10), and *Devotion by Design* (2011), the
National Gallery in London has sought to encourage 'modern secular
audiences [to] engage with the masterpieces of Christian art at an
emotional as well as purely aesthetic or historical level'. To achieve this
goal, curators have employed crepuscular lighting schemes, darkened
walls, reduced wall texts, and even liturgical music, hoping to evoke the
ecclesial environments in which many works were first displayed. For
the most part, such strategies have been limited to exhibitions of pre-
modern works, on the premise that doing so provides a window on to
the practices of the past, much like attending the Globe Theatre to see a
performance of Shakespeare. It is far more unusual for curators to display
contemporary art in such religiously charged environments. We are left
to wonder, for example, how our experience of Ai Weiwei's *Fragments*
(2005) from Qing Dynasty temples, or Preston Singletary's Tlingit-
inspired *Clan House* (2008), might change in settings that accentuated
their religious content.

When modern art is displayed in ways that encourage religious
encounters, it tends to be at the express insistence of artists themselves.
Mark Rothko's bequest to the Tate, for example, stipulated a single room
with low lighting and off-white walls for his *Seagram Murals* (1958),
while James Turrell specified the seating and layout for his 'skyspace'
in MoMA PS1 (1986). More recently, Chris Ofili collaborated with the
architect David Adjaye to create the warm, embracing atmosphere of *The
Upper Room* (1999–2002) for his paintings inspired by the Last Supper.

While Ofili and Adjaye effectively created a chapel inside Tate Britain, other artists have erected independent structures that blur the boundary between artistic and religious space. In 2011, Pieterjan Gijs and Arnout Van Vaerenbergh created an open-air chapel for the Belgian museum Z33, imagining a church inseparable – perhaps even indistinguishable – from the world around it. More controversially, in 2007, Gregor Schneider reproduced the Ka'aba – the holiest site in Islam – on the plaza outside the Hamburger Kunsthalle, presenting the museum as a cultural, possibly even spiritual Mecca. Before it was realized in Hamburg, plans to erect the structure were rejected in Jerusalem, Rome, Venice, and Berlin. While some officials suggested they took this step to avoid offending Muslims, the artist sees it differently. For him, such reticence smacks of censorship, and an unwillingness in today's art world to take risks in socially and politically charged situations. When *Cube* was shown in Hamburg, Schneider points out, it received an overwhelmingly positive reception from Muslims, many of whom saw it as a tribute to their faith and an opportunity for dialogue. Given the success of installations from *The Upper Room* to *Cube Hamburg*, future projects will undoubtedly continue to probe the boundaries between art and religion in the public square.

Just as a deeper engagement with religion has opened horizons for museums and galleries, contemporary art has ushered in fresh possibilities for religious institutions. For disused or deconsecrated spaces in particular, art can provide a way to recover and potentially reactivate lost histories. In 2012, for instance, the Cultural Heritage Artists Project held an exhibition inspired by the dozens of abandoned synagogues in downtown Detroit, inviting artists to research these spaces and – at least imaginatively – regenerate them. In other cases, worship spaces have been physically resurrected as art galleries and museums. Sometimes this has been temporary, as in Wallspace in London, which occupied All Hallows-on-the-Wall, or in John Newling's *Chatham Vines* (2004), which turned an unused church in Kent into a hydroponic vineyard. Other edifices have been permanently converted into exhibition spaces, such as Trnava Synagogue in Slovakia, in which Miroslaw Balka created his elegiac *Agoganys* (2010), or the Eldridge Street Synagogue in

△ **BRIAN CATLING** UK
Processional Cross for St Martin-in-the-Fields, London, 2013
Aluminium gilded in white gold

While Catling calls to mind the agony of Germaine Richier's controversial cross, he delivers a more reassuring promise of redemption. The Vicar of St Martin-in-the-Fields, Sam Wells, notes that Catling's Cross 'brings together themes of suffering, shame, and glory. . . .The contorted shape of the wood invites passionate engagement with the horror and exclusion of the Cross, while the gold inspires us to believe that all our human failure and folly will be redeemed in Christ's final overcoming of suffering and death'.

The Holy Opening, interior design for Mary, Help of Christians Church, Goldscheuer, Kehl (Germany), 2011

Working on scaffolding to spray paint the church, Strumbel recalls 'feeling as shit-scared as I did when tagging on a train. Then, instead of police sirens, church bells begin to toll over my head, and I get exactly the same kind of adrenaline-rush, perhaps even better.' However iconoclastic its origins, Strumbel's street art dovetails elegantly with the iconographic demands of the Catholic Church. The artist says he adores churches, calling them 'the most beautiful kind of museum'.

232

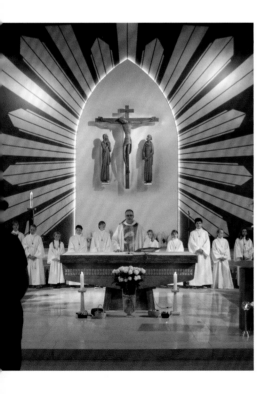

New York, home to historic and artistic exhibitions. Art can also stimulate a religious renascence, as the Maine Jewish Museum found when it transformed an historic synagogue into an art museum, paving the way for the revival of the Jewish community, which shares the space with the museum.

For active religious communities, commissioning works of contemporary art can prove both high risk and high reward. As Meyer Schapiro notes, the success of new works often:

> . . .depends on the initiative and self-reliance of a particular inspired individual – a minister, priest, or layman – whose convictions about art are strong enough to surmount the usual constraints of denominational opinion and the tastes of parishioners.

Consensus, in other words, seldom yields visionary results. At the same time, however, an 'inspired' advocate must be careful not to press congregants too far beyond their comfort level. External displays, like Jenny Holzer and Martin Firrell's text projections, or Rose Finn-Kelcey's tapestry, provide a case in point. While they can dynamically reframe an institution's relationship with the public, even attracting new churchgoers, they can also rankle those accustomed to the familiar appearance of their place of worship. Changes inside the sanctuary, whether structural, decorative, or liturgical, can prove even more sensitive. Frequently, debates have centred on the choice of abstract over figurative imagery (Gerhard Richter, Shirazeh Houshiary, and Brian Catling) or the use of non-traditional media (Tracey Emin, Stefan Strumbel, and Bill Viola). It is even possible for consummately traditional forms of art, like Orthodox icons, to feel thoroughly untraditional to those unaccustomed to them, especially in Protestant churches. In nearly every case, what proves decisive is usually whether new works are given time to become incorporated into the ritual life of a given community. If so, some of the most controversial works often become some of the most beloved.

Not only can art energize existing communities, it can also foster new ones, joining people from different traditions. The great chapels by Henri Matisse, Mark Rothko, and Louise Nevelson in the twentieth century, and by Peter Zumthor and Anthony Caro in the twenty-first century, are not just Christian spaces. To begin with, artists bring their own religious perspectives

to commissions, as in the case of Rothko, Nevelson, and Caro who drew on their Jewish heritage. Just as importantly, great art has a way of escaping categorization. These chapels have become pilgrimage destinations not just for practising Christians on the one hand, or aficionados of modern art on the other, but for people from various backgrounds seeking 'some sort of pathway to truth', as Caro puts it.

In addition to spaces for ecumenical and interfaith contemplation, there is also an increasing demand in the twenty-first century for multi-faith worship spaces. While in the past such spaces were usually bland, practical affairs located down dreary hospital or airport corridors, artists such as Tobi Kahn have demonstrated that it is possible to satisfy disparate religious demands without settling for aesthetic pabulum. Architects, too, have offered creative solutions, from a design in London for an edifice that is a mosque on Fridays, synagogue on Saturdays, and church on Sundays, to the House of One in Berlin, in which a mosque, synagogue, and church branch off separately from a shared, central space. Perhaps it is telling that the architects responsible for the House of One began their practice designing spaces and displays for art exhibitions. Religious practitioners might indeed learn something from the way in which works of art coexist in a well-curated gallery, speaking distinct yet mutually intelligible languages. As we have seen throughout this book, art and religion each offer powerful ways of seeing the other. And perhaps in doing so, they also help us see ourselves a little more clearly.

▽ **DAN LEON, MATTHEW LLOYD, AND SHAHED SALEEM** UK
Friday Saturday Sunday, 2012–ongoing
Architectural project, London

The three architects are Jewish, Anglican, and Muslim, respectively. 'We acknowledged from the start that religion is difficult and complex, and each religion has divergent beliefs and practices,' they write. 'The underlying idea of our project is not that differences should be disregarded, or that all faiths are or should be one. It is rather that these three faiths have an entwined and symbiotic series of relationships, and a history of tolerance and co-existence greater than their history of conflict.'

◁ **KUEHN MALVEZZI** GERMANY

The House of One, design from 2012
View from Gertraudenstrasse, Berlin

The architects wanted to create 'a building like a city, inwardly heterogeneous while identifiable from the outside', writes Wilfried Kuehn. At the very centre of the building lies a 'space with a dome and a centralized plan, higher than the three surrounding houses of prayer. . . .At the same time, this fourth space is very humble, acting as a threshold to the sacred spaces and thus bringing the public space of the city into the building.'

▷ **TOBI KAHN** USA

Emet, Meditative Space, HealthCare Chaplaincy, New York City, 2001

Kahn's meditation room provides chaplaincy staff – normally tasked with supporting others through pain, anxiety, and grief – with a regular space for prayer, contemplation, and spiritual recuperation. Kahn's primary dilemma was how to provide this respite in a way that was meaningful for individuals with shared professional goals but widely divergent beliefs and practices, since chaplains are ordained in a range of Christian and Jewish denominations, as well as Zen Buddhism and Islam. Kahn calls the space *Emet*, truth in Hebrew.

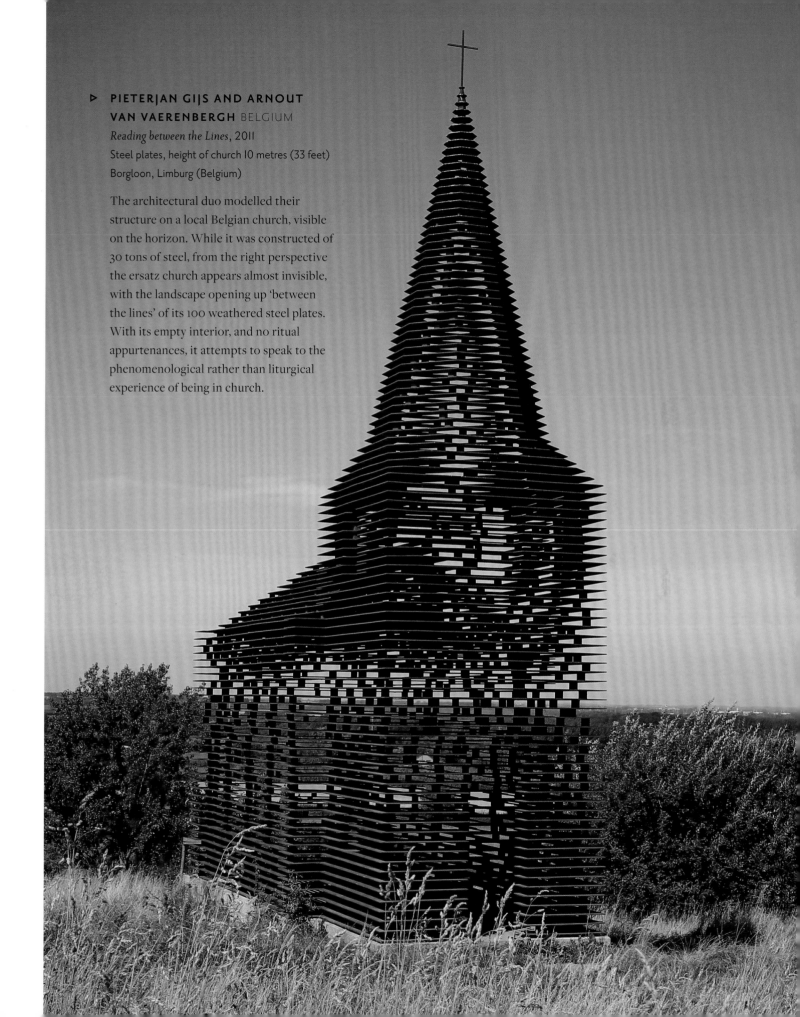

▷ **PIETERJAN GIJS AND ARNOUT VAN VAERENBERGH** BELGIUM
Reading between the Lines, 2011
Steel plates, height of church 10 metres (33 feet)
Borgloon, Limburg (Belgium)

The architectural duo modelled their structure on a local Belgian church, visible on the horizon. While it was constructed of 30 tons of steel, from the right perspective the ersatz church appears almost invisible, with the landscape opening up 'between the lines' of its 100 weathered steel plates. With its empty interior, and no ritual appurtenances, it attempts to speak to the phenomenological rather than liturgical experience of being in church.

▽ **GREGOR SCHNEIDER** GERMANY

Cube Hamburg, 2007
Mixed media, 1400 x 1400 x 1400 cm (551¼ x 551¼ x 551¼ in.)
Installation view, Hamburger Kunsthalle, Hamburg

Schneider says the concept for the Cube came from a discussion
with a Muslim colleague, who 'explained that to understand the
essence of space I should occupy myself with the Ka'aba'. He
explains elsewhere: 'My hope is that this reduced cube might
remind us of the cultural elements that we have in common.'
In addition to resembling the holy Ka'aba of Islam, it also recalls
Kasimir Malevich's famous *Black Square* (1915), itself a reference
to Orthodox icon painting.

△ **AI WEIWEI** CHINA

Fragments, 2005
Iron wood (*tieli*), tables, chairs, and parts of beams and pillars from dismantled
temples of the Qing Dynasty, 500 × 850 × 700 cm (196⅞ × 334⅝ × 275⅝ in.)

Prior to the modern era, Ai reflects, Chinese culture displayed a
'total condition, with philosophy, aesthetics, moral understanding
and craftsmanship'. After the upheaval of the Cultural Revolution,
and recent capitalist reforms, he says, 'this is a large space that
needs to be occupied'. *Fragments* evokes this sense of rupture by
using salvaged wood from demolished temples of the Qing Dynasty
(1644–1911). From above, the structure creates an outline of China,
perhaps signalling the possibility of resurrecting this lost coherence
and creativity.

△ **CHRIS OFILI** UK

The Upper Room, 1999–2002

Oil paint, acrylic paint, glitter, graphite, pen, elephant dung, polyester resin, and map pins on 13 canvases, each: 183.2 x 122.8 cm (72⅛ x 48⅜ in.)

Installation view, Victoria Miro Gallery, London, 2002

Drawing upon the King James Bible's description of an 'upper room' in which the Last Supper takes place (Matthew 14.15), Ofili's thirteen canvases represent Jesus surrounded by his disciples. Each composition features a brightly coloured rhesus macaque monkey resting on balls of elephant dung. The architect David Adjaye reflects, 'Chris wanted to de-commodify painting, to slow the viewer down and make it an experience.' Not only do Adjaye's walnut-wood panels create this effect visually, they lend the room a distinctive aroma.

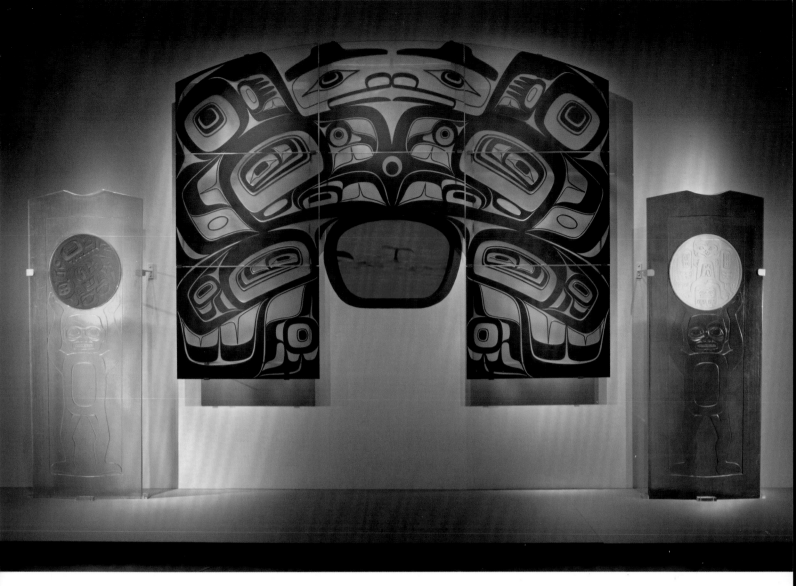

△ **PRESTON SINGLETARY** USA

Clan House (Naakahídi), 2008

Kiln-cast and sand-carved glass; water-jet cut, inlaid, and laminated medallion,
40.6 x 25.4 x 6.4 cm (16 x 10 x 2½ in.)

Singletary's glass installation recalls elements of the traditional
longhouse built by the native Tlingit people of the Pacific
Northwest. While these elements would have been made from
wood by his ancestors, Singletary comments: 'I've come to see
that glass brings another dimension to indigenous art. . . .My work
with glass transforms the notion that native artists are only best
when traditional materials are used.' He has also collaborated with
indigenous artists from across the Americas and Oceania.

▽ **GERHARD RICHTER** GERMANY

Kölner Domfenster (Cologne Cathedral window), 2007
Antique glass, mouth-blown, 2300 x 900 cm
(905½ x 354⅜ in.)

Initially, Richter was asked to create images of
martyrs killed by the Nazis to replace the stained-
glass windows destroyed during the Second
World War. After struggling with this brief, he
found inspiration in one of his own abstract
works, *4096 Colours* (1974), eventually opting
for randomly allocated squares of mouth-blown
glass. The former Archbishop of Cologne Joachim
Meisner strenuously objected to the final product,
complaining that it 'belongs equally in a mosque or
another house of prayer'.

△ **SHIRAZEH HOUSHIARY AND PIP HORNE** IRAN AND UK

East Window, Church of St Martin-in-the-Fields, London, 2008
Glass and stainless steel

Houshiary often draws inspiration from poems on breathing
by the Sufi mystic Rumi. 'I set out to capture my breath,' says
Houshiary, 'to find the essence of my own existence, transcending
name, nationality, cultures'. In the church, these pneumatic
associations take on a new light, evoking the history of the Blitz
– when the original windows were blown out – and the life-giving
breath of the Holy Spirit. Refusing to be still, Houshiary and
Horne's glass cross seems to contract and expand.

△ **TRACEY EMIN** UK

For You, Liverpool Anglican Cathedral, 2008
Neon, 600 cm (236¼ in.)

'The Church has always been a place, for me, for contemplation.
I wanted to make something for Liverpool Cathedral about love and
the sharing of love,' says Emin. Given the confessional, sometimes
sexually explicit works that made her famous, one might read these
words as a declaration of sensual, physical love. Yet as the biblical
Song of Songs teaches us, erotic language can also provide some of
the strongest metaphors for divine love.

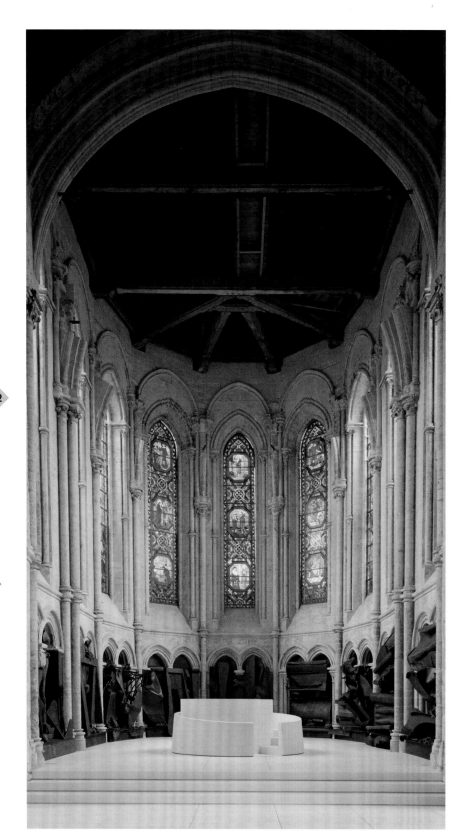

◀ **ANTHONY CARO** UK

Chapel of Light, St Jean Baptiste, Bourbourg, 2008
Baptisimal font: cast concrete
Chapel of Light niches 1–9: steel, stoneware, and jarrah wood

Caro declared he 'very much wanted [the chapel] to be interdenominational. . .
a quiet place in a hectic world. . .where the spiritual and art could and can and should mesh'. At the same time, Caro also created a full-immersion font, making it a fully functioning baptistery (not unlike the baptistery created fifty years earlier at a French church by Marc Chagall, another Jewish artist). Caro's sculptures pick up on this baptismal symbolism, presenting underwater scenes inspired by the story of Creation.

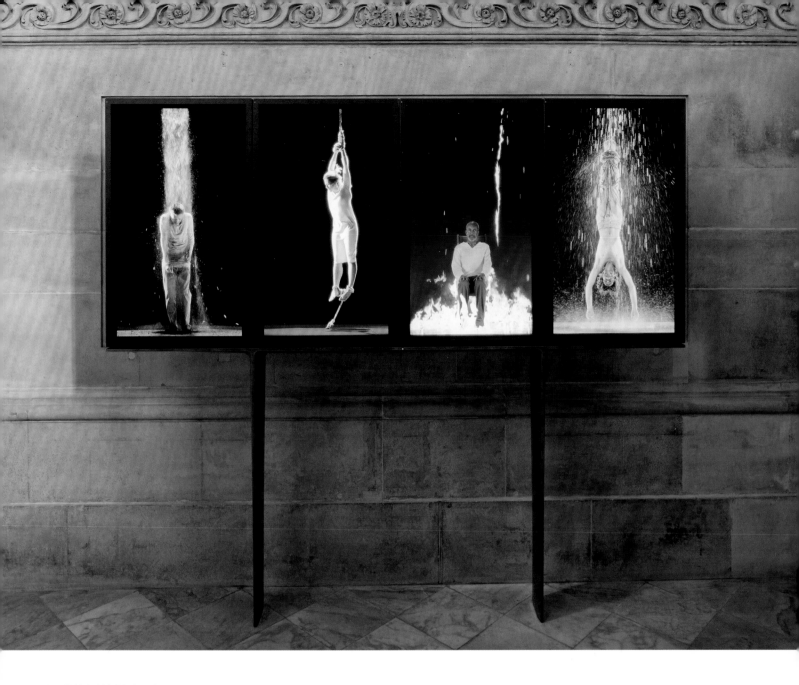

△ **BILL VIOLA** USA

Martyrs (Earth, Air, Fire, Water), 2014
Colour high-definition video polyptych on four vertical plasma displays,
140 x 338 x 10 cm (55 x 133 x 4 in.), duration: 7 mins 15 secs
Installation view, St Paul's Cathedral, London

Viola was commissioned by St Paul's after church officials saw his
exhibition *The Passions* (2003) at the National Gallery in London. The
St Paul's commission was made possible by a practical but also symbolic
collaboration between the cathedral and Tate Modern, located directly
across Millennium Bridge. The framing of the polyptych emphasizes the
conscious homage that this cutting-edge video art pays to traditional
altarpieces, and Viola hopes his works for St Paul's become 'practical
objects of traditional contemplation and devotion'.

▽ **JOHN NEWLING** UK

Chatham Vines, 2004
Vines
Installation view, St John's Church, Chatham, UK

Newling's installation took place over the course of a year, during which he grew thirty-two Pinot Noir grape vines in the central aisle of this disused church in Kent. The project culminated with the harvest of the grapes, which were turned into wine to celebrate the Eucharist at Easter. Not only did Newling literally and metaphorically create new life for the church, he offered a profound vision of the Eucharist, which was produced from the very 'body' of the church.

▷ **MIROSLAW BALKA** POLAND

Agoganys, 2010
Seven snow-machines
Installation view, Trnava Synagogue – Centre of Contemporary Art, Trnava, Slovakia

The artificial snow Balka created in *Agoganys – synagoga* spelled backwards – recalls his videos of Poland's snowy, windswept concentration camps. 'I think that we can only see the Holocaust in fragments,' he reflects. 'I prefer to collect bits and pieces and to stand on the side of the poetry. . . .Adorno questioned if poetry can exist after the Holocaust and I think that, yes, it has to exist – it's the only way. That's why poetry was invented, to help heal people. . . .'

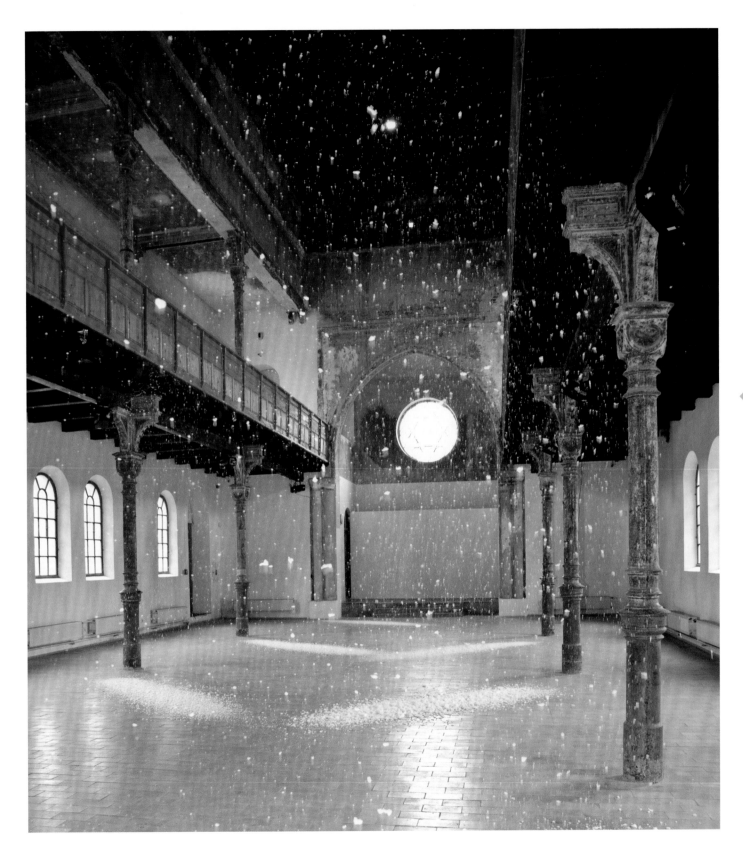

▷ **ROSE FINN-KELCEY**

Angel, 2004

Mural, shimmer discs, plastic, metal, and wood,
521 x 1500 cm (205⅛ x 590½ in.)

St Paul's Church, Bow Common, London

Finn-Kelcey created various works on religious
themes, including *It Pays to Pray* (1999) outside
London's Millennium Dome, which asked
viewers to drop in coins to receive prayers like
chocolate bars. Here she used 83,000 metallic
shimmer-discs to create an angel emoticon.
While the symbol comes straight out of the
Internet age, its tesserae hearken back to
Charles Lutyen's *Angels of the Heavenly Host*
(1963–8) mosaic inside the church, part of
a much longer tradition of church mosaics.

◁ **MARTIN FIRRELL** UK

The Question Mark Inside, 2008
Light projection, St Paul's Cathedral, London

On the dome of St Paul's, Firrell projected
single words such as people, love, hope, life,
thought, breath, and, as shown here, sorrow in
Arabic. In the interior of the dome and on the
western façade, he projected comments entered
online by the public. The quotations selected
were both affirmative and dubious, sometimes
even of the church itself. Statements included:
'Organised religion makes me uneasy'; 'God is
a concept'; 'Morality without religious dogma';
and 'What do we really mean by freedom?'

▷ **JENNY HOLZER** USA

For New York City, 2004
Light projection, St John the Divine,
New York City

Holzer first came to prominence with her
series 'Truisms' (1977–9). While she authored
many of her early texts, recently she has drawn
exclusively upon the words of others, as in
2010 when she projected quotes from German
intellectuals from Goethe to Adorno across the
façades of Frankfurt churches. While images
in churches were once utilized as a sort of
Bible for the illiterate, Holzer turns to texts to
capture the attention of people who are now
saturated with images.

BIBLIOGRAPHY

N.B. Unless otherwise stated, all quotations from the Bible are from the New Revised Standard Version.

Websites given if it is the only way to source the reference.

INTRODUCTION

Berger, Peter, ed., *The Desecularization of the World: Resurgent Religion and World Politics*, Washington, DC: The Ethics and Public Policy Center, 1999.

Bloom, Julie, 'Crucified-Frog Sculpture Troubles the Pope', *New York Times*, 27 August 2008.

Francescani, Christopher, 'Dung-art Whitewash Man: I Did It for Mary', *New York Post*, 20 October 2000.

'Friendship of Nations: Polish Shi'ite Showbiz', slavsandtatars.com.

Halle, David, 'The Controversy over the Show Sensation at the Brooklyn Museum', *Crossroads: Art and Religion in American Life*, eds Alberta Arthurs and Glen Wallach, New York: The New Press, 2001, 139–87.

Hamilton, George Heard, *Painting and Sculpture in Europe, 1880–1940*, vol. 29, 6th ed., New Haven, CT: Yale University Press, 1993.

Higgins, Charlotte, 'Vatican goes back to the beginning for first entry at Venice Biennale', *Guardian*, 31 May 2013.

'Letter of His Holiness Pope John Paul II to Artists', *Libreria Editrice Vaticana*, 4 April 1999.

Nagourney, Adam, 'First Lady Assails Mayor over Threat to Museum', *New York Times*, 28 September 1999.

Otterman, Sharon, 'Catholic Leader Is Turned Away at Exhibit He Deemed Offensive', *New York Times*, 28 September 2012.

'Review – Gilbert & George, *Sonofagod* Pictures "Was Jesus Heterosexual?"' *Londonist*, 1 February 2006.

Robert Rosenblum, lecture on *Demoiselles d'Avignon*, Graduate Theological Union, Berkeley, CA, November 2005.

Scherr, Apollinaire, 'A Fallen Pope Provokes a Sensation in Poland', *New York Times*, 13 May 2001.

Siddique, Haroon, 'Pope labels crucified frog sculpture blasphemous', *Guardian*, 28 August 2008.

CHAPTER 1

Donadio, Rachel, 'Church Plans Art Pavilion at Biennale', *New York Times*, 14 May 2013.

'Doug Argue: Art of Translation', Edelman Arts, New York, 2012.

Fujimura, Makoto, 'Refractions 35: The Artist and the Beautiful (Part 2): The Mystery of Mysteries', 25 June 2010. http://www.makotofujimura.com.

'Interview: Jason Rhoades and Michele Robecchi', *Contemporary* magazine 81, 2006.

'National Museum of the American Indian Welcomes New Sculptures by Artist Rick Bartow', press release, Smithsonian's National Museum of the American Indian, 30 August 2012.

Steiner, Susie, 'Living with a Young Master: Italian landscape (8), Marc Quinn', *Guardian*, 21 June 2003.

'The Vanity of Small Differences', Victoria Miro Gallery, 7 June–11 August 2012.

Widmer, Ted, 'R. Crumb, The Art of Comics No. 1', *Paris Review* 193, summer 2010.

CHAPTER 2

Anderlini, Jamil, 'Zeng Fanzhi: A wealth of art in China', *Financial Times*, 20 September 2013.

Bourriaud, Nicolas, 'Wim Delvoye: Interview', Galerie Perrotin, Paris, 2014.

Cooper, Anderson, 'Cosimo Cavallaro: Interview', *AC 360*, CNN, 29 October 2007.

Geuna, Elena, 'Interview with Zhang Huan. Rebirth: Between Spirituality and Tradition', *Zhang Huan: Rebirth*, Italy: ProjectB Contemporary Art, 2009.

Gilbert & George: Major Exhibition, Tate Modern, London, 15 February–7 May 2007, Room Guide: Room 13.

'Greg Semu: About', http://www.gregsemu.com.

Hirst, Damien and Richard Prince, 'A Conversation', 2009, http://www.damienhirst.com.

Huan, Zhang, *Zhang Huan Ash*, London: Haunch of Venison, 2007.

'Interview with David LaChapelle', *TALK ASIA*, CNN, transcript of television interview, 22 June 2011.

'Interview: David Shrigley', *Monokultur*, 2007.

John, Elton, 'I want Love', *Songs from the West Coast*, London: Mercury Records, 2001.

Jury, Louise, 'Gilbert & George ask: "Was Jesus heterosexual?"' *Independent*, 20 January 2006.

Kilgallon, Steve, 'Art rewards "are there"', *Stuff.co.nz*, 30 October 2011.

Kuper, Jeremy, 'London shows material interest in Africa's old clothe', *Mail* and *Guardian*, 19 April 2013.

McDonald, John, 'Precious and Powerful', *Art Collector*, 135.

Nagesh, Ashitha, '500 Words: Yinka Shonibare MBE', *Artforum*, 4 August 2013.

Porter, Claire R., 'Artist Erik Ravelo puts children on the Cross for controversial project', News.com Australia, 11 September 2013.

'Renée Cox: Artist's Statement', Brooklyn Museum, New York.

Riding, Alan, 'Annette Messager: A bold messenger for feminist art', *New York Times*, 26 June 2007.

Shapiro, David, 'Vanessa Beecroft: interview', *Museo* magazine, 2008.

Wakefield, Neville, 'Vanessa Beecroft', *Flash Art* 251, November–December 2006.

Wong, Jonathan, 'Zeng Fanzhi's *The Last Supper* on Exhibition in Paris', *Sotheby's* magazine, 12 November 2013.

Wroe, Nicholas, 'A life in art: Mark Wallinger', *Guardian*, 29 September 2011.

CHAPTER 3

'Angus Massey: Biography', N & N Aman Gallery, Tel Aviv, 2008.

Bell, Julian, 'Contemporary Art and the Sublime', in *The Art of the Sublime*, eds Nigel Llewellyn and Christine Riding, London: Tate Online Papers, January 2013.

Brodsky, Estrellita B., 'Interview: Carlos Cruz-Diez', *Bomb* magazine, winter 2010.

Burke, Edmund, *A Philosophical Enquiry into the Sublime and Beautiful*, Oxford: Oxford University Press, 2008.

Collings, Matthew, 'Oliver Marsden's Paintings: Changing Brain States', *Passenger*, 2009.

'Divine Apparitions: Aaron Rosen interviews the artist G. Roland Biermann in his London Studio', *Art and Christianity*, winter 2013.

Eliasson, Olafur, 'Your Gravitational Now' in *Spatial Politics: Essays for Doreen Massey*, eds David Featherstone and Joe Painter, Oxford: Wiley-Blackwell, 2013, 125–32.

Ellard, Graham and Stephen Johnstone, 'Interview: Anthony McCall', *Bomb* magazine, autumn 2006.

Freud, Sigmund, *The Uncanny*, London: Penguin Classics, 2003.

Gormley, Antony, *BLIND LIGHT* (2007), http://www.antonygormley.com.

Harper, Glenn, 'Exterior Form–Interior Substance: A Conversation with Xu Bing', *Sculpture* 22.1, 2003, 46–51.

Hughes, Robert, 'Man of Steel', *Guardian*, 22 June 2005.

Jameson, Fredric, 'Postmodernism, or, The Cultural Logic of Late Capitalism', in *The Sublime: Documents of Contemporary Art*, ed. Simon Morley, London and Cambridge, MA: Whitechapel Gallery and MIT, 2010, 141–6.

Kant, Immanuel, *Critique of the Power of Judgment*, ed. Paul Guyer, trans. Paul Guyer and Eric Matthews, Cambridge, UK: Cambridge University Press, 2001.

Kino, Caro, 'Monuments: The Poetry of Dreams', *New York Times*, 5 May 2011.

Kino, Carol, 'Stealing Mother Nature's Thunder', *New York Times*, 11 November 2010.

Lyotard, Jean-François, 'Presenting the Unpresentable: The Sublime', in *The Sublime: Documents of Contemporary Art*, ed. Simon Morley, London and Cambridge, MA: Whitechapel Gallery and MIT, 2010, 130–36.

May, Susan, 'Meteorologica', in *Olafur Eliasson: The Weather Project*, ed. Susan May, exhibition catalogue, London: Tate Publishing, 2003, 15–28.

Miller, David Ian, 'Finding My Religion: Photographer Hiroshi Sugimoto on subjects of a spiritual nature', *SFGate*, 10 September 2007.

Morrow, Bradford, 'Interview: Gregory Crewdson', *Bomb* magazine, autumn 1997.

Newman, Barnett, 'The Sublime is Now' in *Reading Abstract Expressionism*, ed. Ellen Landau, New Haven: Yale University Press, 2005.

Oishi, Lena, 'The Sounds of Silence: an Interview with Jaume Plensa', *Tokyo Art Beat*, 5 July 2007.

'Painter James Lavadour', video (6:28), *Oregon Art Beat*, 30 November 2000.

Quash, Ben, 'The De-sublimations of Christian Art', in *The Art of the Sublime*, ed. Nigel Llewellyn and Christine Riding, January 2013.

Redstone, Elias, 'The Making of a 19th-Century House in London, Built with Mirrors', *T magazine*, *New York Times*, 25 June 2013.

Robertson, Laura, 'The Big Interview: Carlos Cruz Diez', *Double Negative* magazine, 19 June 2014.

Rosen, Aaron, 'Step into the Light: Light Show at the Hayward', *Art and Christianity*, summer 2013.

Ruskin, John, *Modern Painters*, vol. I, London: George Allen, 1906.

Saltz, Jerry, 'It's Boring at the Top: Is Andreas Gursky – the highest-priced photographer alive – running out of ideas?', *New York* magazine, 28 May 2007.

Searle, Adrian, 'Metal Works: Interview', *Frieze* 119, November–December 2008.

Sherwin, Skye, 'Artist of the week 76: Chiharu Shiota', *Guardian*, 24 February 2010.

Christopher Turner, 'Lightning Fields', *Modern Painters*, April 2009.

Turner, Grady T., 'Interview: Yayoi Kusama', *Bomb* magazine, winter 1999.

Wainwright, Oliver, 'Random International installs torrential rain in Barbican Gallery', *Guardian*, 3 October 2012.

'Xu Bing: the Living Word', *The Morgan Library and Museum*, 2011.

Dal Zotto, Sara, 'Interview with Chiharu Shiota', *Nasty* magazine, summer 2013.

CHAPTER 4

Adams, Doug, 'Theological and Political Perceptions of Freedom and Community: Works by Christo and Jeanne-Claude' in *Visual Theology: Forming and Transforming the Community through the Arts*, eds Robin Jensen and Kimberly J. Vrudny, London: Glazier, 2009, 109–18.

Berger, John, 'Into the Woods: On Jitka Hanzlova's Forest', in *The Sublime: Documents of Contemporary Art*, ed. Simon Morley, London and Cambridge, MA: Whitechapel Gallery and MIT, 2010, 125–7.

Bowden-Pickstock, Susan, *Quiet Gardens: The Roots of Faith*, London: Continuum, 2009.

Carson, Rachel, 'The Real World around Us', in *Lost Woods: The Discovered Writing of Rachel Carson*, ed. Linda Lear, Boston: Beacon Press, 1998, 148–63.

Cotter, Holland, 'Public Art Both Violent and Gorgeous', *New York Times*, 14 September 2003.

'Roden Crater: About', http://rodencrater.com.

Emer, 'Edward Burtynsky', *Photo Forager*, 19 January 2012.

Emerson, Ralph Waldo, 'Nature' in *Nature and Other Essays*, New York: Classic Books International, 2010, 2–47.

Enright, Robert, 'An Interview with Giuseppe Penone', *Border Crossings*, December 2013, 23–37.

Ewing, Alexander, 'The Q&A: Angela Palmer, Artist', *More Intelligent Life*, summer 2014.

Faesler, Carla, 'Interview: Francis Alÿs', *Bomb* magazine, summer 2011.

Friedman, T. and Andy Goldsworthy, *Hand to Earth: Andy Goldsworthy Sculpture 1976–90*, Leeds: Henry Moore Centre, 1990.

Heidegger, Martin, 'The Origin of the Work of Art' in *Poetry, Language, Thought*, trans. A. Hofstadter, New York: Harper & Row, 1971.

Higgins, Charlotta, 'Richard Long: "It was the swinging 60s. To be walking lines in fields was a bit different"', *Guardian*, 15 June 2012.

'Interview with James Turrell: Roden Crater', *Art21*, 2001.

Lubow, Arthur, 'The Pyrotechnic Imagination', *New York Times*, 17 February 2008.

McDermott, Emily, 'Conversation: Mariko Mori', *Ocula*, February 2014.

McDonald, Soraya Nadia, 'São Paulo artist Henrique Oliveiras' massive tunnels offer commentary on Brazil's favelas', *Washington Post*, 11 June 2014.

Perry, Tony, 'Leonard Knight, artist at Salvation Mountain, dies at age 82', *Los Angeles Times*, 10 February 2014.

Salkeld, Lauren, 'The Tree of 40 Fruit Is Exactly as Awesome as It Sounds', *Epicurious*, 2014.

Spinoza, Baruch, *Ethics*, trans. Edwin Curley, London: Penguin, 2005.

Thorpe, Harriet, 'Darren Almond: to leave a light impression', *Studio International*, 2014.

CHAPTER 5
Akers, Norman, 'Artist Statement', http://normanakers.com.

Benjamin, Siona, 'Artist Statement', 2009, http://artsiona.com.

Benjamin, Siona, personal correspondence, 2013.

Berry, Ian, 'A Dialogue with Shahzia Sikander by Ian Berry' in *Shahzia Sikander: Nemesis*, eds Ian Berry and Jessica Hough, Saratoga Springs, NY and Ridgefield, CT: The Frances Young Tang Teaching Museum and Art Gallery at Skidmore College/The Aldrich Contemporary Art Museum, 2005, 5–19.

Bhabha, Homi, *The Location of Culture*, Abingdon, UK: Routledge, 2010.

Boyarin, Daniel and Jonathan Boyarin, 'Diaspora: Generation and the Ground of Jewish Diaspora' in *Theorizing Diaspora*, eds Jana Evans Braziel and Anita Mannur, Oxford: Blackwell, 2003.

Daftari, Fereshteh, 'Islamic or Not' in *Without Boundary: Seventeen Ways of Looking*, ed. Fereshteh Daftari, New York: Museum of Modern Art, 2006.

Eccles, Jeremy, 'Gordon Bennett explored indigenous past through his conceptual art', *Sydney Morning Herald*, 27 June 2014.

Fauntleroy, Gussie, 'Looking Forward: Trends in Native Arts', interview with Mateo & Diego Romero, *Southwest Art*, August 2000.

Gilroy, Paul, 'The Black Atlantic as a Counter-culture of Modernity' in *Theorizing the Diaspora*. London: Blackwell, 2003, 49–66.

Hall, Stuart, 'Cultural Identity and Diaspora', in *Diaspora and Visual Culture: Representing Africans and Jews*, ed. Nicholas Mirzoeff, London: Routledge, 2000, 21–33.

Harminder Singh: The Inconsistency of Everything, exhibition, 23 April–3 July, New Art Exchange, Nottingham, 2010.

'Indigenous work nabs religious art prize', *ABC News*, 29 August 2007.

'Jim Denomie talks about his painting *Non Negotiable*', video, Science Museum of Minnesota, 2014.

Kitaj, R. B., *First Diasporist Manifesto*, London: Thames & Hudson, 1989.

Luke, Ben, 'Pigments of the Imagination', *Telegraph*, 18 Feburary 2006.

Romero, Diego, 'Interview: New Mexico Public Broadcasting System', Youtube video (2:54 / 3:28), *ARTISODE* 2.6.

Rosen, Aaron, 'Waxing Poetic: Anish Kapoor at the Royal Academy', *Art and Christianity* 60, winter 2009.

Nagesh, Ashitha, 'Interview with Yinka Shonibare, MBE', *Artforum*, 9 April 2013.

Plensa, Jaume, video recorded live at Frederik Meijer Gardens & Sculpture Park, 2 October 2008.

Said, Edward, *Orientalism*, London: Penguin, 2003.

'Sculptor fills Tate with a hole', *BBC News*, 8 October 2007.

Shapira, Aithan, 'Meditations', in *Religion and Art in the Heart of Modern Manhattan: St Peter's Church and the Louise Nevelson Chapel*, ed. Aaron Rosen, London: Ashgate Publishing, 2015.

Shapira, Aithan, personal correspondence, 2014.

Sikander, Shahzia, 'Artist Statement', *Signs: Journal of Women in Culture and Society*, 12 October 2012.

Spivak, Gayatri Chakravorty, 'Can the Subaltern Speak?' in *Marxism and the Interpretation of Culture*, ed. Cary Nelson and Lawrence

Grossberg, Champaign, Illinois: University of Illinois Press, 1988.

Steward, Sue, 'Romuald Hazoumé's petrol perfumed art', *The Arts Desk*, 29 October 2009.

Tan, Shaun, comments on *The Arrival*, http://www.shauntan.net

Wiley, Kehinde, 'The World Stage: Israel', video, 8 March 2012.

Zwick, Tracy, 'Return: an interview with Yael Bartana', *Art in America*, 4 April 2013.

CHAPTER 6
Améry, Jean, 'Torture', *The Phenomenon of Torture: Readings and Commentary*, ed. William F. Schulz, Philadelphia, PA: University of Pennsylvania Press, 2007.

Antoni, Janine, 'Interview: Mona Hatoum', *Bomb* magazine, spring 1998.

Awst & Walther, personal communication, 2014.

Baker, Kenneth, 'Abu Ghraib's horrific images drove artist Fernando Botero into action', *SFGate*, 29 January 2007.

Baudrillard, Jean, 'L'esprit du terrorisme', *Le Monde*, 3 November 2001.

Broomberg & Chanarin, personal communication, 2014.

Gallois, Christophe, 'Interview with Mounir Fatmi', 2008, http://mounirfatmi.com

Gavin, Francesca, 'Awst & Walther: a lexicon of questions', *White Review*, February 2012.

Girard, René, *Violence and the Sacred*, trans. Patrick Gregory, London: Continuum, 2009.

Hirsch, Faye, 'In the studio: Wael Shawky', *Art in America*, 1 April 2013.

Hobin, John, 'In the Playroom', Ontario: White Water Gallery, 2010.

Jones, Jonathan, 'Look what we did: the Chapman Brothers', *Guardian*, 31 March 2003.

JR, 'Interview with Stephen Colbert', television interview, *Colbert Report*, 28 August 2014.

Kuksi, Kris, 'Kris Kuksi: Biography', Joshua Liner Gallery, New York, 2014.

Lane, Guy, 'If the light goes out: Edmund Clark's pictures of Guantánamo Bay', *Guardian*, 3 November 2010.

Messinger, Kate, 'Divine Darkness: an interview with Kris Kuksi', *Wild* magazine, 8 April 2011. Musa, Hassan, 'Biography', http://hassanmusa.com.

'The Museum', Museum on the Seam, Jerusalem.

Ophir, Adi, 'Divine Violence', *Two Essays on God and Disaster*, Jerusalem: The Van Leer Jerusalem Foundation, 2013.

'Roof Garden Installation by Imran Qureshi to Open at Metropolitan Museum May 2014', press release, Metropolitan Museum of Art, 10 May 2013.

Schwartz, Regina, *The Curse of Cain: The Violent Legacy of Monotheism*, Chicago: University of Chicago Press, 1997.

Stahl, Lisa, 'Contemporary History: Q+A with Yan Pei-Ming', *Art in America*, 30 May 2012.

'Wael Shawky: Cabaret Crusades', press release, MoMA, New York, 28 April 2014.

Waked, Sharif, 'Chic Point: Fashion for Israeli Checkpoints', *Nafas Art Magazine*, March 2005.

Weiss, Yoav, 'Yoav Weiss: press releases', N & N Aman Gallery, Tel Aviv, 2008.

CHAPTER 7
Abramović, Marina, 'Statements' in *The Sublime: Documents of Contemporary Art*, ed. Simon Morley, Cambridge, Massachusetts: MIT Press, 2010, 212.

Bell, Catherine, 'Ritual' in *The Blackwell Companion to the Study of Religion*, ed. Robert Segal, London: Blackwell, 2006, 397–409.

Bellah, Robert, 'Civil Religion in America' in *A Reader in the Anthropology of Religion*, 2nd edition, ed. Michael Lambek, London: Blackwell, 2008, 509–18.

Borra, Catherine, 'Interview: Idris Khan', *Flash Art* Online, March–April 2010.

De Certeau, Michel, *The Practice of Everyday Life*, Berkeley: University of California Press, 1988.

Corner, Elena, 'Has destroying all their worldly goods made these artists happy?' *Independent*, 10 January 2010.

Curti, Paolo, 'Paolo Curti and Co. Gallery opens its new space with a personal exhibition of the Cuban artist Anna Maria Pérez Bravo', http://paolocurti.com.

Delaney, Helen, 'Summary: The Chapman Family Collection, 2002', *Tate* online, May 2009.

Harnden, Anna, personal communication, 2014.

'Interview with John Federov: *Forest at Night*', *Art21*, 20 October 2001.

D'Mello, Rosalyn, 'Interview: Chitra Ganesh on her upcoming Delhi solo', *Blouin Artinfo*, 25 September 2013.

Knudsen, Stephen, 'Prying Religion, Sexuality, Self-Identity and Forensics. A Conversation with Angela Strassheim', *ArtPulse* magazine, July 2012.

Laib, Wolfgang, 'Wolfgang Laib: press release', Sean Kelly Gallery, New York, September 2007.

Merton, Thomas, *New Seeds of Contemplation*, New York: New Directions, 2007.

Merton, Thomas, *Thoughts in Solitude*, New York: Farrar, Straus and Giroux, 1999.

Newman, Barnett, 'The First Man Was An Artist' in *Art in Theory 1900–2000: An Anthology of Changing Ideas*, eds Charles Harrison and Paul J. Wood, London: Blackwell, 2002.

Nickerson, Jackie, *Faith* 18 September–16 November 2008, press release, Grimaldi Gavin, Paris.

Pizarro, Jordi, 'Artist Statement', 2014, http://www.jordipizarro.com.

Sicuro, Andre, *Back to Simplicity*: Martina Abramović, video (4:15), 2011, https://vimeo.com.

'Tapfuma Gutsa: Biography and Exhibitions', October Gallery, London, 2011.

Turner, Victor, *The Ritual Process: Structure and Anti-Structure*, Chicago: Aldine, 1969.

Vogt, Jonas, 'Interview: Hermann Nitsch', *Vice*, 1 November 2010.

Wang, Zhan, 'Past Exhibit: 86 Divinity Figures, Long March Space', 2008, http://longmarchspace.com.

Winston, Sam, 'Artworks: Birth-day', http://www.samwinston.com.

Winston, Sam, personal communication, 2014.

CHAPTER 8
Balmforth, James, personal communication, 2014.

Bellah, Robert, 'Civil Religion in America' in *A Reader in the Anthropology of Religion*, 2nd edition, ed. Michael Lambek, London: Blackwell, 2008, 509–18.

Eisenman, Peter, 'Is there a Religious Space in the Twenty-First Century?' in *Constructing the Ineffable: Contemporary Sacred Architecture*, ed. Karla Cavarra Britton, Hew Haven: Yale University Press, 2010.

Gayford, Martin, 'Anselm's Alchemy', *RA Magazine*, 22 September 2014.

Guido, Anthony, 'Michael Arad: Memorial Architect Reflects on Design Process', *9/11 Memorial*, 5 March 2013.

'Néle Azevedo Interview', *GreenMuze*, 12 December 2008.

Navarro, Iván, 'Enlightening Navarro: Law & Disorder', interview with Antonio Arévalo, *Drome* magazine 16, 2009.

Neelova, Nika, personal communication, 2014.

O'Hagan, Sean, 'How these men will honour the 7 July dead in this royal corner of London', *Guardian*, 31 May 2009.

'Q&A with architect Daniel Libeskind', CNN, 13 November 2006.

Ouroussoff, Nicolai, 'A forest of pillars, recalling the unimaginable', *New York Times*, 9 May 2005.

Round, Simon, 'Interview: Daniel Libeskind', *Jewish Chronicle*, 6 May 2010.

Searle, Adrian, 'Making Memories: Rachel Whiteread', *Guardian*, 17 October 2000.

Spiegelman, Art, *In the Shadow of No Towers*, New York: Pantheon, 2004.

Temin, Kathy, 'Meditations' in *Religion and Art in the Heart of Modern Manhattan: St Peter's Church and the Louise Nevelson Chapel*, ed. Aaron Rosen, London: Ashgate Publishing, 2015.

Temin, Kathy, personal communication, 2014.

Temin, Kathy, 'My Monument: White Forest', video (4:39), Queensland Television, 28 September 2013.

Young, James, *At Memory's Edge: After-Images of the Holocaust in Contemporary Art and Architecture*, New Haven: Yale University Press, 2002.

CHAPTER 9

Altman, Anna, 'Never quite filling the void: Kader Attia', *Art in America* magazine, 24 September 2009.

Amado, Miguel, 'Kader Attia: 500 Words', interview, *Artforum*, 23 August 2013.

Ates, Güler, personal communication, 2014.

Bearman, Joshuah, 'Interview: Marjane Satrapi', *Believer* magazine, August 2006.

Butler, Judith, *Bodies that Matter: On the Discursive Limits of 'Sex'*, Abingdon, UK: Routledge, 2011.

Butler, Judith, *Gender Trouble: Feminism and the Subversion of Identity*, New York: Routledge, 2010.

Camhi, Leslie, 'Centrifugal Force: Unravelling the Art of Sigalit Landau', *Tablet*, 17 June 2008.

Close, Chuck, 'Interview: Kiki Smith', *Bomb* magazine, autumn 2004.

Delice, Serkan, 'Fake World' in *Taner Ceylan: The Lost Paintings Series*. New York, co-published by Standard Press, Paul Kasmin Gallery and Damiani, 2013.

Doshi, Riddhi, 'Rashid Rana: lifting the veil', *Hindustan Times*, 1 April 2012.

Huysal, Yusuf, personal correspondence with Taner Ceylan, 2014.

'Interview with Kiki Smith: Learning by Looking – Witches, Catholicism, and Buddhist Art', *Art21*, 2 September 2003.

Kim, Byron, 'Interview audio: Synecdoche', audio (2:03), New York: *MoMA Multimedia*, 2008.

Kim, Byron, personal communication, 2012.

Lankarani, Nazanin, 'Going his own way, a Pakistani artist arrives', *New York Times*, 13 October 2010.

Victor Majzner, personal communications, 2011–12.

Martinez, Rosa, 'Ghada Amer 2011–2013', http://www.rosamartinez.com.

McNulty, Bernadette, 'Spencer Tunick: bare with me', *Telegraph*, 2 August 2010.

Merleau-Ponty, Maurice, *Phenomenology of Perception*, trans. Colin Smith, Abingdon, UK: Routledge, 2009.

Morton, Julia, 'Greer Lankton: a Memoir', *Artnet*, 26 July, 2006. www.artnet.com/magazineus/features/morton/morton1-26- 07.asp.

Nicholls, Jacqueline, personal communications, 2012–13.

Pollock, Griselda, *Vision and Difference: Feminism, Femininity and the Histories of Art*, Abingdon, UK: Routledge, 2003.

Radnor, Abigail, 'Picture of the week: Desert Spirits by Spencer Tunick', *Guardian*, 9 May 2014.

Rosen, Aaron, 'United (Jewish) Artists', *Hadassah Magazine*, winter 2013.

Salakhova, Aiden, 'Fascinans and Tremendum', video, *Blouin Artinfo*, 4 January 2013.

Stewart, Pamela, 'Interview with Artist-Photographer Spencer Tunick', *PetaPixel*, 7 August 2013.

CHAPTER 10

'Art in the Cathedral', Liverpool Cathedral, http://www.liverpoolcathedral.org.uk/about/art-in-the-cathedral.aspx

Brown, Mick, 'Sir Anthony Caro: Light for Darkness', *Telegraph*, 15 October 2008.

Davies-Crook, Susanna, 'Disassembling Bambi', *Exberliner*, 7 December 2011.

Daftari, Fereshteh, 'Beyond Islamic Roots: Beyond Modernism', *Res: Anthropology and Aesthetics* 43, spring 2003, 175–86.

Duncan, Carol, *Civilizing Rituals: Inside Public Art Museums*, London: Routledge, 1995.

El-Mecky, Nausikaä, 'Meditations' in *Religion and Art in the Heart of Modern Manhattan: St Peter's Church and the Louise Nevelson Chapel*, ed. Aaron Rosen, London: Ashgate Publishing, 2015.

Finaldi, Gabriele, *The Image of Christ*, London: National Gallery, 2000.

Gayford, Martin, 'Gerhard Richter: Behind the pictures', *Telegraph*, 20 September 2008.

Howes, Graham, *The Art of the Sacred: An Introduction to the Aesthetics of Art and Belief*, London: I. B. Tauris, 2007.

Jenkins, Simon, *England's Thousand Best Churches*, London: Allen Lane, 2012.

Jones, Jonathan, 'Hallalujah! Why Bill Viola's Martyrs Altarpiece at St Paul's is to die for', *Guardian* blog, 21 May 2014.

Kahn, Tobi, personal correspondence, 2014.

Kington, Tom, 'Modern Catholic churches resemble museums, says Vatican', *Telegraph*, 2 June 2013.

Koestlé-Cate, Jonathan, 'Meditations' in *Religion and Art in the Heart of Modern Manhattan: St Peter's Church and the Louise Nevelson Chapel*, ed. Aaron Rosen, London: Ashgate Publishing, 2015.

Leon, Dan, Matthew Lloyd and Shahed Saleem, 'Meditations' in *Religion and Art in the Heart of Modern Manhattan: St Peter's Church and the Louise Nevelson Chapel*, ed. Aaron Rosen, London: Ashgate Publishing, 2015.

Lynch, Patrick, 'An interview with Peter Zumthor', *Architect's Journal*, April 2009.

Kuehn, Wilfried, 'Meditations' in *Religion and Art in the Heart of Modern Manhattan: St Peter's Church and the Louise Nevelson Chapel*, ed. Aaron Rosen, London: Ashgate Publishing, 2015.

Magill, R. Jay, 'A Cube, Like Mecca's, Becomes a Pilgrim', *New York Times*, 15 April 2007.

Vastano, Stefano, 'Demolire Goebbels', interview with Gregor Schneider, *L'Espresso*, 5 February 2015, 76–9.

To My Sweet Sister

Whitney Hammond

There's a blaze of light in every word
It doesn't matter which you heard
The holy or the broken Hallelujah
LEONARD COHEN

ACKNOWLEDGMENTS

This book is the product of conversations. My commissioning editor, Jacky Klein, challenged me from the start to stretch beyond my comfort zone and seek out artists from across the world. Frequently teetering on the edge of my own expertise, this meant depending on the advice of various art historians, gallerists, and critics, including Kathleen Ash-Milby, Hannah Barry, Gus Casely-Hayford, Rosemary Crumlin, Gerard Houghton, Alice Hutchison, Ezra Konvitz, Ayla Lepine, James Lindon, Tim Marlow, Devika Singh, Erica Segre, Maria Starkova-Vindman, and Peggy Wang, among many others. I also owe a great debt to my student research assistant Yusuf Huysal, and at Thames & Hudson Celia White and Maria Ranauro for helping me identify new artists, arrange image rights, and a thousand other practical tasks, Sarah Praill for her striking design and Caroline Brooke Johnson for editing the text. Friends including David de Bruijn, Rachel Fendler, Graham Howes, Ayla Lepine, Ben Quash, Chloe Reddaway, and Giles Waller will also recognize ideas in this book that I have deviously culled from conversations here and there. Above all, I want to thank the artists who appear in this book, many of whom not only shared their work but also their time, graciously allowing me to pepper them with questions.

My family have supported me throughout this project. My father, Clifford Rosen, and my stepfather, James Hammond, offered particularly helpful feedback on drafts of this book. My wife, Carolyn Rosen, was a compliant hostage to the project from start to finish, but is more importantly my best friend. As ever, thoughts of my sister Whitney have been with me throughout. Her presence can be felt most palpably in the painting by Victor Majzner featured in chapter nine. In that image an arm descends from heaven, tattooed with a passage from the Song of Songs: 'Set me as a seal upon your heart, as a seal upon your arm. For love is as strong as death' (8.6). The composition was inspired by my brother Ross, who has this verse tattooed on his arm in memory of our sister. There is much in this canvas that stirs associations Victor could not have known, yet which haunt his canvas nonetheless. My sister loved delicate, exotic flowers, and even had an hibiscus tattoo, which she designed herself. Recalling these memories, the droplets of water in the painting are, first and foremost for me, tears of loss for my sister. But they are also waters of renewal, preventing this dazzling menagerie of flowers from wilting. I have always thought there is a horrible poignancy in the fact that people give flowers – doomed to decay – as tokens of comfort to the bereaved, or place them upon the graves of loved ones. Victor's painted flowers are, I think, more proper markers of undying love; love that is truly 'as strong as death'.

Page numbers in *italic* refer to the illustrations

Abramović, Marina 162, 164, *165*
Adam and Eve 30–31, 44
Adams, Doug 102
Adjaye, David 230–31, 238
Adorno, Theodor 247
Africa 16, 30, 37, 50, 63, 97, 116, 119, 120, 121, 128, 132, 138, 149, 150, 162, 164, 180
Ai Weiwei 230, *237*
Akers, Norman 119, *130–31*
Almond, Darren 97, *107*
Altindere, Halil 96, *104–5*
Alÿs, Francis 94, *104*
Amer, Ghada 209, *218–19*
Améry, Jean 141–2
Anatsui, El 116, *117*, 119
Angkor Wat 229
Arab Spring 209, *218, 219*
Arad, Michael *193*
Argue, Doug 26, *36*
Ates, Güler 209, *217*
Attia, Kader 209, *218*
Australia 15, 27, 99, 115, 119, 124, 127, 164
Awst (Manon) & Walther (Benjamin) *149*
Azevedo, Néle de 185, *196*

Balka, Miroslaw 231, *244–5*
Balmforth, James 185, *202–3*
Bamiyan Buddhas 7, 8
Banksy 140, *152–3*
Bartana, Yael 120, 121
Bartow, Rick 27, *32–3*
Baudrillard, Jean 141
Beecroft, Vanessa 50, *62–3*
Bell, Catherine 161
Bell, Julian 72, *79*
Bellah, Robert 163, 183
Benjamin, Siona *114*, 116, 125
Bennett, Gordon 117–19, *126–7*
Berger, John 101
Berlin 152, 184, 185, 188, 189, 190, 231, 233, 234
Berlin Jewish Museum 184, 188, *189*
Bernini, Gian Lorenzo 207
Beuys, Joseph 161
Bhabha, Homi 119
Bialobrzeski, Peter 30, *31*
Bible 8, 28, 30–31, 43, 47, 66, 96–7, 119, 124, 138, *146–7*, 149, 154, 180, 196, 222, 238, 241, 247
 Genesis 17, 26, 28, 30, 32, 36, *43*, 95
 Exodus 124, 147
 Judges 119
 Song of Songs 207, *224*, 225, 241, 253
 Isaiah 149
 Gospels 6, 10, 13, 28, 29, 30, 48, 58, 102, 116, 207, 238

Revelation 50, 53, 97, 106
Biermann, G. Roland 76, *90*
Bosch, Hieronymus 30, 150
Botero, Fernando 142
Bourgeois, Louise 186
Boyarin, Daniel and Jonathan 120
Brabander, Yves de 211, *223*
Brambilla, Marco *34–5*
Broomberg (Adam) & Chanarin (Oliver) 138, *147*
Budapest 185–6, 201
Buddha and Buddhism 7, 8, 27, 43, 48, 58, 75–6, 87, 90, 102, 128, 163, 170, 234
Burke, Edmund 71–2
Burne-Jones, Edward 174
Burtynsky, Edward 97, 99
Bush, George W. 137
Butler, Judith 211
Butzer Design Partnership *191*

Cai Guo-Qiang 94, 95
Caravaggio 47, 207, 213
Carmody (Kevin) Groarke (Andrew) *194*
Caro, Anthony 232–3, *242*
Carson, Rachel 97
Catling, Brian 231, 232
Cattelan, Maurizio 9, *13*, 30, *43*
Cavallaro, Cosimo 49, 63
Certeau, Michel de 162, 163
Ceylan, Taner 211, *223*
Chagall, Marc 49, 242
Chapman, Jake and Dinos 15, 137, *145*, 161, *167*
Christianity 7–17, 19, 20, 22, 27, 28, 34, 47–66, 96, 99, 102, 105, 110, 119, 127, 138, 142, 149, 166, 170–71, 173, 207–9, 212–13, 227, 229–35, 238, 240–44, 246, 247
 Church of England 149, 229, 230, 231, 233, *240, 241, 243*
 Orthodox Church 162, 166, 232, 236
 Roman Catholic Church 12–13, 15, 17, 34, 50, 60, 63, 66, 125, 127, 163, 170, 207, 227, 232
Christo and Jeanne-Claude 94, *102–3*
Clark, Edmund 142, *157*
climate change/global warming 93, 96–7, *106, 107, 196*
Clinton, Hillary 13
colonialism/postcolonialism 19, 54–5, 115–17, 119, 121, 167
Cox, Renee 47–8
Creation 23, 27–45, 93, 96, 130, 242
Crewdson, Gregory 76, *89*
Cross and crucifixion 10, *14*, 15, 20, 48–53, *54*, *59–63*, 65, 127, 130, *144*, 162, 164, *168*, 227, 231, *240*
Crumb, Robert 28, *32*
Cruz-Diez, Carlos 75, *86*
Cummins, Paul 186, *187*

Danto, Arthur 140–41
Dawkins, Richard 19, 127

death 16, *23, 43*, 50, 53, 64, 66, 128, 142, *178, 179, 182–202*, 224, 225, *226*, 227, 231, 253
Delacroix, Eugène 138
Delvoye, Wim 49, 50, *51*
Demand, Thomas 163, *176–7*
Denomie, Jim 117, *124–5*
Derrida, Jacques 87
Descartes, René 208
diaspora 119–21, 124, 125, 130, 132, 135
Dos Santos, Fiel *148–9*
Dubai 17, 18, 23
Durkheim, Émile 164

East Asia 28, 30, 43, 56, 58, 75–6, 102, 124, 144, 170, 183, 237
Eden, Garden of 30–31, *39–41*, *43–5*, 96
Eisenman, Peter 185–6, *190*
Eliasson, Olafur 75, *81*
Emerson, Ralph Waldo 96
Emin, Tracey 232, *241*
Enlightenment 71–2, 229
environment and nature *23*, 30, 32, 72, 75, 78, 81, 93–111, 164, 179
Erlich, Leandro 75, *82*

Fam Arquitectura y Urbanismo S.L. *182, 202*
Fatmi, Mounir 138, *146*
feminism 123, 209
Feodorov, John 164, *181*
Finn-Kelcey, Rose 232, *246*
Firrell, Martin 232, *246–7*
Frank, Thilo *21*
Freud, Sigmund 76, 176, 188
Friedrich, Caspar David 77, *107*
Fromm, Erich 30
Fukimura, Makoto 28, *29*, 30

Ganem, Jean-Paul 97, *110–11*
Ganesh, Chitra 162, *168–9*
Gauguin, Paul 8, *10*
gender 20, 211, 213, 216–27, also see sexuality
Gijs, Pieterjan 231, *235*
Gilbert & George 9, 50, *52*
Gilroy, Paul 121
Girard, René 137
Giuliani, Rudolph 13, 15
God(s) 9, 13, 20, 27–30, *39*, 49, 50, 53, 75–6, 94–9, 119, 123, 125, 128, 138, 142, 164, 174, 181, 209, 223, 227, 229, 247
Goethe, Johann Wolfgang von 229, 247
Goldsworthy, Andy 94
Gormley, Antony *84–5*
Goya, Francisco de 49, 137, 141, 144, *145*
El Greco 223
Green Movement (Iran) 209, 211
Grünewald, Matthias 47
Guantánamo Bay Detention Camp 142, *157*
Gupta, Shilpa *136*, 141, *155*
Gursky, Andreas 76–7, *77*
Gutsa, Tapfuma 164, *180*

Hall, Stuart 115
Hamburg 231, *236*
Hanzlová, Jitka 94, *100*
Hatoum, Mona 140, 142, *143*
Hazlitt, William 229
Hazoumè, Romuald 119, *128–9*
Heidegger, Martin 94
Heine, Heinrich 188
Heizer, Michael 93
Helms, Jesse 13, 15
Hinduism 22, 27, 74, 76, 90, 116, 119, 123, 125, 128, 141, 166, 179
Hirst, Damien 15, 49, *60*
Hitchens, Christopher 19
Hitler, Adolf 43, 188, 190
Hobin, Jonathan 142, *156*
Holocaust (Shoah) 121, 154, 183, 184, 185–6, 188–90, 201, 244–5
Holzer, Jenny 232, *247*
Horne, Pip 240
Houshiary, Shirazeh 232, *240*
Howes, Graham 229
Huang Yong Ping 30, *42–3*
Hunter, Tom 162, *174*

iconoclasm 10, 15, 47, 162, 163, 170, 172, 232
Islam 7, 17, 18, 21, 22, 27, 104, 116, 125, 138–42, 146, 150, 176, 209, 211, 220, 231, 233, 234, 236, 240, also see mosque

Jameson, Fredric 76
Jencks, Charles 96, *98*
Jerusalem 130, 138–40, 166, 231
Jesus Christ 6, 8–11, *13–16*, 20, 23, 46–66, 102, 105, 110, 127, 142, 164, 170, *171, 173*, 207, 209, *212, 213*, 227, 238
Jews and Judaism 8–9, 12, 22, 27, 102, 115, 116, 120–21, 125, 130, 132, 138–41, 154, 184, 185–6, 188–90, 199, 201, 209, 221, 225, 231–4, 242, 244–5, also see synagogue
Jinks, Sam 50, *64–5*
John Paul II, Pope 9, *13*, 17
JR 140, *152*
Judge, Harminder 119, *128*

Kahn, Tobi 233, *234*
Kahraman, Hayv *18*
Kant, Immanuel 72–5, 76
Kapoor, Anish 75, *82–3*
Kester *148–9*
Khan, Idris 163, *176*
Kiefer, Anselm 185, *196–7*
Kim, Byron 208, *214*
King, Martin Luther, Jr. 43, 183, 202
Kinkade, Thomas 20
Kippenberger, Martin 10
Kitaj, R.B. 120, 121
Knight, Leonard 92, 94–6, *105*
Kuehn Malvezzi 234
Kuksi, Kris 138, *150–51*
Kusama, Yayoi 70, 75, *88*

LaChapelle, David *46*, 50, *66*
Laib, Wolfgang 160, 163, *179*
Landau, Sigalit 206, 208, *225*
Landy, Michael 163, *172*
Lankton, Greer 211, *226*
Lavadour, James 72, *78*
Leon, Dan *233*
Leonardo da Vinci 6, 7, 11, *47–8*, 50
Libeskind, Daniel 184, *188–9*
Lin, Maya 183
Lloyd, Matthew 233
London 9, 15, 17, 18, 48–9, 58, *81*, *82*, 90, 94, *108*, 119, 128, 132, 142, 147, 174, 186, *187*, 194, 212, 229–31, 233, 240, 243, 246–7
Long, Richard 94, *101*
Longinus 71
Luna, James 162, *163*
Lyotard, Jean-François 77

Maalouf, Amin 150
McCall, Anthony 85
McNaughton, John 20
McVeigh, Timothy 191
Madrid 18, *182*, 186, 202
Magruder, Michael Takeo 30, *39*
Majzner, Victor *224–5*
Malevich, Kasimir 236
Malraux, André 229
Mandela, Nelson 183
Mantegna, Andrea 223
Marsden, Oliver 76, *90*
Martin, John 72
Mary, Virgin 9, 10, 13, 15, *16*, 50
Mary Magdalene 207, *213*
martyrs/martyrdom 142, 227, *223*, 240, 243
Masaccio 31
Massey, Angus 72–5, *74*
Maté, Adelino Serafim *148–9*
Matisse, Henri 48, 232
Mavromatti, Oleg 10, 50
Mecca 21, 142, 231, 236
Medina, Cuauh-Témoc *104*
meditation 90, 163–4, 179, 229, 234
memory 18–19, 76, 89, 91, 135, 163, 179, 183–203, 227
Merleau-Ponty, Maurice 208, 209
Merton, Thomas 163
Mesiti, Angelica 207, *208*
Messager, Annette 49, *61*
Michelangelo 15, 27, 50
Middle East 7, 17–18, 23, 57, 72, 99, 104–5, 116, 120–21, 130, 132, *133*, 137–42, 166, 183, 209–11, 218–220, 216–17, 222–3, 225
migration 23, 119–21, *122*, *124*, 130, 132, 135
Mori, Mariko 96, *102*
mosque *7*, 9, 96, 233, 240
Mueck, Ron 207, *212*
Mumbai (Bombay) 18, 116, 155
Musa, Hassan 138, *139*
myths and mythology 10, 19, 27, 28, 138, 168, 220

native peoples 27, 32, 55, 93, 115, 119, 125, 127, 130, 134, 161–4, 167, 239
Navarro, Iván 184, *194–5*
Neelova, Nika 186, *198–9*
Nes, Adi 48, 57, 211, *222*
Neshat, Shirin 209, *210*
Nevelson, Louise 232–3
New York City 13, 15, 18, 34, 43, 58, 63, 66, 94–5, 102, *103*, 130, 141, 184, *192–5*, 231–2, *234*, *247*
Newling, John 231, *244*
Newman, Barnett 48, 71, 77, 161, 202
Nhatugueja, Hilario *148–9*
Nicholls, Jacqueline 209, *221*
Nickerson, Jackie 162, *175*
Nitsch, Hermann 162, *168*
Noah (and the Flood) 28, 95, 96, 97

Obama, Barack 15
O'Callaghan, Regan *230*
O'Doherty, Brian 230
Ofili, Chris 10–15, 16–17, *16*, 230–31, *238*
Oklahoma City bombing 184, 191
Oliveira, Henrique 97, *108–9*
Ophir, Adi 138
Orientalism 116, 211
Ortega, Rafael *104*

Palestinians 138–41, 142, 152
Palmer, Angela 97, *108*
Parthenon (Elgin) Marbles 7, 9
Pauer, Gyula 185, *200–201*
Penone, Giuseppe 97
Pérez Bravo, Marta María 164, *180*
Perry, Grayson 31, *44*
Picasso, Pablo 8, 141
pilgrimage 94, *166*, 229, 233
Piper, Tom 187
Pizarro, Jordi 161, *166*
Plensa, Jaume 75, 88–9, 121, *135*
Pollock, Griselda 209, 211
postmodernism 71, 76–7, 134
prayer 47, 58, 104, *105*, 163, 164, 218, 223, 229, 230, 233, 234, 240, 246
protest 10, 63, 145, *154*, 209, 218, *219*
Purdie, Shirley 119, *127*
Putin, Vladimir 10, 50

Quash, Ben 72
Quinn, Marc 30, *40*
Qur'an 138, 146, 176
Qureshi, Imran 141, *155*

race and ethnicity 16, 20, 63, 119, 104, 115, 125, *126*, 212, 214
Rana, Rashid 209, *220*
Random International *84*
Raphael 16
Reformation 47, 207
Reichek, Elaine 30, *44–5*

Reinhardt, Ad 163
Rembrandt 176
Richier, Germaine 231
Richter, Gerhard 228, 232, 240
ritual 19, 23, 34, 102, 128, 161–203, 232, 235, 243
Romanticism 71, 72
Rome 47, 229, 231
Romero, Diego 119, *134*
Rothko, Mark 8, 12, 230, 232–3
Rovner, Michal 115, *122*
Rumi 240
Ruskin, John 75
Russia 10, 50, 162, 199

Saatchi, Charles 15, 17
sacrifice 18, 48, 57, 137, 144, 162, 165, 168, 169, *187*
Sah 'Azad', Govinda 36–7
Said, Edward 116
saints 174, 207, 213, 223, 230
St Paul's Cathedral, London *243*, *246–7*
St Peter's Basilica, Rome 50, 72, 229
Salakhova, Aidan 209, *216*
Salcedo, Doris 117, *118–9*
Saleem, Shahed 233
Satrapi, Marjane 209, *216*
Schapiro, Meyer 232
Schechner, Richard 162
Schmidt, Kevin 97, *106*
Schneider, Gregor 231, *236*
Schwartz, Regina 138
Schweitzer, Dave 223
secularization 18–19, 57, 66, 229–30
Semu, Greg 47–8, *55*
Serra, Richard 72, *73*
Serrano, Andres 10–16, *14*, 49
sexuality 9, 19–20, 32, 50, 52, 207, 209–11, 215–23, 226–7, 241
Shapira, Aithan 121, *130*
Shaw, Raqib 30, *41*
Shawky, Wael 138, *150*
Shiota, Chiharu 76, *91*
Shonibare, Yinka 48, *54*, 121, *132*
Shrigley, David 50–53, *53*
Sikander, Shahzia 116, *123*
Sikhism 22, 128
Singletary, Preston 230, *239*
Slavs and Tatars 23
Smith, Kiki 209, *227*
Smithson, Robert 93, 225
Snyder, Joan 141, *154*
South America 104, 107, 108–9, 119, 185, 194
South Asia 8, 18, 36, 41, 114–16, 123, 125, 134, 141, 155, 166, 168, 170
Spiegelman, Art 184, 216
Spinoza, Baruch 96
Spivak, Gayatri Chakravorty 116–17, 119
Strassheim, Angela 162, *173*
Strumbel, Stefan 232, *232*

Studio Azzurro 30, *38*
Sublime 36, 70–91, 93–4, 176
Sufism 240
Sugimoto, Hiroshi 72, *80–81*
synagogue 231, 233, 244, *245*

Tan, Shaun 121, *124*
Taylor-Johnson, Sam 50, *65*
technology 36, 39, 76, 83, 84, 93, 137, 176, 181
Temin, Kathy 185, *199*
Ter-Oganyan, Avdey 10, 162, *162*
terrorism 18, 43, 95, 141, 142, 146, 155, 156, *182*, 183–4, 186, 191–5, 202
Titian 207
Togay, Can 185, *200–201*
Topçuoğlu, Nazif 207, *213*
torture 141–2, 170, 186
Tunick, Spencer 208–9, *215*
Turner, J. M. W. 72, *75*
Turner, Victor 162
Turrell, James 93–4, 230

Vaerenbergh, Arnout van 231, *235*
Van Aken, Sam 97, *110*
Vatican 17, 27, 229
veil 17, 18, 209, 211, *216*, *217*, *218*, 220, 223
Viola, Bill 232, 243
violence 57, 66, 137–57, 183, 186, 187, 196, 201, 241

Wagner, Roger 47, 48
Waked, Sharif 140, *140–41*
Walker, Peter 193
Wallinger, Mark 49, 58, *58–9*, 66–7
Warhol, Andy 8, *11*, 66
Warner, Lachlan 164, *170–71*
Washington, DC 27, 32, 183
Weiss, Yoav 140, *152–3*
Wells, Sam 231
Whiteread, Rachel 184, *188*
Wiley, Kehinde 120–21, *132–3*
Williams, Rowan 230
Winston, Sam 163, *178–9*
World Trade Center attacks (11 September 2001) 43, 95, 141, 156, 184, *192–5*, 197
World War, First 186, *187*
World War, Second 121, *154*, 183–6, *188–90*, 196, 199–201, *201*, 240, 244

Xu Bing 75–6, *87*

Yan Pei-Ming 137, *144*
Young, James 183

Zen Buddhism 75–6, 87, 163, 234
Zeng Fanzhi 48, *56*
Zhan Wang 162, *170*
Zhang Huan 48, *58*
Zulu, Sandile *34*
Zumthor, Peter 232

256